TASCHEN est.1980	TASCHEN	TASCHEN est. 1980	TASCHEN	TASCHEN est. 1980	TASCHEN	TASCHEN est.1980	TASCHEN	TASC est. 15
	TASCHEN est.19%0		TASCHEN est. 1980		TASCHEN est. 1980		TASCHEN est. 1980	TASQ
TASCHEN est. 1980		TASCHEN est.1980		TASCHEN est. 1980		TASCHEN est. 1980		TASCI est. 15
TASCHEN	TASCHEN est.1980		TASCHEN est.1980		TASCHEN est.1980		TASCHEN est. 1980	TASC
TASCHEN est. 1980		TASCHEN est.1980		TASCHEN est.1980		TASCHEN est.1980		TASCI est. 19
	TASCHEN est.1980		TASCHEN est.1980		TASCHEN est.tyNo		TASCHEN est.19%0	TASCH
TASCHEN est.1980		TASCHEN est.1980		TASCHEN est. 1980		TASCHEN est.19%0		TASCI est.194
	TASCHEN est.1980		TASCHEN est.1980		TASCHEN est.1980		TASCHEN est. 1980	TASCH
TASCHEN est. 1980		TASCHEN est. 1980		TASCHEN est.1980		TASCHEN est. 1980		TASCI est.198
	TASCHEN est.1980		TASCHEN est.1980		TASCHEN est.1980		TASCHEN est.1980	TASCH
TASCHEN est.1980	TASCHEN	TASCHEN est. 1980	TASCHEN	TASCHEN est.1980	TASCHEN	TASCHEN est.1980	TASCHEN	TASCI est. 198

Cubism

ANNE GANTEFÜHRER-TRIER UTA GROSENICK (ED.)

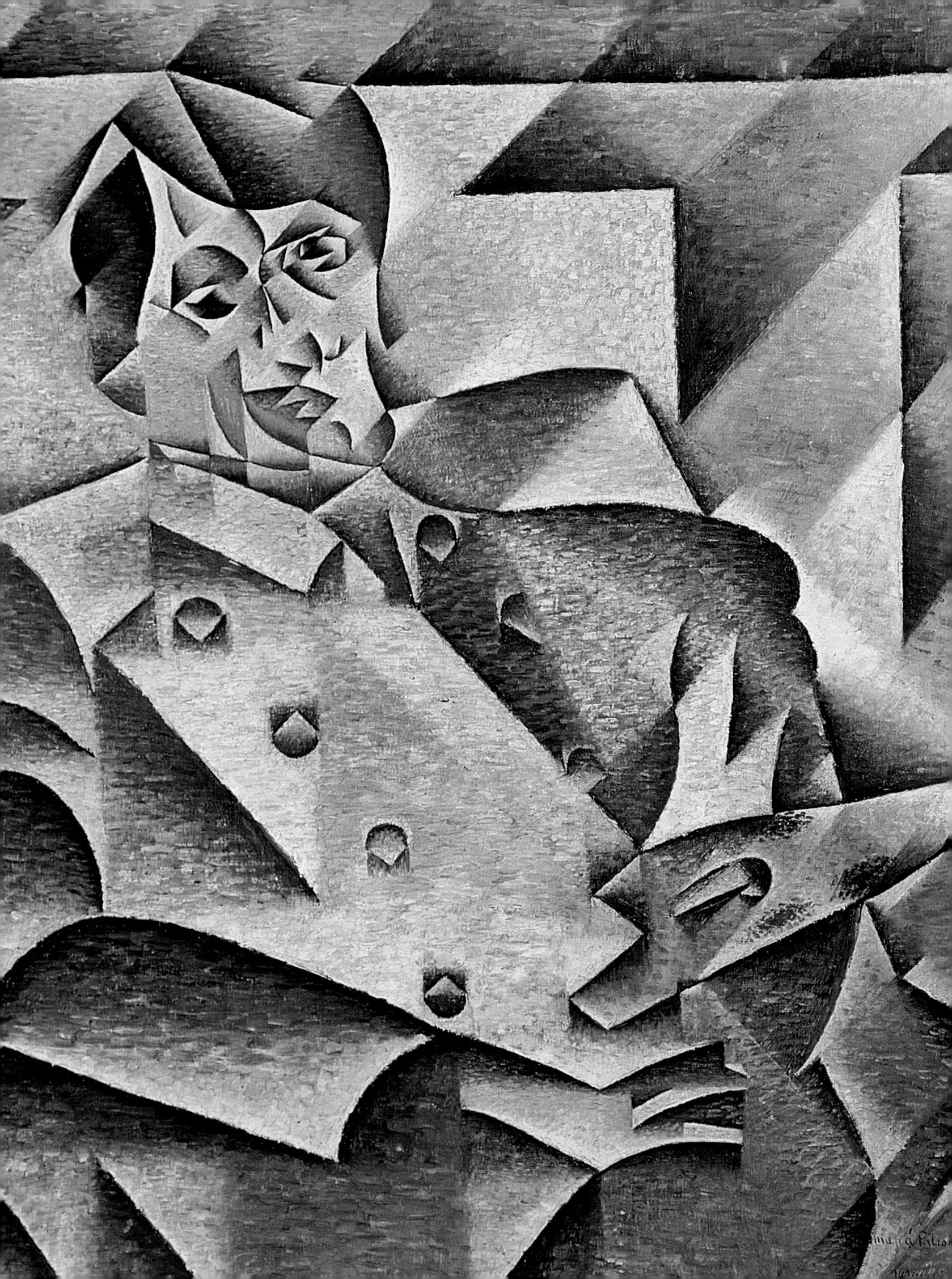

Contents

6	A new cognitive order?			
26 28	1907 PABLO PICASSO — Les Demoiselles d'Avignon PABLO PICASSO — Three Women			
30 32 34	1908 GEORGES BRAQUE — Large Nude GEORGES BRAQUE — Houses in L'Estaque PABLO PICASSO — Fruit Bowl and Bread on a Table			
36 38 40 42 44 46	GEORGES BRAQUE — Castle at La Roche-Guyon PABLO PICASSO — Reservoir at Horta, Horta de Ebro PABLO PICASSO — Houses on the Hill, Horta de Ebro GEORGES BRAQUE — Violin and Palette PABLO PICASSO — Head of a Woman (Fernande) FERNAND LÉGER — Nudes in the Forest			
48 50 52 54	1910 GEORGES BRAQUE — Woman with a Mandolin PABLO PICASSO — Girl with a Mandolin (Fanny Tellier) GEORGES BRAQUE — Bottle and Fishes ROBERT DELAUNAY — The Tower behind Curtains			
56 58	JUAN GRIS — Houses in Paris JEAN METZINGER — Tea Time	Bromley Public Libraries ORP		
60	HENRI LE FAUCONNIER — The Huntsman	30128 80022 746 7		
62 64 66 68 70	1912 PABLO PICASSO — Maquette for Guitar GEORGES BRAQUE — Bowl of Fruit, Bottle and Glass ALBERT GLEIZES — The Cathedral of Chartres JEAN METZINGER — The Bathers FERNAND LÉGER — Smoke	Askews 709.04032 ART	04-Nov-2009 £8.99	
72 74 76 78	1913 JUAN GRIS — The Smoker JUAN GRIS — The Guitar PABLO PICASSO — The Guitar FERNAND LÉGER — Still-life with Colourful Cylindrical For	rms		
80 82 84 86 88	1914 PABLO PICASSO — Pipe, Glass, Bottle of Vieux Marc GEORGES BRAQUE — Pipe, Glass, Dice and Newspaper JUAN GRIS — Tea Cups FERNAND LÉGER — The Balcony RAYMOND DUCHAMP-VILLON — The Great Horse			
90 92	1915 JUAN GRIS — The Breakfast JEAN METZINGER — Still-life			
94	1917 ALBERT GLEIZES — In the Port			

A new cognitive order?

1. PABLO PICASSO

Study for Les Demoiselles d'Avignon 1907, black ink on paper, 8.2 x 9 cm Paris, Musée Picasso

2. PABLO PICASSO

Les Demoiselles d'Avignon 1907, oil on canvas, 243.9 x 233.7 cm New York, The Museum of Modern Art, acquired through the Lillie P. Bliss Bequest "Cubism has tangible goals. We see it only as a means of expressing what we perceive with the eye and the spiri while utilizing all the possibilities that lie within the natura properties of drawing and colour. That became a source of unexpected joy for us, a font of discoveries."

Pablo Picasso

"What is a Cubist? It is a painter of the Braque-Picasso School." This statement was to be read on April 23, 1911 in the daily paper "Le Petit Parisien", shortly after the opening of the scandal-rife "Salon des Indépendants", which took place from April 21 to June 13 of that year. The Cubists – including Albert Gleizes, Jean Metzinger and Fernand Léger – had their own exhibition room at the salon; works by Pablo Picasso and Georges Braque were not included in the presentation.

The origins of the word Cubism can be traced back to the handiwork of Henri Matisse (1869-1954), who cannot be counted among the later Cubists, and to the renowned French journalist and art critic Louis Vauxcelles. Some years earlier Vauxcelles had coined the term "les fauves" (the wild animals) to refer to the artists of "Fauvism", which also took its name from this. In September 1908 the art critic spoke with Matisse, who was a member of the jury of the "Salon d'Automne". Matisse reported that Georges Braque had submitted paintings "with little cubes" to the autumn salon. Thereby Matisse was characterizing a landscape painting by Braque created in the same year in L'Estaque (Marseille) in the south of France. To describe it in more detail, as reported by Daniel-Henry Kahnweiler in his book "Der Weg zum Kubismus" (The rise of Cubism), he noted "two ascending lines meeting at the top, and between these several cubes". As Matisse recalls, it was Georges Braque who created the first Cubist painting and thus established Cubism as a stylistic direction. Because of negative criticism Braque removed the painting from the "Salon

d'Automne" in the Grand Palais on the evening before the opening of the exhibition.

Vauxcelles originally established the term "Cubism" in a report about the "Salon des Indépendants" in the year 1909. From then on the latest paintings by Pablo Picasso and Georges Braque would be attributed to the newly created style, without either artist having played an active role in coining the term. Picasso later recalled: "As we developed Cubism we did not do it intentionally, rather we wanted only to express what was inside of us. Nobody dictated a program to us, and our friends, the poets, attentively followed our efforts without ever forcing anything upon us." Elsewhere Picasso remarks: "Cubism has tangible goals. We see it only as a means of expressing what we perceive with the eye and the spirit, while utilizing all the possibilities that lie within the natural properties of drawing and colour. That became a source of unexpected joy for us, a font of discoveries."

One could not speak, either at that time or later, of a Picasso or Braque "school". Right until Cubism's end, it remained equally difficult to associate it with a clearly defined program or school.

Guillaume Apollinaire (1880–1918) wrote in 1912: "The new painting is called Cubism. It received this name by way of a term of mockery from Henri Matisse, who noticed the cubic forms in a picture with buildings." As early as October 1911 in the Parisian daily paper "L'Intransigeant" published between 1880 and 1948, he called Picasso the originator of Cubism: "The public generally believes that Cubism is painting in the form of cubes. That is not what it is. In 1908

1905 — The Russian-Japanese War is ended through the mediation of US President Theodore Roosevelt

1905 — Mutiny on the Russian battleship Potemkin

1905 — Norway declares its independence from Sweden

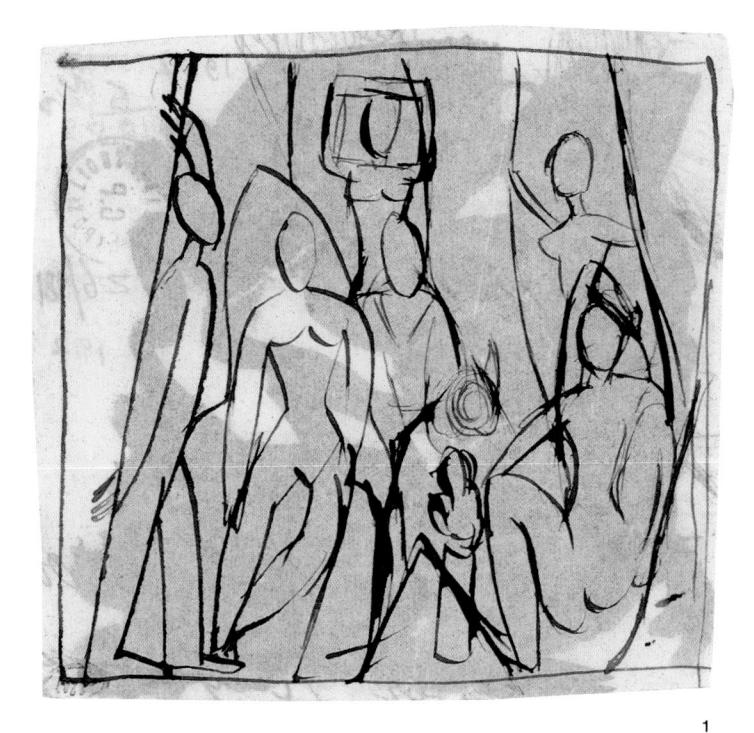

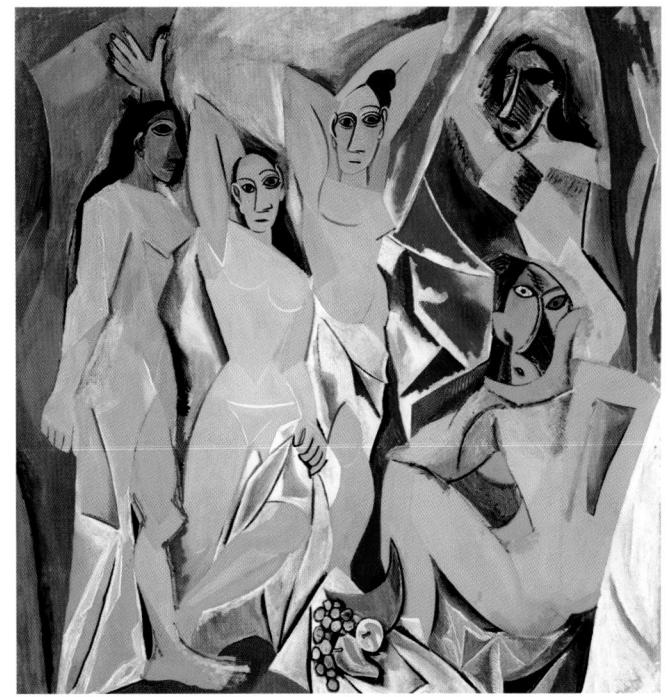

2

we saw several pictures by Picasso depicting simply and solidly drawn houses, which gave the public an impression of cubes, and thus the label for the latest direction in painting was created." Unquestionable, however, is that Picasso and Braque shaped Cubism in its initial phase, namely between 1907 and 1909.

Picasso as forerunner - "Les Demoiselles d'Avignon"

As varied as the surviving descriptions of Cubism's origins are, agreement nonetheless exists over the fact that Pablo Picasso, with his large-format painting Les Demoiselles d'Avignon - it measured approximately 244 x 234 centimetres - laid the cornerstone for the first revolution in 20th century art. The painting, produced between 1906 and 1907, marks the beginning of "Cubist thought". Like a clap of thunder, with this work Picasso was the first artist to ignore the rules of perceptible space, naturalistic coloration, and the rendition of bodies in natural proportions. The three-dimensionality of the female nudes and the space they move in fragment into a two-dimensional type of ornamentation and unite different perspectives simultaneously. The illusion of space and plasticity takes second place to the question of the representation and structuring of forms. The sum of these innovations that contradicted all academic conventions at the beginning of the 19th century caused concern among many of Picasso's contemporaries and prompted sometimes violent criticism. His art

dealer, Daniel-Henry Kahnweiler, called the painting a "desperate, earth-shaking struggle with all problems at once."

The cradle of Cubism

Some of the Cubists who later exhibited in the Paris salon had initially introduced themselves in 1905 in the "Salon d'Automne" as a unified group of artists, for whom the art critic Vauxcelles coined the name Fauvism with his dictum "Donatello parmi les fauves!" (Donatello among the wild animals!). These included Georges Braque, Henri-Achille-Émile-Othon Friesz (1879–1949), André Derain (1880–1954), Kees van Dongen (1877–1968), Raoul Dufy (1877–1953) and Maurice de Vlaminck (1876–1958), among others. Unlike the Impressionists they emphasized the expressiveness and dynamics of pure colours, and dispensed with modelling light and shadow within colours. The Fauvist group of artists drifted apart between 1907 and 1909.

In addition to the analytical character of the Fauvists' approach, another important underpinning for the creation of Cubism was Impressionism, which emerged between 1860 and 1870. The Impressionists turned away from illustrating topics loaded with meaning and began portraying everyday scenes in a lighter and seemingly more natural tonality. The rendition and accentuation of natural sources of light was a main objective of the artists around Edgar

1905 — First Moroccan Crisis

1906 — Olympic Games in Athens

1905 — Albert Einstein postulates the Theory of Relativity

3. EDMOND FORTIER

Malinke woman, West Africa 1906, collotype print (postcard) Paris, Musée Picasso, Picasso Archive

4. PABLO PICASSO

Woman in Profile 1906/07, oil on canvas, 75 x 53 cm Private collection

5. PABLO PICASSO

Woman

1907, oil on canvas, 119 x 93 cm Riehen/Basel, Fondation Beyeler

Babangi mask from the French Congo n. d., wood, height 35.5 cm
New York, The Museum of Modern Art

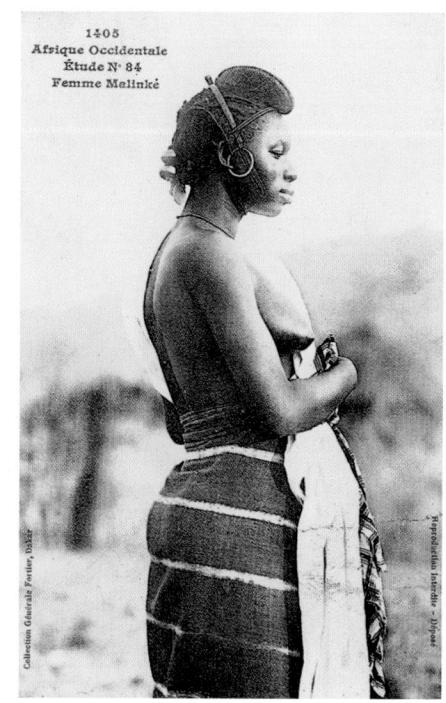

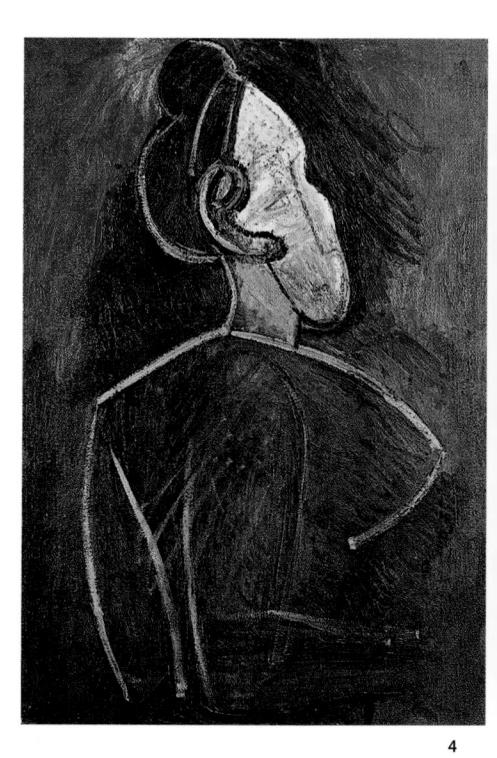

3

Degas (1834–1917), Édouard Manet (1832–1883), Claude Monet (1840–1926), Camille Pissarro (1830–1903), Auguste Renoir (1841–1919) and Paul Cézanne (1839–1906).

Above all a number of Cubist artists invoked the theories of Paul Cézanne. Frequent reference is made in early discussions and analyses of Cubism to his role as forerunner. Picasso stressed: "What Cézanne did with reality was much more progressive than the steam engine." Picasso first encountered Cézanne's pictures in the rooms of Henri Matisse, who had acquired the painting *Bathers (Baigneuses)* from Cézanne in 1899. Cézanne, who even before the Cubists had dispensed with the illusion of space, depicted the scenery as an arrangement of flat planes without emphasizing spatial depth. In 1904 Cézanne expressed the following to his fellow-painter Émile Bernard (1868–1941): "All natural forms can be reduced to spheres, cones and cylinders. One must begin with these simple basic elements, and then one will be able to make everything that one wants. One must not reproduce nature, but represent it; but by what means? By means of formative coloured equivalents."

In 1911 Michel Puy wrote in the magazine "Les Marges": "Cubism is the culmination of simplification, which was begun by Cézanne and continued by Matisse and Derain ... it is said to have begun with Mr. Picasso; however since this painter rarely exhibits his works, Cubist development was observed mainly in the work of Mr. Braque. Cubism seems to be a system with a scientific basis that allows the artist to base his efforts upon a reliable coordinate system."

Puy's description reduced Cubism to a rule-dominated method used by artists; a system that presupposes a school, which as such had never existed.

A comparison of Cézanne's *Bathers* with Picasso's painting *Les Demoiselles d'Avignon* reveals several surprising parallels: The cloth hung as a tent over a branch in Cézanne's painting reappears as a draped background in *Demoiselles*. The poses of two bathers can be described nearly identically with the poses of the second standing figure from the left and the squatting figure in the lower right in Picasso's painting *Les Demoiselles d'Avignon*.

African curiosities - Inspiration from overseas

The Cubists used various media and image sources for their work. In addition to photography, the preoccupation with African art played a prominent role.

The artists of Fauvism had also discovered African tribal art's merits in the years 1905 to 1906. De Vlaminck speaks of an outright "hunt for negro art", which had begun among the avant-garde artists. Paris – the capital of French colonial power – was a good hunting ground at this time. He personally participated in this as well when he acquired three African statuettes and a white hunting mask in a café in Argenteuil in 1905. André Derain, with whom he was befriended, later saw this mask in his studio and bought it from him shortly there-

1906 — San Francisco is almost completely destroyed by an earthquake

1906 — Introduction of light bulbs with tungsten filaments

1907 — Universal suffrage is introduced in Austria

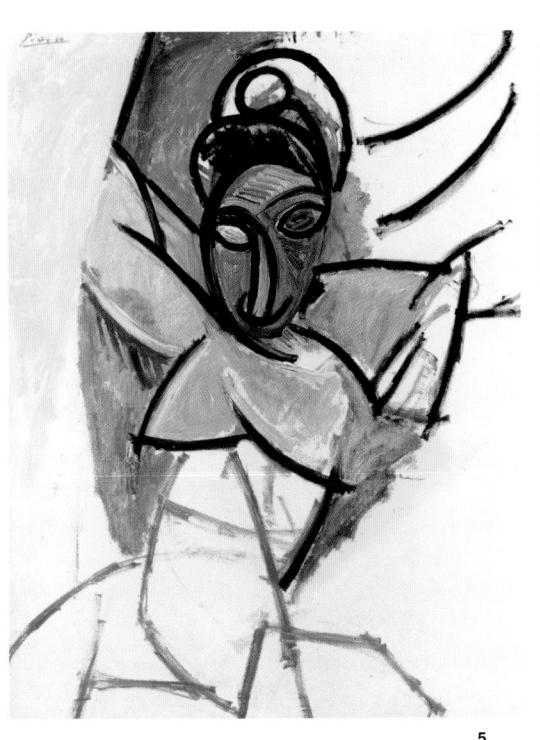

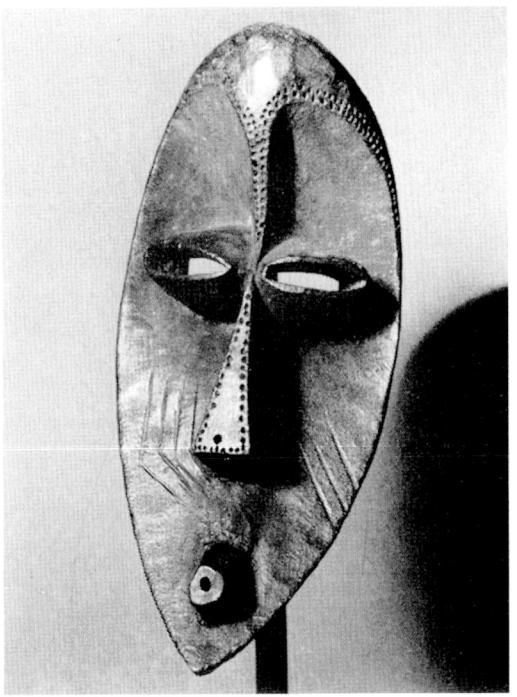

"As we developed Cubism we did not do it intentionally, rather we wanted only to express what was inside of us. Nobody dictated a program to us, and our friends, the poets, attentively followed our efforts without ever forcing anything upon us."

Pablo Picasso

after. Like many other artists, he too visited the extensive Gauguin retrospective in the "Salon d'Automne", and inspired by this he also viewed the ethnographic collection of the British Museum in London in 1906. Henri Matisse possessed a remarkable collection of African sculptures purchased primarily in Parisian second-hand stores. This list of examples could be extended indefinitely. Nonetheless, Daniel-Henry Kahnweiler declared that the passion for collecting inspired by Gauguin's work had hardly affected the art of the Fauvists, but on the contrary that the statuettes and figures of African origin had accumulated in the studios only as curiosities.

Of Georges Braque we know only that he had acquired in the port of Marseille a mask from the African country of Gabon. Pablo Picasso is particularly well known for the fact that he allowed his passion for collecting and joy of experimentation to flow into his work: thereby he also discovered African tribal art for the art of painting. In addition to many statuettes and masks, the numerous photographs of African origin archived in his estate tell of a sophisticated preoccupation, for example, with the hair and head decoration of the women. If one compares the image of a Malinke woman photographed by Edmond Fortier in 1906, which today is in the Musée Picasso in Paris, with Picasso's picture *Woman in Profile (Femme de profil)* painted in the winter of 1906/1907, it becomes clear that the photo-postcard served as a direct model for the painting.

Other works created in this period – including *Les Demoiselles d'Avignon* – also tell of Picasso's dependence on African portrayals.

The bright, luminous coloration of the 1907 painting *Woman* (*Femme*), today in the Beyeler collection in Basel, sets it apart from other Picasso works from this period. The face of the depicted woman is shown centrally and painted in brown tones, like an African mask. Additionally, the suggestion of adornment on the woman's head is reminiscent of the traditional hair fashion of African women.

In addition to African sculpture, Picasso also studied early Iberian art after having visited an exhibition of newly excavated artefacts in the Musée du Louvre, Paris, in March 1907. Soon thereafter he acquired two pre-Christian Iberian statuettes from the artist and art dealer Géry Piéret, who was then living in poverty in Paris. Piéret had worked at times for Apollinaire and also knew Picasso.

During a subsequent stay in the Spanish village of Gosol, Picasso deepened his knowledge of the "archaic" sculpture of the Iberian peninsula. Some years later, at the end of August 1911, Picasso learned that the erstwhile salesman Piéret had been identified and arrested as the thief of the *Mona Lisa*. Written by Piéret himself, an article appeared in the magazine "Paris-Journal" about further thefts from the Louvre, including the two Iberian sculptures purchased by Picasso in 1907. When Picasso learned of this, he and Apollinaire together brought the two sculptures to the editors of the "Paris-Journal", who then published an article stating that the statuettes had been returned anonymously. Nonetheless Apollinaire and Picasso were later called before the committee of inquiry. Apollinaire was accused of receiving stolen goods and, until being acquitted of this charge,

1907 — New Zealand becomes a British Crown Colony

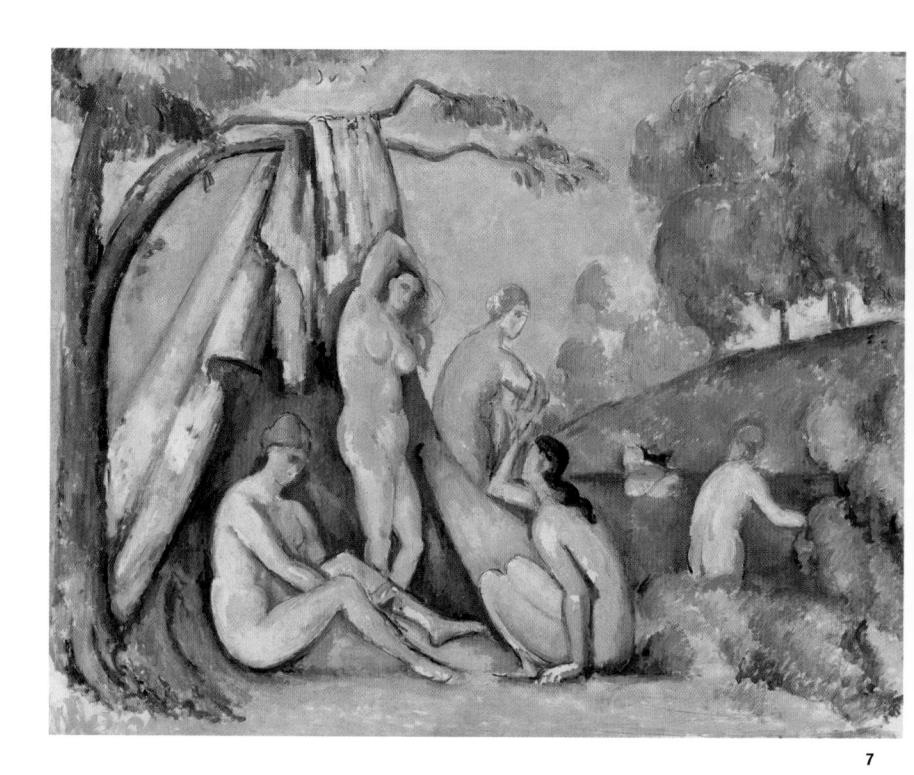

"To paint a picture means composing ... Great sensibility is the most suitable disposition for good artistic conception."

Paul Cézanne

spent a week in prison; the affair remained without consequence for With the help of photography ... Picasso.

During these years Picasso's studio seemed to visitors like a cabinet of curiosities. In an article about the artist, André Salmon describes the impression made by his studio in the Boulevard de Clichy: "Grimacing back from every piece of furniture are strange wooden figures, which are among some of the most exquisite pieces of African and Polynesian sculpture. Long before Picasso shows you his own works, he allows you to admire these primitive wonderworks ... Picasso resists above all being called the father of Cubism, which he only inspired."

Certainly Daniel-Henry Kahnweiler, as a close confidant of the artist, correctly assessed Picasso's role as forerunner regarding the discovery of African sculpture when he wrote in his book about Juan Gris in 1946: "In the autumn of 1906 it required Picasso's preparatory work for Les Demoiselles d'Avignon to create the necessary climate for an expansion of the aesthetic horizon." Max Jacob recalls that Pablo Picasso had discovered African sculpture for himself in the studio of Henri Matisse. There Matisse had placed a black wooden figure into his hands, which Picasso could not separate himself from for the entire evening. On the following day drawings of women's heads with, for example, only one eye or a long nose in place of the mouth appeared in Picasso's studio, and Max Jacob confirmed: "Cubism had been born".

Picasso was an attentive observer who often made use of a camera to document his personal surroundings. His estate contains approximately 1000 Cartes-de-Visite, numerous photo postcards, many photographs by well-known photographers such as Brassaï (1899-1984) and André Villers (b. 1930), as well as anonymous photographs and innumerable photos that Picasso had taken himself. After the turn of the century he used photographic images in many cases as inspiration for paintings and drawings. This can be demonstrated both in details and in the complete composition of several paintings. Picasso probably needed some photos as a means of reflecting upon what he had accomplished to that point, as had other artists - Auguste Rodin for example - before him.

During his summer sojourns outside of Paris, which often lasted two to three months, photographic reproduction of his paintings and drawings allowed Picasso to inform his dealer in Paris, Daniel-Henry Kahnweiler, about his latest pictures, and Kahnweiler used the negatives sent to him to present new pictures to collectors.

In July 1912 Picasso requested his artist friend Braque: "I told Kahnweiler you could, if you like, bring my photo machine along when you come to Sorgue." At the same time Picasso asked Kahnweiler: "Please take my camera along if you go to the Boulevard de Clichy in the next little while, and have Morlin develop some of the plates and send them to me as fast as possible, or Braque could bring them to me."

1907 — Rudyard Kipling receives the Nobel Prize for Literature Austro-Hungary with the approval of Russia

1908 — Annexation of Bosnia and Herzegovina by

1908 — The Congo becomes a Belgian colony

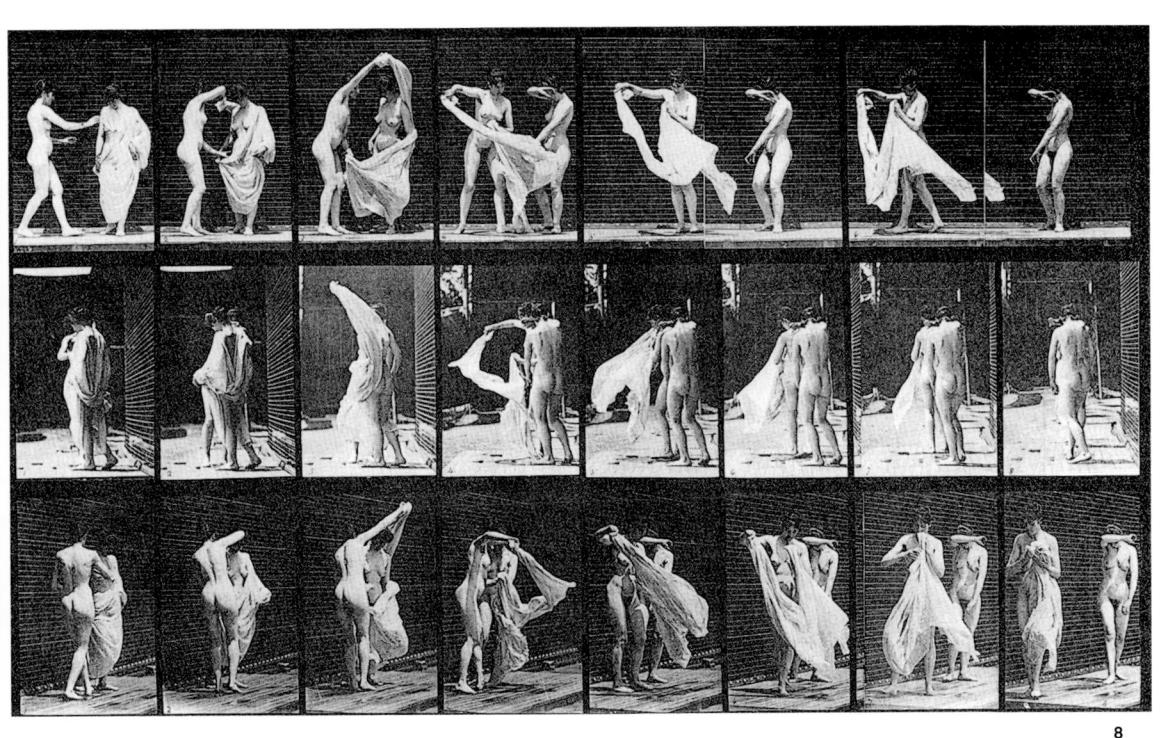

7. PAUL CÉZANNE

<u>Female Bathers in Front of a Tent</u> 1883–1885, oil on canvas, 63.5 x 81 cm Stuttgart, Staatsgalerie Stuttgart

8. EADWEARD MUYBRIDGE

Woman disrobing another
c. 1885, Plate 429 from "Animal
Locomotion", 1887, collotype print,
46.9 x 59.2 cm; image: 20.8 x 35.4 cm
Ottawa, National Gallery of Canada,
Gift of Benjamin Greenberg, 1981

History of a friendship

It was Guillaume Apollinaire (1880-1918) who led Georges Braque into Picasso's studio for the first time. With his combined roles as journalist, art critic, speaker, and curator, Apollinaire had a large sphere of influence and was also on friendly terms with numerous artists in Paris and beyond. Thus it was a simple thing for him to introduce the young Braque to Picasso, who was considered revolutionary. It was presumably the end of November or beginning of December 1907 when Braque accompanied Apollinaire to Picasso's studio. At that time Picasso had just finished his picture Les Demoiselles d'Avignon and had begun the painting Three Women (Trois femmes). Georges Braque's reaction to Picasso's picture Les Demoiselles d'Avignon was extraordinary. According to statements by Picasso's relationship partner at that time, Fernande Olivier, Braque exclaimed: "With your pictures you apparently want to arouse in us a feeling of having to swallow rope or drink kerosene." Braque was overwhelmed and initially seemed unable to deal with what he had seen.

That must have changed very quickly, for Braque's paintings testify from that point on to a knowledge and deep understanding of Picasso's latest pictures. A close friendship also quickly developed between the two painters. In the early phase of this friendship with Pablo Picasso, Braque became receptive to new subject matter in his work. He created one of his few female nudes, the picture *Large Nude (Grand nu)* of 1908, which with its 140 x 100-centimetre

dimensions – thus comparable to Picasso's large painting *Les Demoiselles d'Avignon* – counts as one of Braque's larger paintings.

In Braque's nude, viewers are also faced with distorted female body forms equipped with over-proportioned muscles, and even the correlation of the extremities to one another is fictitiously laid out. Musculature and body mass are greatly emphasized by means of a few clearly placed lines, such as in the region of the buttocks and the right calf. The female nude seems a little awkward in front of an angular, rigidly draped cloth. Both the cloth, with which the woman seems to conceal herself from the background, and the bordering colour surrounding the cloth, which fluctuates from red through ochre to yellow, are reminiscent of Paul Cézanne's Bathers (Baigneuses) and Picasso's Les Demoiselles d'Avignon. Comparable to Picasso's work from the early phase of Cubism, Georges Braque also uses colour as an aid in shaping and organizing light and dark. The colour is no longer realistically bound to the object being represented, or to put this in Picasso's own words: "Cubism was never anything other than this: painting for painting's sake, while excluding all concepts of unimportant reality. Colour plays a role in the sense that it helps to depict volumes."

Thereby the Cubists also always remained faithful to the object in the early phase of this artistic movement. "I refuse to accept that there should be three or four thousand possible ways to interpret my painting. I want there to be only one single way, and in this one it must be possible to a certain degree to recognize nature, which after all is nothing but a type of struggle between my inner being and the exteri-

1908 — Henry Ford develops the first commercially successful car, the Model T

1908 — The airship Zeppelin No. 4 explodes

1908 — Olympic Games in London

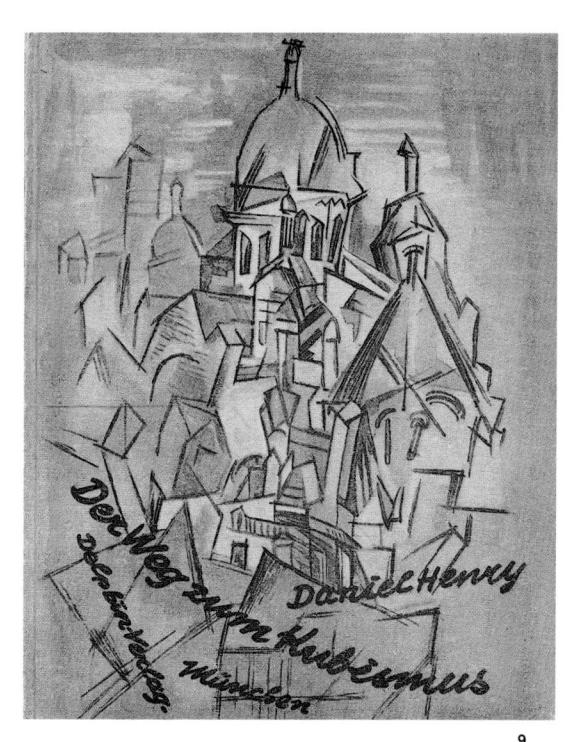

Daniel Henry, "Der Weg zum Kubismus"
(The rise of Cubism)
Cover, Munich, Delphin-Verlag, 1920

10. PABLO PICASSO

Daniel-Henry Kahnweiler
1910, oil on canvas, 100.6 x 72.8 cm
Chicago, The Art Institute of Chicago,
Gift of Mrs. Gilbert W. Chapman in memory
of Charles B. Goodspeed

11. PABLO PICASSO

Daniel-Henry Kahnweiler in the Boulevard de Clichy studio, Paris 1910, gelatine silver print, dimensions unavailable Paris, Musée Picasso, Picasso Archive

or world, as it exists for most people. As I have often said, I am not trying to express nature." The Cubists never disappointed Picasso's desire for the picture's subject matter to be recognizable: viewers always find an identifiable motif, the design of which may seem to be trying to become independent, but which thereby remains verbally comprehensible or identifiable.

Due to their familiar association with one another and their extremely intensive exchange of ideas, numerous common features can be demonstrated in the work of the two artists, which naturally were also observed - sometimes critically - by their contemporaries. Thus Braque's painting from 1908 of a female nude, unusual for him, shows remarkable parallels to Picasso's Les Demoiselles d'Avignon. Daniel-Henry Kahnweiler, who represented both artists, observed that in the winter of 1908/09 "shared, concurrent work by the two friends" began. In his groundbreaking work "The rise of Cubism" of 1920 Kahnweiler (alias Daniel Henry) writes: "Both of these artists are the great founders of Cubism. In the development of the new art the contributions of these two are bound closely together, and can often hardly be distinguished from one another. Out of friendly, brotherly discussions arose many an advance in the new mode of expression, which sometimes one, sometimes the other would be the first to put to practical use in his works. The credit is due to both of them. Both are great, admirable artists, each in their own way."

Pablo Picasso and Georges Braque saw each other more or less daily, and intensively exchanged their ideas on artistic questions.

Picasso recalls: "Nearly every evening either I came to Braque in his studio or he came to me. We both simply had to see what the other had done during the day." Their relationship was characterized by complete trust. The close exchange between the two artists is particularly revealed during their seasonal, spatial separations during the summer months, when both were usually in different locations outside of Paris. Only in these phases were they dependent on written communication, which today brings us closer to the history of their friendship, at least in excerpts. In September 1912, for example, Georges Braque complains in a letter to his dealer Kahnweiler: "Picasso's departure has created a vacuum." Picasso also missed his close friend. In May 1912 he wrote to Braque: "But I miss you. What has become of our walks and feelings? I cannot conduct our discussion about art in writing." In April 1913 Picasso is missing the intense conversations with his artist friend Braque when he writes to him: "It is really too bad that you can't reach Céret by telephone - such good discussions about art."

The closeness of the two artists led to the fact that the subject matter they selected – not by any arrangement – was identical. Thus Braque and Picasso occupied themselves in the winter of 1908/09 with the subject of still-life, thereby also taking up – comparable to the *Bathers* – one of Paul Cézanne's primary subjects. And here it must be noted that Georges Braque had formerly been concerned predominantly with depicting landscapes, while Picasso felt a connection to the human figure.

1908 — Arnold Schönberg composes atonal music

1909 — Secret agreement between Russia and Italy regarding the Balkans

1909 — William Howard Taft becomes the new US President

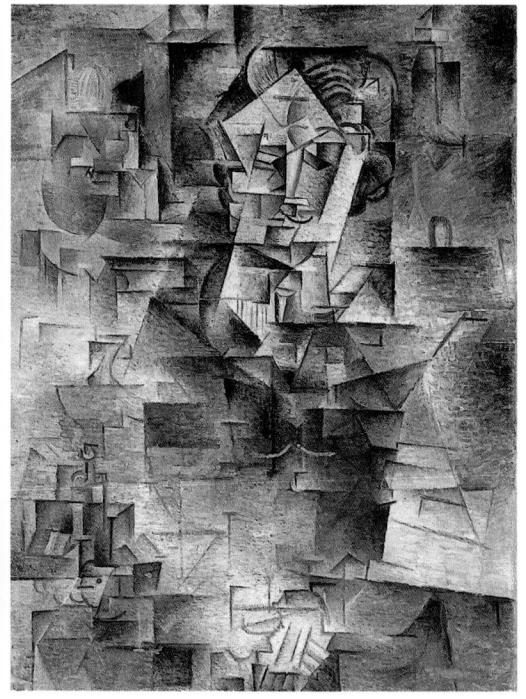

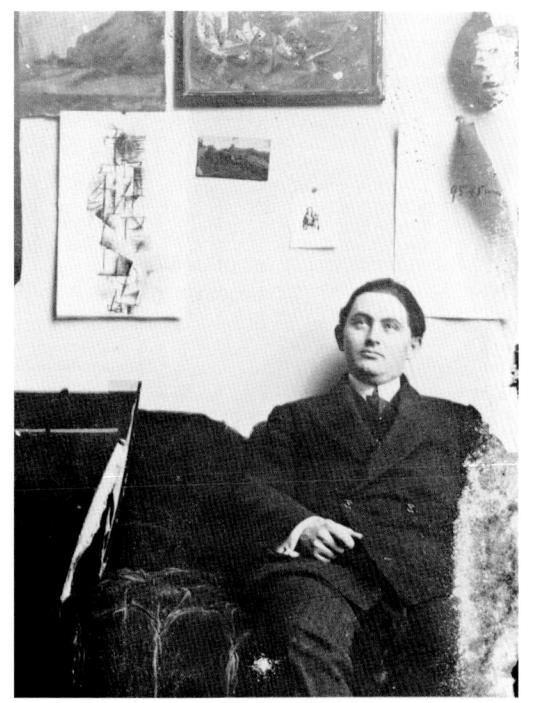

"I have received Apollinaire's book about Cubism. I am really depressed by all of this drivel."

Pablo Picasso to Daniel-Henry Kahnweiler

10

Salon Cubists - Gallery Cubists

The works of the other Cubists who are so familiar to us today appear in exhibitions beginning only in 1910. Albert Gleizes, Fernand Léger and Jean Metzinger presented their current work in the "Salon des Indépendants" from March 18 to May 15, 1910. Jean Metzinger stood out here with the first Cubist portrait, which he had made of Guillaume Apollinaire.

They experienced their public breakthrough as a "group of cubistically working artists" in 1911 at the "Salon des Indépendants" with Robert Delaunay, Henri le Fauconnier, Albert Gleizes and Jean Metzinger. According to Guillaume Apollinaire's description, "room 41 which was reserved for the Cubists" left "a deep impression on the public". In 1912 Apollinaire further recalled: "On exhibition were the artful and impressive works of Jean Metzinger; some landscapes by Albert Gleizes together with his pictures *L'homme nu* and *La femme au phlox*; from Marie Laurencin the *Portrait de Mme Fernande X.* and *Les jeunes filles*; from Robert Delaunay a *Tour Eiffel*; from Le Fauconnier *L'abondance*; and from Fernand Léger *Nus dans un paysage.*" Today the exhibition is considered Cubism's first group manifestation.

After the presentation in room 41 the Cubists were divided into two groups: those in the exhibition who were referred to as "Salon Cubists" – Delaunay, Gleizes, and Metzinger – as opposed to the "Gallery Cubists" Braque and Picasso. Georges Braque, who in 1908

with his participation in the "Salon d'Automne" had inspired Matisse to the formulation "petits cubes", took part one last time in an exhibition in the "Salon des Indépendants" in the spring of 1909. With that, he joined Picasso's decision to no longer exhibit in the salons. After that, works by Pablo Picasso and Georges Braque were only to be seen in exhibitions at the galleries of Kahnweiler and Vollard, and in various exhibitions abroad. Not until 1920 did Braque reverse this decision. Admission to the studios of Braque and Picasso was refused, incidentally, to the so-called "Salon Cubists".

Kahnweiler's artists

To Braque and Picasso, Daniel-Henry Kahnweiler was more than just a gallery owner. As a scholarly author and exhibition curator he was also largely responsible for disseminating Cubism as an art style. Over the course of time a close friendship bound him to both of them.

In 1915 Kahnweiler began work on his legendary book "The rise of Cubism". Besides the 1912 publication "Du Cubisme" (On Cubism) by Albert Gleizes and Jean Metzinger, it is one of the ground-breaking publications about Cubism from that time. Due to the war, Kahnweiler's book did not appear until 1920, published by the Delphin-Verlag in Munich. As early as 1916 an abridged version of the text had appeared entitled "Der Kubismus" (Cubism) in the magazine

1909 — Robert Edwin Peary becomes the first person to reach the North Pole

1909 — First crossing

12.

Ambroise Vollard in his office in Paris c. 1930, gelatine silver print, dimensions unavailable

13. PABLO PICASSO

Ambroise Vollard

1910, oil on canvas, 93 x 66 cm Moscow, The Pushkin State Museum of Fine Arts, I.A. Morozov Collection

14.

Pablo Picasso in his studio in the Rue Schoelcher 1914, black and white photograph, dimensions unavailable Paris, Archives Charmet

15. PABLO PICASSO

The Guitar Player

1910, oil on canvas, 100 x 73 cm Paris, Musée national d'art moderne, Centre Pompidou, Gift of André Lefèvre, 1952

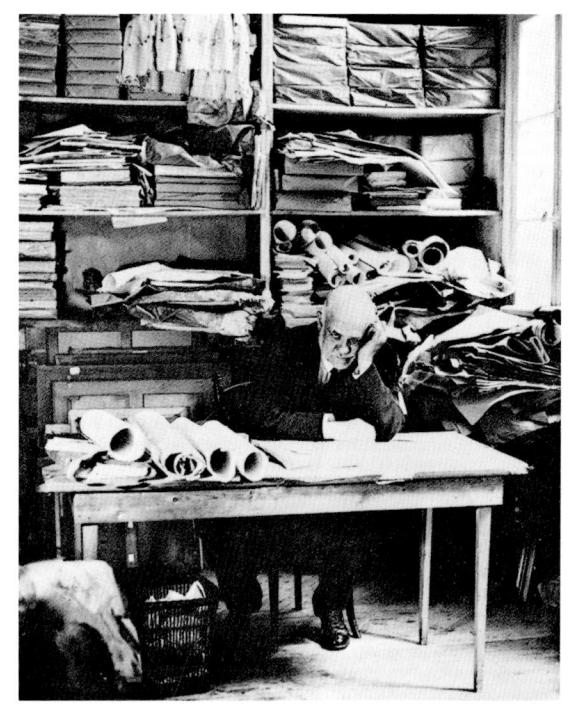

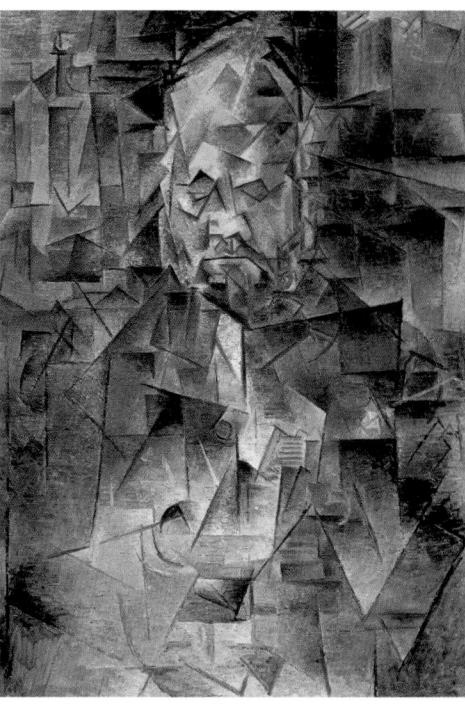

used the penname Daniel Henry, most likely to avoid unnecessary confrontation as a German in France; the more so as his stock of art had been seized as German property during the war, and had been compulsorily sold in two auctions in 1921.

In 1907 at only 22 years of age Daniel-Henry Kahnweiler, who had been born in Mannheim and who, in 1902 at the instigation of his parents, had travelled to Paris to apprentice with the stockbroker Tardieu, opened his own gallery in Paris. Located in rue Vignon 28, it was about 4 x 4 meters in area and had previously served as a tailor's studio. After attending the "Salon des Indépendants" in March of that year, Kahnweiler acquired paintings from the artists involved, including works by de Vlaminck, van Dongen, Signac, and Braque. Soon thereafter he concluded his first exclusive contracts with Derain, de Vlaminck, and Braque.

In May 1907 a young man visited Kahnweiler in the gallery, whom he described as "small, stout, badly dressed ... but with wonderful eyes". The following day the young man came into Kahnweiler's gallery again, this time in the company of another gentleman. The two later turned out to be Pablo Picasso and the art dealer Ambroise Vollard (1868-1939), who maintained a gallery in rue Lafitte and who represented Paul Cézanne, Paul Gauguin, Auguste Renoir and Pablo Picasso, besides other well-known artists.

Through William Uhde, a gallery owner and collector residing in

"Die Weissen Blätter" in Zurich. For the edition published in 1920 he Picasso was working on at the time. He visited the artist for the first time in July 1907 in his studio at 13, rue Ravignan, and was thus one of the first viewers of the painting Les Demoiselles d'Avignon.

> After experiencing this contentious painting Daniel-Henry Kahnweiler became Cubism's most important art dealer, and through exclusive contracts he secured for himself as "marchand de tableaux" the entire production of the artists he represented.

> At the beginning of September 1908, after returning from L'Estaque where he had spent the summer, Georges Braque handed over a series of new works that he had created there to the jury of the "Salon d'Automne". The work was rejected by the jury. Even after attempts by two jury members to nonetheless allow two pictures, Braque withdrew all the paintings. Kahnweiler thereupon offered Georges Braque a solo exhibition in his gallery. The presentation took place from the 9th to the 28th of November 1908, comprised 27 works, and was accompanied by a small catalogue for which Apollinaire had written a foreword. One of the pictures shown was the Large Nude of 1908.

In the same year Kahnweiler bought about 40 pictures from Picasso and, as Isabelle Monod-Fontaine describes in her detailed biography of Daniel-Henry Kahnweiler, he decided in agreement with his artists: "... after the end of the year to present no more solo exhibitions in his gallery, but simply to hang the works. Additionally the painters would no longer take part in the salons, and no more adver-Paris, Kahnweiler learnt of an unusual, large-format painting that tising would be done for the gallery; instead, its reputation would be

1909 — Invention of the plastics Bakelite and Cellon 1910 — Japan annexes Korea 1910 — King George V ascends the British throne 1910 — Nicaragua becomes a US protectorate "We all know that art is not truth. Art is a lie that makes us realize truth, at least the truth that is given to us to understand. The artist must know the manner whereby to convince others of the truthfulness of his lies."

Pablo Picasso

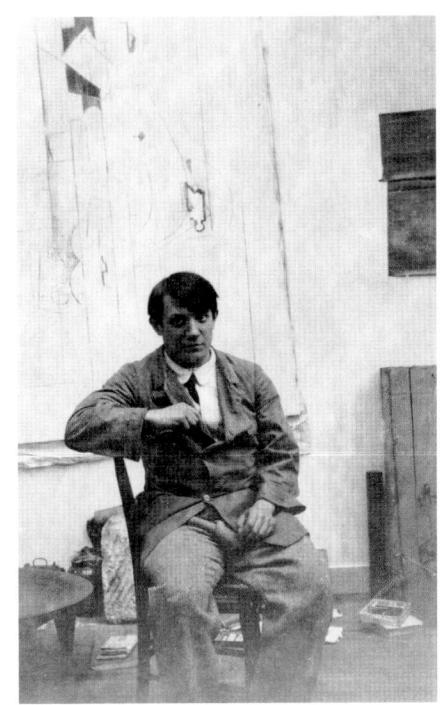

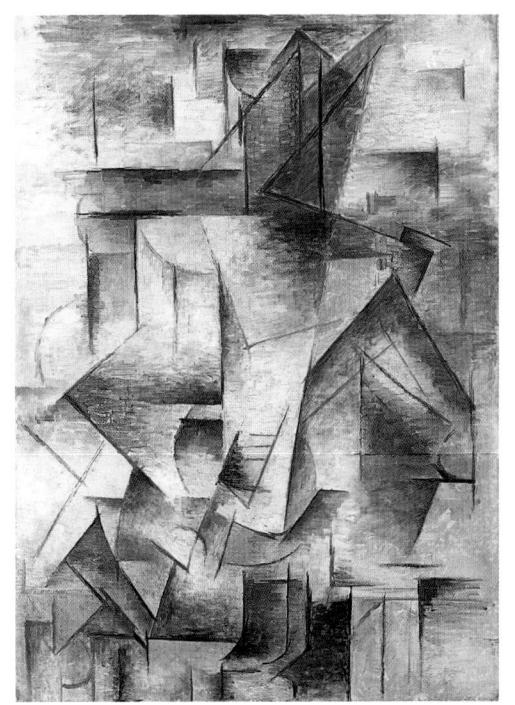

clients."

In the autumn of 1910 Picasso began to paint a portrait of Kahnweiler, who visited him in his studio for about 20 sittings. Picasso's photograph showing Kahnweiler in the artist's studio was likely also created in this context. The portrait occupied Picasso until the end of the year. Comparable to the photograph, the Cubist portrait also shows the dealer with the lightest colour areas in the region of his face and hands. Picasso composed the portrait in a range of colour in which the light and dark shadings of the brown-dominated picture serve simply to depict forms and volumes, and are not dictated by the true colours of the motif.

Before this, in the spring of 1910, Picasso had begun portraits of Wilhelm Uhde and Ambroise Vollard and was similarly occupied for a long time with these. He needed about half a year for the portrait of the prominent art dealer Vollard and did not declare it finished until fall of the same year. Picasso's relationship partner Fernande Olivier later wrote in this regard: "He began to make Cubist portraits. He painted Uhde, who gave him the small Corot for it ... Then he portrayed Vollard and Kahnweiler. He worked for a very long time on these portraits, particularly on the portrait of Vollard that dragged on for months." In the case of the latter, Picasso continued at his summer residence to work on the picture in Vollard's absence. On June 16, 1910 Picasso wrote to Gertrude Stein in Florence: "My dear friends: Since you left, I have worked hard each day on Vollard's portrait.

supported solely by word-of-mouth propaganda and a few loyal I will send you a photo when it is finished." It can be assumed that Picasso used a photograph in addition to the sittings when painting this portrait. The face of the art dealer with its seemingly natural coloration emerges clearly in the picture, which is otherwise composed in grey and blue tones. The composition is much more tranquil than in the portrait of Kahnweiler, and permits viewers to concentrate on the face, while Kahnweiler's portrait is polymorphic and formal, with shifts in perspective, thus appearing much more animated.

> Kahnweiler placed Picasso under contract for the first time in 1911. They agreed upon a three-year term. Thanks to William Rubin's detailed research for his book "Picasso and Braque. Pioneering Cubism" we know that the average prices assessed were: for drawings 100 francs; for 81 x 65-centimetre paintings (called '25s') 1000 francs; and finally 3000 francs for so-called '60s', which were paintings 130 x 97-centimetres in size. Picasso also augmented the contract with the following addendum: "Furthermore I have the right to retain all drawings that appear to me to be necessary for my work," and: "I decide when a picture is finished." Within half a year his prices had trebled; depending on the size of the pictures his dealer had to pay between 500 and 3000 francs. Kahnweiler himself demanded three times his acquisition price from purchasers. Picasso's earlier pictures were offered at even higher prices.

> In November 1912 Georges Braque agreed upon a new contract with Kahnweiler that was to apply for one year. In this contract "drawings with woodgrain paper, marble, or other additives" were dis-

> > 1910 — Downfall of the Monarchy

1910 — Wassily Kandinsky paints the first abstract watercolour

"There is Georges Braque.
What a wonderful life he leads.
He strives with passion for
beauty and achieves it – one
would like to say – effortlessly ...
Each of his pictures is a
monument to an ambition, as
undertaken by no one before him."

Guillaume Apollinaire

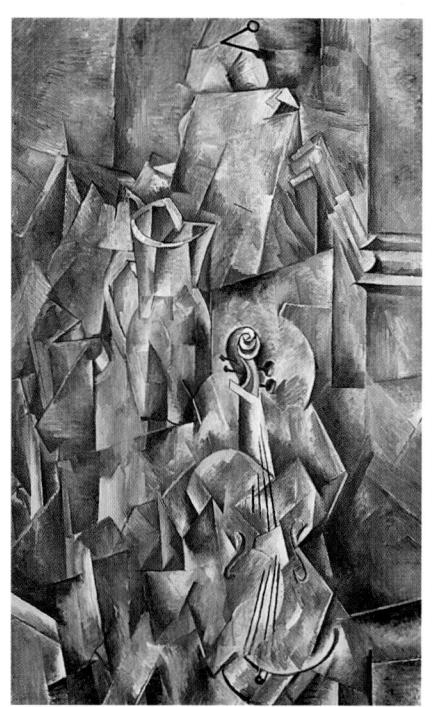

tinguished from other works. Kahnweiler committed himself to 40 francs for drawings, 75 or 50 francs for "drawings with woodgrain paper, marble, or other additives", and 250 francs for canvases. No distinctions by picture size were recorded in the contract. Thus Kahnweiler paid Braque approximately one quarter of the prices that he conceded to Picasso. Other artists with whom Kahnweiler had concluded exclusive contracts for various lengths of time were, for example, André Derain, Juan Gris and Maurice de Vlaminck.

Despite the contracts between gallerist and artists, the association was not always harmonious. Thus for the exhibition "Moderne Kunst Kring 2" that took place in Amsterdam from October to November 1912 and for which ten works had been requested of him, Georges Braque contributed a painting even though Kahnweiler had advised him completely against this. Kahnweiler must then have complained about this to the artist, because in September 1912 Braque answered him: "Your surprise seems excessive to me. I must tell you, however, that my own surprise was no less when I learned that the price of one hundred francs made you feel ill. Now you ask me to conduct no business without your participation ... And thereby you deprive me of the possibility of compensating myself for the rather modest prices you pay me. Considering your demands you remunerate me too little ... You must understand that the reasons for your deprecatory attitude, particularly pertaining to the exhibition, are not as unknown to me as you perhaps believe." Georges Braque would have been aware of the different valuation of his work on the art mar-

ket as compared with that of Pablo Picasso. Presumably this was one reason for his discontent.

Picasso also obtained a niche for the direct sales of his paintings to two collectors: Gertrude Stein and her brother Leo Stein acquired pictures for their collection directly from the artist. Kahnweiler was informed about this. The Steins' Picasso collection comprised 33 paintings, three gouaches, 59 drawings and a sketch book.

From analysis to synthesis ...

During so-called "early Cubism" (1906/07–1909) the fact that that the imitation of nature was no longer art's primary subject can be credited to Pablo Picasso and Georges Braque. The pictures acquire a reality of their own in which they are no longer constrained by central perspective, naturalistic body forms, and local colour of the represented object. Many paintings unite several perspectives from positions the artist had taken while viewing the subject. The subjects of the pictures thus become art subjects and Guillaume Apollinaire stated appropriately: "Cubism differs from earlier painting in that it is not an art of imitation, but an art of imagination."

The English critic, writer and painter Roger Eliot Fry (1866–1934), who was curator of the Museum of Modern Art in New York from 1905 to 1910, wrote about Picasso in the magazine "The Nation": "Picasso is strongly contrasted to Matisse in the vehemence

1911 — War between Italy and Turkey

1911 — Uprisings in Mexico

1911 — Revolution in China, China becomes a Republic

1911 — Nobel Prize for Chemistry to Marie Curie

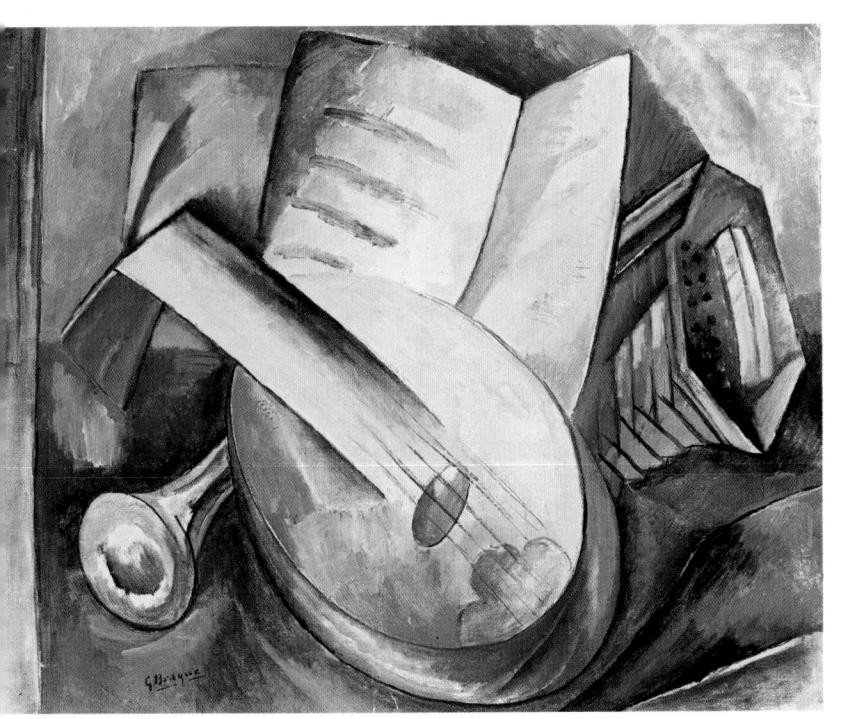

16. GEORGES BRAQUE

Pitcher and Violin

1910, oil on canvas, 117 x 73 cm Basel, Öffentliche Kunstsammlung, Kunstmuseum Basel, Gift of Raoul La Roche, 1952

Georges Braque in his studio n. d., black and white photograph, dimensions unavailable Paris, Archives Charmet

18. GEORGES BRAQUE

Musical Instruments 1908, oil on canvas, 50 x 61 cm Private collection

and singularity of his temperament ... He has become possessed of the strangest passion for geometric abstraction, and is carrying out hints that are already seen in Cézanne with an almost desperate consistency."

"Analytical Cubism" dates from 1909/10 to 1912. The style remains primarily characterized by the works of Pablo Picasso and Georges Brague. Their motifs are not only portrayed from various perspectives simultaneously but are also fragmented into smaller forms, which let them become set pieces of a physical whole.

In 1910 Michel Puy wrote in his book "Le dernier état de la peinture" (The latest state of painting): "Braque embodies the most extreme theories, which he then carries to the extreme. He has reduced the universe to the simplest geometrical lines in space. He saw landscape through the chemist's retort, and namely in such a way as if it were sometimes surrounded by a certain greenery: for him the centre is composed of a sea of crystals whose cool colours were apparently studied several hundred meters under the earth's surface in the light of a miner's lamp, even if these centres are surrounded by something green."

Many works from this period are dominated by a single colour that has no relation to the real colour of the represented object. The coloration steps into the background and stresses the picture's formal organization. The varying zones of light and dark serve to illustrate plasticity, whereby comparable to the perspectives, several light Eduard Trier quotes Henri Laurens' artistic concern as follows in his sources may be included.

Pablo Picasso also carried the fragmentation of an object into smaller forms into the work's readability: "One sees a picture only in sections; always just one section at a time: Thus for example the head, not the body, if it is a portrait; or the eye, but not the nose or the mouth. Therefore everything is always correct. Each deformation is correct, for exactly that reason."

Orphic Cubism

The works of Robert Delaunay and Fernand Léger created around 1911 make particular use of the design principles of colour, light and dynamics. In a series of treatises about Cubism this has led to a further distinction for Orphic Cubism being made.

In 1908 Léger had already settled in La Ruche (the beehive), the artists' colony on Montparnasse. There he met Guillaume Apollinaire, Robert Delaunay and many others. In 1910 these people introduced him to the Kahnweiler gallery and there he became acquainted with the works of Braque and Picasso.

In the years 1913 and 1914 Henri Laurens (1885–1954), who had been a close friend of Braque since 1911, exhibited selected works in the "Salon des Indépendants". The focus of his work was the female figure, the physical unity of which he broke up with open areas. book "Bildhauertheorien" (Theories of sculpture): "The cavities must

1911 — Roald Amundsen becomes the first person to reach the South Pole

1911 — The Inca city of Machu Picchu is discovered in Peru

1911 — The Mona Lisa is stolen from the Louvre in Paris

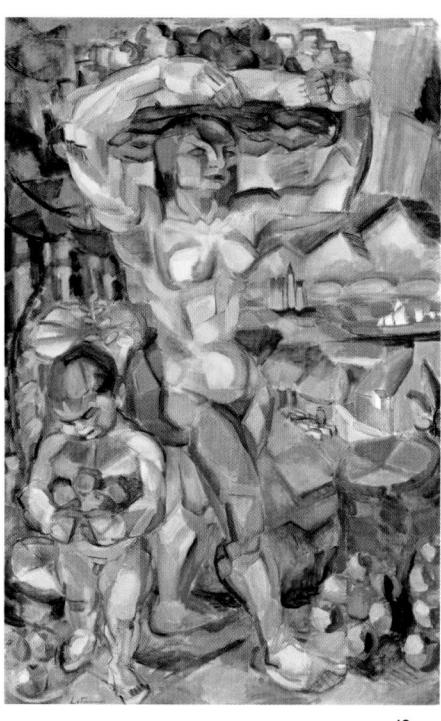

19. HENRI LE FAUCONNIER

<u>Abundance</u>

1910/11, oil on canvas, 191 x 123 cm Den Haag, Haags Gemeentemuseum

20. JEAN METZINGER

Portrait of Albert Gleizes

1911, oil on canvas, 65 x 54 cm Providence, Museum of Art, Rhode Island School of Design, Paris Auction and Museum Works of Art Funds

21. FERNAND LÉGER

Woman in an Armchair

1913, oil on canvas, 130 x 97 cm Riehen/Basel, Fondation Beyeler

19

have as much significance in a sculpture as do the volumes. Sculpture is primarily appropriation of space, a space limited by forms. Many people make sculptures without feeling for the space; therefore their figures have no character at all." Not until his exhibition at the "Salon" did Henri Laurens come to prominence as the first original sculptor of Cubism. Kahnweiler first became acquainted with the sculptor in 1920 despite his very good contact with Braque.

Juan Gris was Pablo Picasso's studio neighbour. His early work proves in an exemplary manner the tremendous effect Cubism had on younger artists of the time, whose production then provided new impulses to late Cubism. Gris' intellectual abilities gave Cubism a theoretical basis that had not been formulated until then. Painting, Gris summarized Cubism's developments and achievements.

Synthetic Cubism

After approximately 1912 the Cubists' artistic techniques changed immensely. The pictures again become more readable. In the so-called "Synthetic Cubism" phase from about 1912 until 1914, artists such as Georges Braque, Pablo Picasso, Juan Gris and Fernand Léger, for example, started with abstract picture elements and composed these into new motifs. The "papier collé" technique was invented, which can be seen as the basis for all subsequent collage techniques all the way to the ready-made.

With Georges Braque's picture *Fruit Dish and Glass (Compotier et verre)* the first "papier collé" was created. The work was produced during Braque's summer stay in Sorgue in the south of France at the beginning of September 1912. Braque later recalled that by complete coincidence during a stroll through Avignon he had discovered a roll of paper with an imitation oak-wood pattern (faux bois) in the display window of a wallpaper store.

The previous winter Georges Braque had worked an imitation of wood grain as well as the composer's name in stencilled letters into his picture *Hommage à J. S. Bach*. Braque, who had been trained as a stage painter, had mastered both of these techniques; the imitation of materials as well as the application of stencilled lettering. He said the material laid out in the shop window had inspired him to consider how he could employ it in his artistic work. Before his first attempts Braque waited until Picasso had left for Paris, where the latter had to supervise the move into his new studio. Braque then bought a roll of the paper and created the picture *Fruit Bowl and Glass* as well as a few further "papiers collés" before Picasso returned from Paris.

In the same month Georges Braque wrote from Sorgue to Kahnweiler in Paris: "We have beautiful weather again and I am working outside the entire day. I am content. Work is progressing well on some pictures, and painting with sand gives me great pleasure. Therefore I am considering extending my stay here by a good month."

Following the use of imitation wood paper, the step of inserting further materials and found objects into the pictures was not great.

1912 — The First Balkan War begins

1912 — Woodrow Wilson becomes the new President of the United States

1912 — The last Emperor of China Pu-Yi abdicates

"A picture is imitative of nothing and draws solely from itself its reason for being."

Albert Gleizes and Jean Metzinger

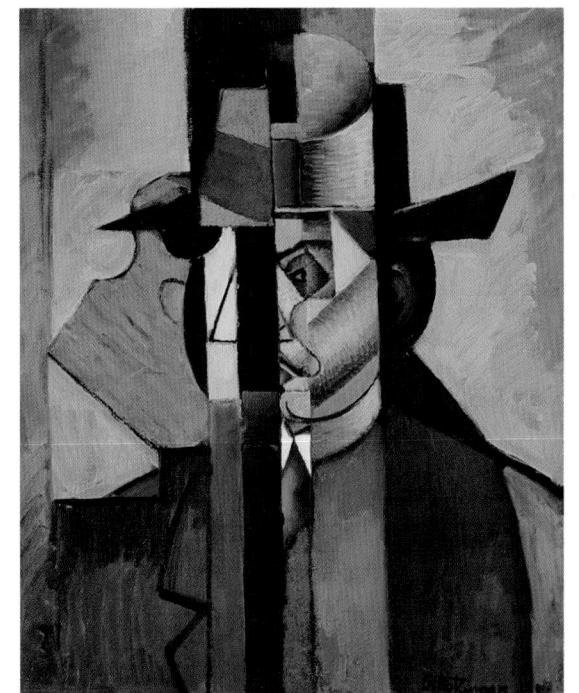

20

21

For his first experiments Braque had presumably waited very deliberately for Picasso's departure, since the very familiar and close exchange between the two must surely have made it difficult in some phases to find separate and independent representational forms. Soon thereafter Picasso also began to experiment with Braque's newly discovered technique. In October 1912 he wrote to Braque: "I am availing myself of your newest paper and sand process. Right now I am devising a guitar and am using a little earth on our hideous canvas." Picasso consistently continued to develop the theme: In October 1912 he created the wall sculpture *Guitar (Guitare)* that today, along with his first sketch, is in the Museum of Modern Art in New York. It is his first open-form construction.

From Georges Braque survives only a photograph of a paper construction in his studio in the Hôtel Roma at 101, rue Caulaincourt from the end of February 1914. This too was a construction mounted on the wall, or to be more precise, in a corner of the room.

From this point on, paper, newspaper, wallpaper, imitation wood grain, sawdust, sand, and similar materials appeared in the Cubists' pictures. The boundaries flow freely together between painted and real subject, all the way to object. The pictures worked in this way acquire a tangible, material character that creates a new pictorial reality; the reality of the picture.

In January 1913 on the occasion of a Robert Delaunay exhibition in the Der Sturm gallery in Berlin, Apollinaire gave a lecture that could have led to the fact that the critics freques was later published under the title "Die moderne Malerei" (Modern the person of the artist and not on their work.

painting) in the magazine "Der Sturm". This was one of the earliest references to the new procedures "papier collé" and collage, which Braque and Picasso had already developed in 1912.

A misunderstood artistic direction

From today's point of view Cubism arguably represents the most revolutionary innovation in art at the beginning of the 20th century. The bibliography of Cubism is more extensive than for any other stylistic direction in modern art. It is easy to forget that Cubist artists did not enjoy broad social acceptance among their contemporaries. Most of the reactions to exhibitions and to the few publications about Cubism were marked by violent criticism. Only a small circle of writers such as Guillaume Apollinaire, and of collectors and dealers admitted their support for the new artistic direction.

In the "Paris-Journal" André Salmon reviewed Picasso's exhibition in the Galerie Vollard (December 20, 1910—February 1911): "Picasso has no adherents, and we have to endure the brazenness of those who publicly assert in manifestos to be his adherents, and lead other reckless souls astray ... There are art lovers who can simultaneously admire Picasso and Matisse. We must feel sorry for these happy ones." The lack of public acceptance for Cubist works could have led to the fact that the critics frequently concentrated on the person of the artist and not on their work.

1912 — Mongolia and Tibet separate from China

1912 — Wreck of the Titanic

1912 — The first legal edition of the Bolshevik workers' paper "Pravda" appears

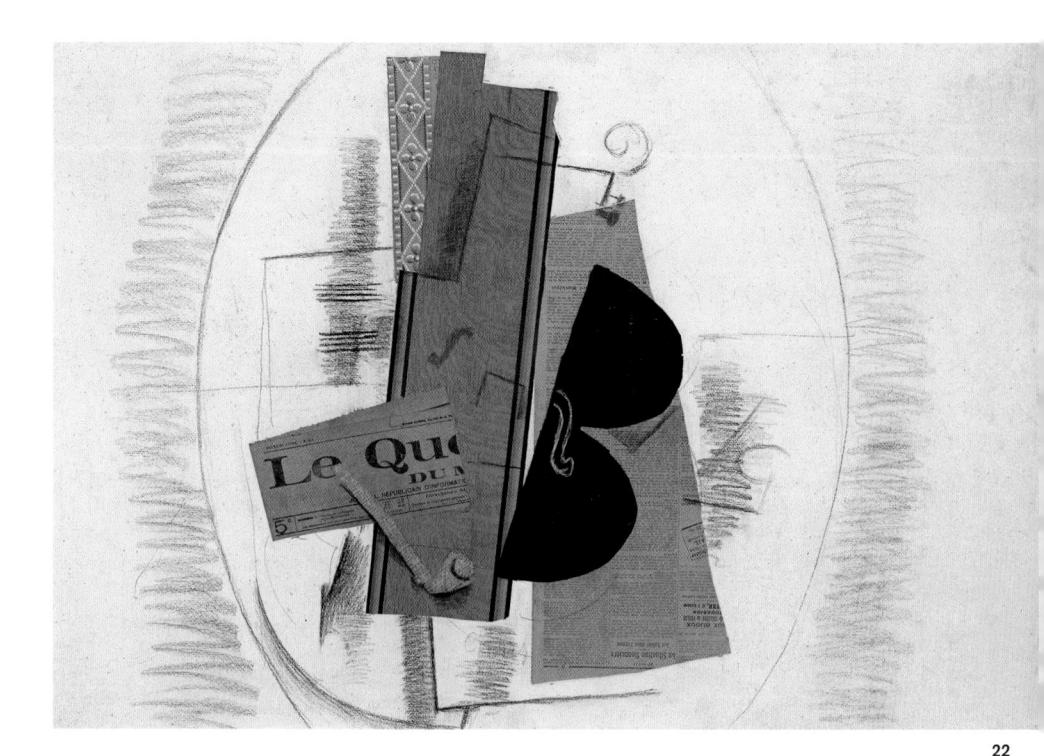

"In fact, art is an enchantment, something mysterious that envelopes us. Because our feelings are formed much more by logic than by the unconscious, which dominates the world, the magical power of art escapes us."

Georges Braque

André Salmon published a series of artist's portraits in the "Paris-Journal" and portrayed Georges Braque thus in his article: "Isn't this a black king (a behemoth), who wanted to become white at the Ecole des Beaux-Arts? Well now, he has not bleached enough. Georges Braque went into the bath house in order to wash himself clean of tradition. It is he, who, even if he didn't invent Cubism, at least made it popular - after Picasso and before Metzinger. I do not believe there is another painter who loves painting more passionately than this good-hearted colossus, who hides the head of a bushman under his Tyrolean hat à la Ernest la Jeunesse. If Georges Braque lies down for the siesta hour the cubes accumulate in his thoughts, and soon they become a 'man with violin' or the 'torso of the virgin'. This practical painter practises wrestling, ice skating and trapeze acrobatics, and loosens up every morning by boxing with a sand bag before he begins painting. He is a dandy with a style completely his own, who buys by the dozen Roubaix suits that came back from America, maintaining that their long storage in the ship's hold improves their fit and makes them incomparably supple."

In putting the events of those times together, the biographical chronology for Picasso and Braque compiled by Judith Cousins is an irreplaceable source. It appeared in William Rubin's book on the occasion of the exhibition "Picasso and Braque. The birth of Cubism" in the Museum of Modern Art, New York and in the Kunstmuseum Basel (1989/90). Many of the reviews collected by Judith Cousins from that time testify to an irreverent and awkward dispute with the Cubists'

pictorial compositions. André Salmon presented the following riddle to the readers of "Paris-Journal" on July 14, 1911: "Recently a talented painter and son of a famous Impressionist came with another interesting painter into a gallery that is considered a temple of Cubism. At the sight of a work by B. the son of the impressionist master whispered in a confidential tone: 'Viewed on the whole this landscape is not bad.' 'Quite in order, however it is not a landscape, but a man playing the violin', says the other. 'How do you know that?' 'B. always paints men playing the violin'. Wanting to have the final word, the first painter takes the friend aside and shows him a painting by P., the rival of B. 'But that is really a landscape.' At this point a gallery attendant intervenes: 'The gentleman errs. That is a woman playing the mandolin; but the picture can only be understood with difficulty. I've already been here for two weeks and I still don't understand it very well.' Anyone who doubts the truth of this story will be convinced, if he guesses the identities of the story's protagonists."

Cubism exhibitions

With the exception of a few gallery presentations and the salon exhibitions in the spring and autumn there were few possibilities of seeing the Cubists' current works in Paris and France. Beginning in 1910 the dealer Daniel-Henry Kahnweiler sent works by the artists he represented to avant-garde exhibitions abroad. The "Sonderbund"

1912 — Nobel Prize for Literature to Gerhart Hauptmann

1912 — International "Sonderbund" art exhibition in Cologne

1913 — King George I of Greece falls victim to an assassination

22. GEORGES BRAQUE

Violin and Pipe (Le Quotidien)
1913, chalk, charcoal and pasted paper,
74 x 106 cm
Paris, Musée national d'art moderne,
Centre Pompidou

23. JUAN GRIS

<u>Still-life (Violin and Ink Bottle on a Table)</u> 1913, oil on canvas, 89.5 x 60.5 cm Düsseldorf, K20 – Kunstsammlung Nordrhein-Westfalen

24. PABLO PICASSO

Card player

1913/14, oil on canvas, 108 x 89.5 cm New York, The Museum of Modern Art, acquired through the Lillie P. Bliss Bequest

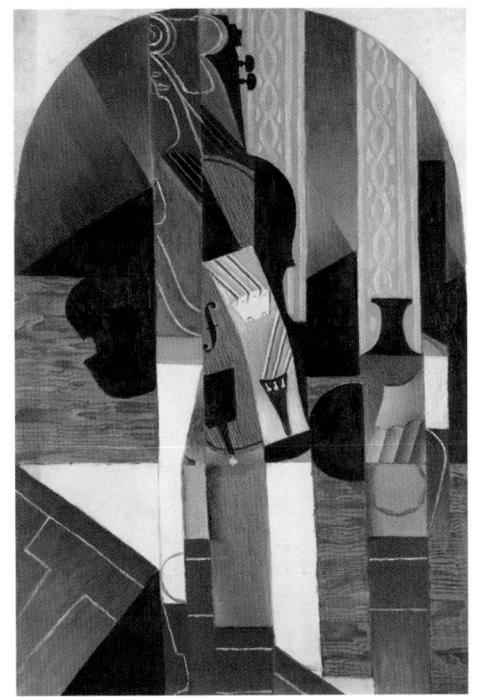

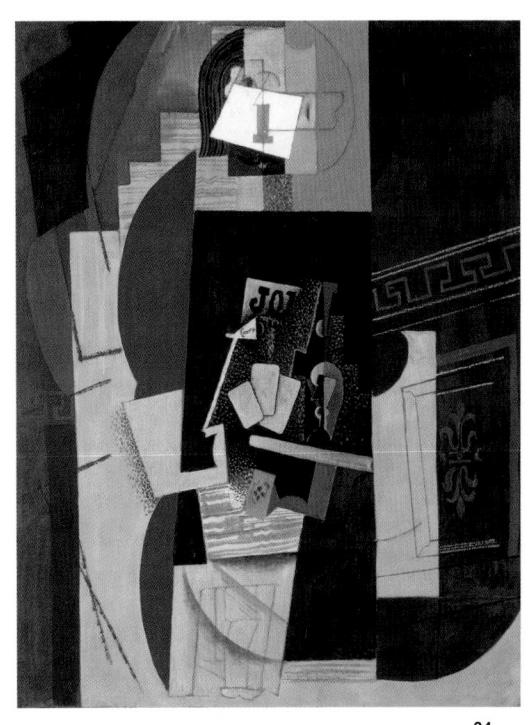

23

"Painting is stronger than I am. It makes me do whatever it wants."

Pablo Picasso

exhibitions taking place alternately in Düsseldorf and Cologne offered an important forum, in which pictures by Georges Braque and Pablo Picasso were exhibited in the years 1910, 1911 and 1912. In September 1910 Galerie Thannhauser in Munich presented an exhibition with works from both artists. And works by the Salon Cubists around Gleizes, Le Fauconnier and Lhote could be seen in the recurrent exhibition "Karo Bube" in Moscow; in 1911 only works by Gleizes were exhibited; in 1912 works by Gleizes, Léger, Picasso and Le Fauconnier; and in 1913 pictures by Picasso and Braque. A further important exhibition abroad, "Moderne Kunst Kring", was shown in Amsterdam from October to November, 1912. Works by Braque, Gleizes, Léger, Metzinger and Picasso were united here.

In 1910 Leo and Gertrude Stein brought Picasso together with Marius de Zayas, whose father owned the Spanish-language magazine "América: Revista mensual ilustrada". De Zayas conducted an interview with Picasso that was printed in May 1911 in his father's magazine, thus presenting Picasso's statements about art for the first time to an audience in the United States. The interview was additionally translated into English and printed in the April/July edition of "Camera Work".

The first New York exhibition with drawings and watercolours by Pablo Picasso was to be seen in Alfred Stieglitz' Gallery 291 from March to April, 1911. Stieglitz had previously visited Matisse, Picasso and Rodin in their studios in Paris, and later recalled it as a "tremendous experience".

The exhibition in Stieglitz' gallery comprised 83 drawings and watercolours and was organized by Marius de Zayas, Edward J. Steichen, Frank Haviland and Manolo. Presumably it had been Gertrude Stein who induced Pablo Picasso to exhibit in the "Photo Secession" in New York; at least this is how Steichen recalls it in his memoirs. In New York too, Picasso met with a great lack of understanding for his work.

A review published on May 1 in "The Craftsman" reads: "Picasso does not want to see nature, but how he feels about nature ... But if Picasso is sincerely revealing in his studies the way he feels about nature, it is hard to see why he is not a raving maniac, for anything more disjointed, disconnected, unrelated, unbeautiful than his presentation of his own emotions it would be difficult to imagine."

Despite the slowly growing acceptance of Cubist art, exhibitions of the recently created work provoked violent criticism again and again. In the 1912 "Salon d'Automne" new pictures from Gleizes, Léger and Metzinger were displayed. Lampué, a Paris city councillor, reacted to them with extreme agitation and questioned the use of a public building by "a gang of evildoers, who behave in the world of art like apaches".

Jules-Louis Breton, a socialist member of parliament, even went so far as to label the "Salon d'Automne" as a joke "in the worst possible taste". Furthermore he counted the exhibition among those "meetings, which risk compromising our marvellous artistic inheritance. And the worst is that it is mostly foreigners who knowingly or

1913 — "Armory Show" in New York, Chicago and Boston

1908 — Henry Ford introduces assembly-line production

1913 — The Danish physicist Nils Bohr develops atomic theory

25. GEORGES BRAQUE

Fruit Bowl

1908, oil on canvas, 53 x 64 cm Stockholm, Moderna Museet, Bequest of the Museum Director Rolf de Maré

26. HENRI LAURENS

Bowl of Fruit

1918, collage, 43.7 x 47.7 cm Hanover, Sprengel Museum

27.

Henri Laurens' studio in Paris 1953/54, gelatine silver print, 16 x 14.6 cm Private collection

unknowingly bring our French art in our national temples into discredit ... In fact, my dear sirs, it is objectionable that our national exhibition halls must suffer such exhibitions of such anti-artistic and anti-national character."

Whereupon Marcel Sembat, another socialist delegate and close friend of Henri Matisse reacted: "My dear friend, if a picture does not please you, you have the undisputed right not to look at it and to view a different one. But you do not call for the police."

From February 17 to March 15, 1913, eight works by Picasso and three pictures by Braque were shown at the first "Armory Show", the international exhibition of modern art in the former armoury of the 69th cavalry regiment in New York. Subsequent stops for the exhibition were then Chicago and Boston. Daniel-Henry Kahnweiler lent the work of Georges Braque for the presentations and, alongside Leo Stein and Alfred Stieglitz, was also a lender of some of Picasso's works. Stieglitz lent Picasso's bronze head *Tête de femme (Fernande)* from 1909, which he made available only for the New York show. This first "Armory Show" comprised approximately 1600 exhibited works, of which about a third were from Europe, and gave decisive impulses to the world of art. The exhibition broke the previous hegemony of the National Academy of Design, which was reserved for conservative contemporary art.

In 1913 at the end of February the first Picasso retrospective in Germany took place in the Munich gallery of Heinrich Thannhauser. The exhibition comprised 76 paintings plus 38 pastels, watercolours,

drawings and etchings, and was also on view in Prague and Berlin subsequent to the spectacle in Munich.

From December 9, 1914 until January 11, 1915 Stieglitz exhibited 20 works by Braque and Picasso from the collection of Gabrielle and Francis Picabia in his New York exhibition rooms, Gallery 291. Marius de Zayas selected the work for the exhibition. In the late 1940s he later wrote: "Both the Photo Secession and the Modern Gallery committed an unforgivable sin in not having shown a solo exhibition of Braque's work. His contribution to modern art was and is one of the most valuable. When his work was first exhibited in New York in the Photo Secession (1914–1915), it was to be seen together with pictures by Picasso. The same happened in the Modern Gallery. Braque's work was always shown with Picasso or the pictures of other painters."

Interdependencies: Cubism and journalism

Albert Gleizes and Jean Metzinger were known as early theoreticians and artists of Cubism, and were not close to Pablo Picasso and Georges Braque. Neither of them was admitted into the studios of the protagonists of Cubism. It is therefore not surprising that from Gleizes' and Metzinger's point of view neither Picasso nor Braque had played a decisive role in the development of Cubism as an artistic style.

1913 — The first refrigerators are used in private American households

1913 — Walter Gropius builds the Fagus Factory in Berlin

1913 — Igor Stravinsky composes the ballet "Le Sacre du Printemps"

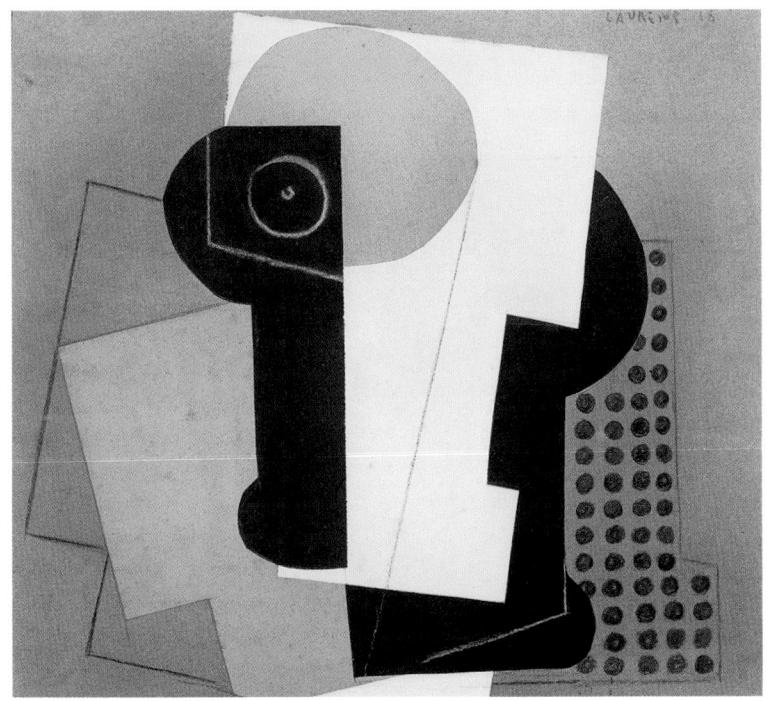

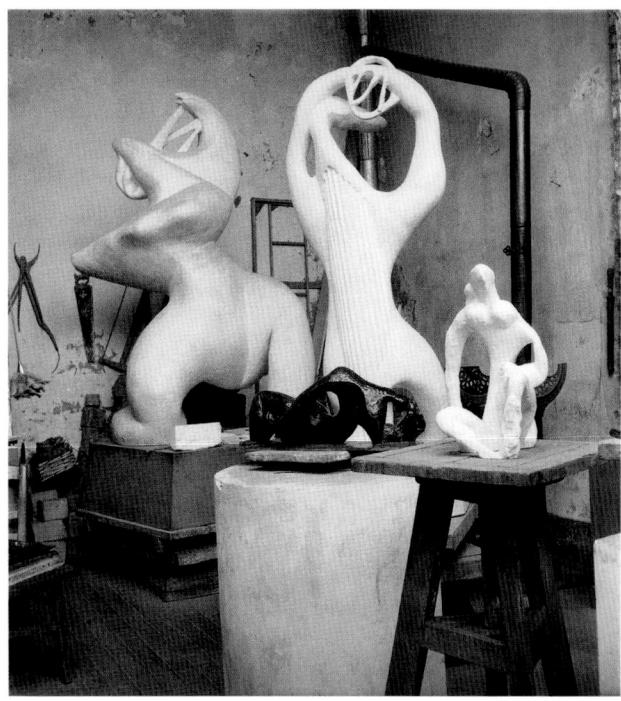

26

Pablo Picasso paid close attention to the literature published about Cubism. On October 31, 1912 he wrote to Braque, who was staying in Sorgues: "Apparently the book by Metzinger and Gleizes ('On Cubism') has already appeared, and the one by Apollinaire will appear in a few days. Salmon has also written a book about painting ('La jeune peinture française'/Young French painting). He treats you with outrageous injustice."

Despite all criticism of the publications about Cubism or of their authors, due to the small number of exhibitions the publications played a special role as social propagators. Thus, for example, Guillaume Apollinaire in the "Paris-Journal" accompanied the reproduction of pictures by Braque in "Les soirées de Paris" of April 15, 1914 with the assessment: "The last edition of 'Soirées de Paris' contained eight reproductions of pictures by Georges Braque, who together with Picasso is one of the initiators of Cubism. Georges Braque is one of the most interesting contemporary French painters and one of the least well known. To be precise he has only shown pictures once in a group exhibition, that is in the Galerie Kahnweiler in November 1908. Since then he has shown neither in the 'Salon d'Automne' nor with the Indépendants. This is the first time a French magazine has published illustrations of his works."

Despite his closeness to the artists of Cubism, Apollinaire's statements met with relatively little acceptance. When Apollinaire published a collection of essays "Les peintres cubistes: médiations esthétiques" (The Cubist painters: aesthetic mediations) in March 1913

about Cubism and the Cubists, Picasso informed his dealer and trusted acquaintance Kahnweiler in August of that year: "Your news about the discussions of painting are truly sad. I have received Apollinaire's book about Cubism. I am really depressed by all of this drivel."

Apollinaire learnt of the criticism of his observations and at the end of April 1913 wrote to Kahnweiler: "Thank you for your subscription to my book – On the other hand I have heard that you found my statements about painting uninteresting, which I find strange on your part. – As a writer I have solely supported painters who you yourself have discovered after I have (i. e. Picasso). And do you think that it's good to attack someone who on the whole is the only one who can create the foundation for future artistic understanding? In such a case he who seeks to destroy will be destroyed, for the movement that I support is not finished; it cannot be stopped and everything that is undertaken against me can only fall back on the movement itself. Take this as the simple warning of a poet who knows what must be said, who knows who he is, and what others are in matters of art."

The First World War

With the outbreak of the First World War the situation for the artists changed abruptly. Since with the exception of Picasso all the artists of Cubism were relatively young, many of them were conscripted to military service. On August 2, 1914 Picasso accompanied

914 — The Austrian heir to the throne Archduke Franz Ferdinand and his wife Sophie are murdered in Sarajevo

1914 — Outbreak of the First World War

1914 — The Panama Canal connects Atlantic and Pacific

28. PABLO PICASSO

Harlequin with Violin 1918, oil on canvas, 142.2 x 100.3 cm Cleveland, The Cleveland Museum of Art, Leonard C. Hanna, Jr. Fund

29. FERNAND LÉGER

Charlie Chaplin 1923, wooden relief, 70 x 30 cm Private collection

30. SALVADOR DALÍ

Pierrot and Guitar 1924, oil and collage on canvas, 55 x 52 cm Madrid, Museo Thyssen-Bornemisza

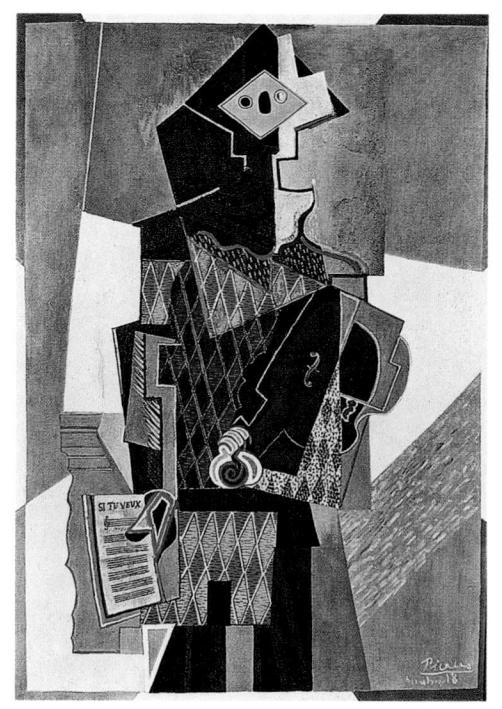

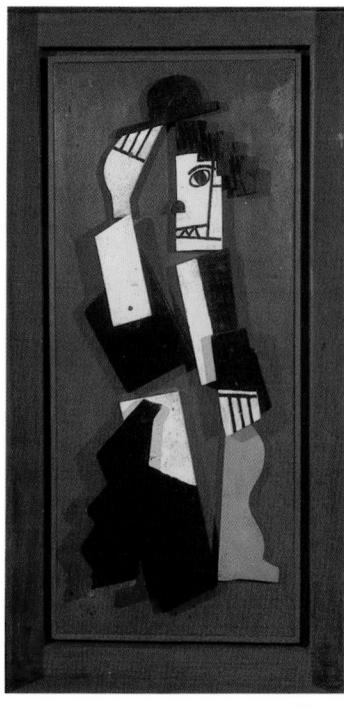

Braque and Derain, who had received their mobilization orders, to the train station in Avignon. Picasso himself initially stayed in Avignon. On September 11 he wrote to Gertrude Stein: "We intend to remain here until the end of the war. We aren't badly off here, and I'm even working a little. But the thought of Paris, my house, and all of my belongings there worries me."

The exchange of information between the artists and their friends came to an almost complete halt; information often only still flowed if it was passed on by third parties.

Juan Gris informed Kahnweiler on October 30, 1914 (from Collioure): "Matisse also writes from Paris, that ... Derain is on the front, that Vlaminck is painting in Le Havre for the army, and that when the war broke out Picasso withdrew a large sum, talk is of 100,000 francs, from a bank in Paris ... I have no news of Braque, who interests me the most."

At the end of October 1914 Braque, who had waited for an extended period in Le Havre for his marching orders, became a machine gunner in Lyon. Picasso returned to Paris in November 1914. Braque, who was promoted to lieutenant in December 1914. suffered a severe head wound in 1915, and after surviving an operation required more than a year to recover. Cubism as an independent artistic style was lost in the confusion of the First World War. The war also broke up the deep friendship between Picasso and Braque, whose personality had changed as a result of the severe head wounds he had suffered.

After the war the protagonists of Cubism, above all Picasso, Braque, and Léger, surmounted their previous achievements. They devoted themselves anew to the human figure and realism in their work.

Picasso recalls his farewell to Cubism: "They wanted to make a type of physical culture out of Cubism. Thus you saw weaklings who suddenly began acting important. They imagined that reducing everything to a cube meant elevating everything to force and greatness. Out of this arose an overblown type of art, without a real relationship to the logical work that I aspired to do."

The effects of Cubism on other artists

Despite the relatively low public acceptance of the Cubists the interest of other artists in their work was great. This could be seen from the studio visits of artists among themselves and the influence of Cubist design methods beyond Cubism.

Thus for example the Futurists Gino Severini, Umberto Boccioni and Carlo Carrà visited Picasso in his studio. After his meeting with Picasso, Boccioni was interested in learning all new developments, and in the summer of 1912 he wrote to Severini in Paris: "Procure all news about the Cubists and of Braque and Picasso ... Go to Kahnweiler and see whether he has photos of newer works (which have been created since my departure), and purchase one or two of them. Provide us with all information that you can obtain."

1914 — Mahatma Gandhi returns to India after a 20-year stay in South Africa

1914 — "Deutsche Werkbund" exhibition in Cologne

1915 — Italy enters the First World War

1915 — A German U-boat sinks the British passenger ship Lusitania with 1400 passengers

"Cubism is a highly distinguished art form; a creative art form and not an art of reproduction or interpretation."

Pierre Reverdy

In the first half of April of the year 1914, Vladimir Tatlin visited revolutionized contemporary art and particularly painting between Picasso in his studio at 5, rue Schoelcher. Jacques Lipchitz acted as interpreter. It is likely that during his stay in Paris, Tatlin had also visited Braque's studio.

In retrospect, Cubism had considerable influence on the later movements of importance in the 20th century, particularly on Italian Futurism; Rayonism and Suprematism in Russia; French Orphism and Purism; the Blauer Reiter in Germany; the De Stijl movement in the Netherlands; and finally on the internationally spread Dadaist movement and all Constructivist art. Almost all leading artists of the first half of the 20th century were influenced by Cubism during their early years of production and their works were shaped by its discoveries and compositional forms.

In 1922 Alexander Archipenko summarized in an article in the "Internationalen Rundschau der Kunst der Gegenwart": "One can say that Cubism had created a new cognitive order in respect of pictures. The viewer no longer takes delight; the viewer is himself creatively active, and speculates and creates a picture by building upon the plastic characteristics of those objects that are sketched out as forms ..."

Cubism, whose origins lie in the years shortly after the turn of the 20th century, and which was abruptly terminated by the outbreak of the First World War, is without a doubt among the most important stylistic idioms in the art of the 20th century. The works of the artists who shaped Cubism - above all Pablo Picasso and Georges Braque -

1907 und 1914. The influence of Cubist works on the subsequent stylistic directions of Classical Modernism is unparalleled.

1915 — The first gas attack in the history of warfare by Germany in the Belgian town of Ypres leads to 5,000 dead and 10,000 severely injured 1915 — The Junkers factory builds the first all-metal aircraft

Les Demoiselles d'Avignon

1907, oil on canvas, 243.9 x 233.7 cm New York, The Museum of Modern Art, acquired through the Lillie P. Bliss Bequest

b. 1881 in Malaga, d. 1973 in Mougins (near Cannes)

In the year 1906 Pablo Picasso developed his first ideas for Les Demoiselles d'Avignon, a pioneering picture for Cubism. That spring out of dissatisfaction Picasso had already broken off a portrait sitting with the American authoress Gertrude Stein, with whom he was friends. She and her brother Leo were committed collectors of his work. He finished the picture during the summer of 1906 in her absence, by portraying her face with features similar to

those of an Iberian mask. The faces of the five women in the picture Les Demoiselles d'Avignon – all of them women of pleasure in a Spanish bordello – are also all reminiscent of masks.

They pose naked in a stage-like setting before a coarsely structured cloth that resembles a curtain. They present themselves frankly to the viewer: They stand upright, thereby touting their breasts with raised elbows, or sit with legs spread. Only the second figure from the left and the central figure cover themselves partly with a lightcoloured cloth. The body forms of the represented figures are angular and unproportionally arranged: Breasts of shadowed diamonds, the pelvis no more than a triangle, over-dimensional hands and feet. Their faces cannot be interpreted in perspective. One of them combines both a frontal and a side view. The eye region of the figure sitting on the right is displaced; the coloration of the face resembles a painted-on mask. A still-life of fruit, in colours matching the rest of the picture, lies in the lower central portion of the picture. "Fleshy" colours fluctuating from ochre to pink dominate, set against white and blue. The picture's readability is hampered by changing perspectives within the figures, by unnatural proportions, and by the flat, mask-like faces

The title refers to the so-called Maisons d'Avignon, the houses of pleasure in Avignon Street in Barcelona. Picasso, who had lived there before Paris, allowed memories of it to flow into this picture.

The painting *Les Demoiselles d'Avignon* met rejection even among Picasso's closer circle of friends and collectors, since some rejected the representation of a bordello scene – with its emphasis on carnality and nakedness – in unusual proportions and perspectives. The picture's unusually large size stresses the artist's unorthodox way of looking at things for his time. Leo Stein felt the painting to be a "terrible muddle" and Derain is said to have remarked, "that one day Picasso will be found hanged behind his large picture". According to Derain, this painting appeared "somehow crazy or hideous to everybody".

Initially, the title of the picture was *Le Bordel d'Avignon*. An early study for *Les Demoiselles d'Avignon* shows the picture with two further figures, probably male visitors of the establishment, surrounded by female figures that seem rather static. Nothing was yet to be seen of the mask-like design of the heads. As early as March 1907, Iberian sculptures in the Louvre had aroused Picasso's interest. Shortly thereafter he acquired two Iberian heads from the art dealer Géry Piéret, and a visit to the Musée ethnographique in the Palais du Trocadéro also contributed to Picasso reworking three of the five female figures.

Picasso first exhibited the picture publicly for a short time in 1916. In 1924 through the mediation of André Breton it went into the collection of the fashion designer Jacques Doucet, and finally in

1939 into the Museum of Modern Art in New York. Only here was the significance of this picture to the history of art adequately reflected in its presentation and representation.

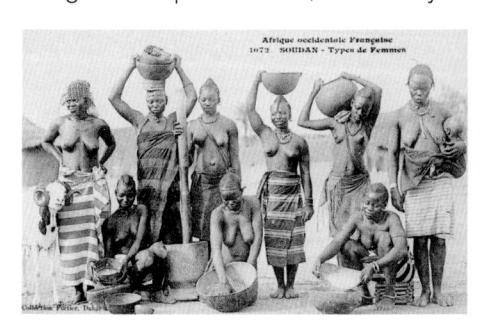

Edmond Fortier, Types of Women, West Africa, 1906

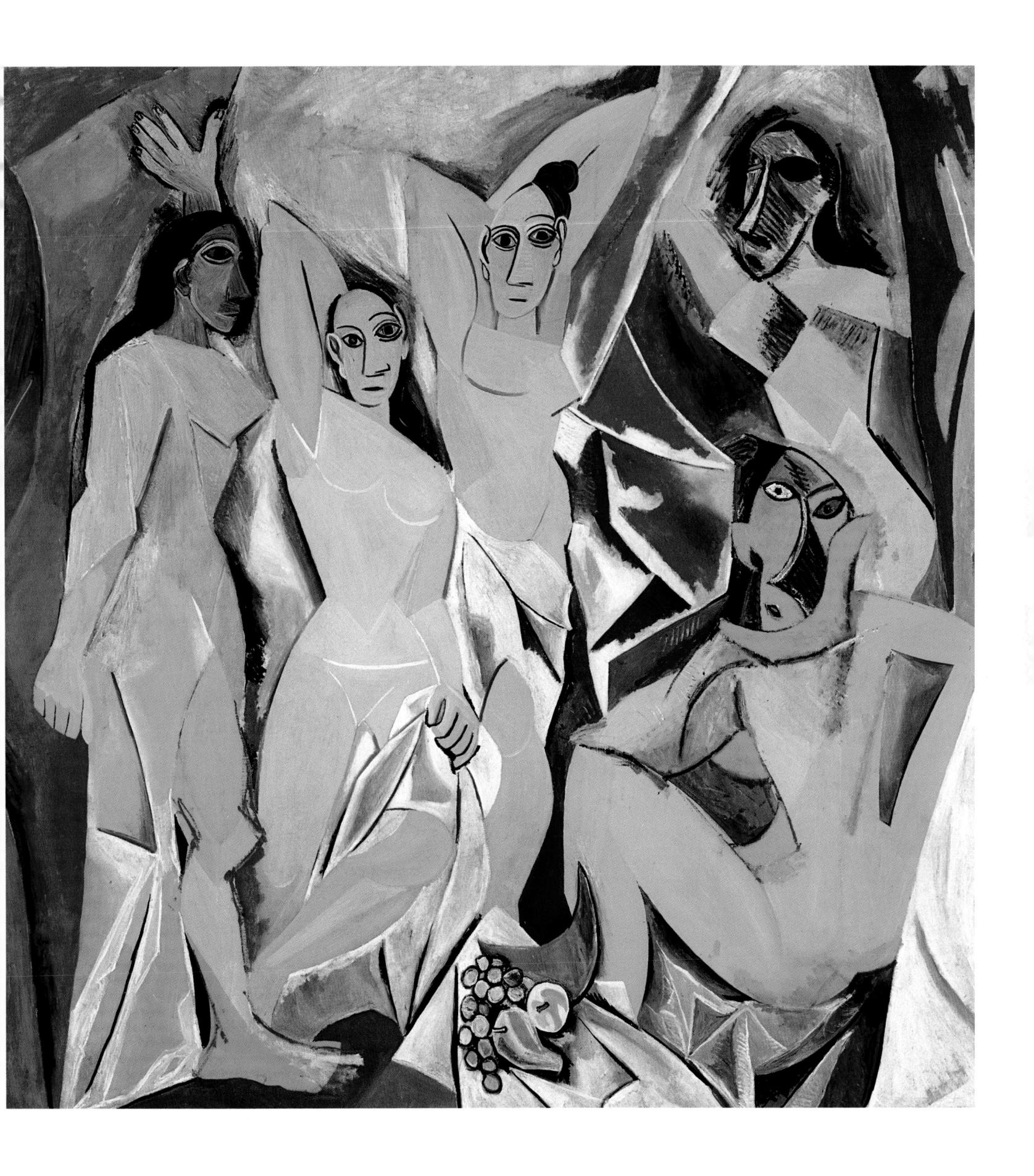

PABLO PICASSO

Three Women

1907/08, oil on canvas, 200 x 178 cm Saint Petersburg, Hermitage Museum

"Against the wall stood an enormous painting, a strange picture of light and dark colours ... a large group – and beside it another picture of three women in a kind of red-brown, crude and posing; all in all quite frightening," reported Gertrude Stein of her visit to Pablo Picasso's studio in October 1907. Despite the unflattering comment on the picture, Gertrude Stein and her brother Leo acquired the final version of the painting *Three Women (Trois femmes)* from Picasso at the beginning of the year 1909 for their shared art collection.

Soon after completing *Les Demoiselles d'Avignon*, Picasso began small sketches for the painting *Three Women*, which he finished at the end of 1908. This large format work, with its dark coloration and angular fragmentation of bodily curves, also met with a lack of understanding and rejection among the painter's contemporaries.

The portrayal of the three female nudes clearly relates to his picture Les Demoiselles d'Avignon, completed one year earlier. Even more than with the Demoiselles the faces of the women - like stylized masks - appear superimposed on the heads. The flesh-coloured pink of the Demoiselles that emphasizes their nakedness has yielded to dark ochre colours varying from black to bright orange. With eyes closed and heads bent they assume uncommunicative or introverted bodily attitudes that contrast with their exhibited nakedness. Although the formulation of the bodies and faces of the three women is coarser by far than in the Demoiselles, the left and central figures describe a movement that makes the *Demoiselles* appear static in comparison. The initially tense bodily attitudes - referring to the individual figures - become graceful, dance-like poses when the picture is viewed as a whole. The figure kneeling on the left and the one standing centrally encompass the figure on the right by describing a semicircle with their poses. The dynamics suggested in this way allow the introverted masks to become the expression of a trance, in which the perception of the outside world allows innermost feelings to be acted out, expressed as movement.

The picture's vocabulary of form is far more reduced than in the earlier picture *Les Demoiselles*; the expressive power, however, is

"Against the wall stood an enormous painting, a strange picture more complex and substantially more difficult. The numerous studies tand dark colours ... a large group – and beside it another pic-for the painting *Three Women* show that Picasso sought a solution that lay between figurative appearance and dynamic abstraction.

In the final version the women no longer move in a spatially perceivable and definable space. There is simply the suggestion of a darkly set off background.

The art critic André Salmon in the Bateau-Lavoir studio, summer 1908

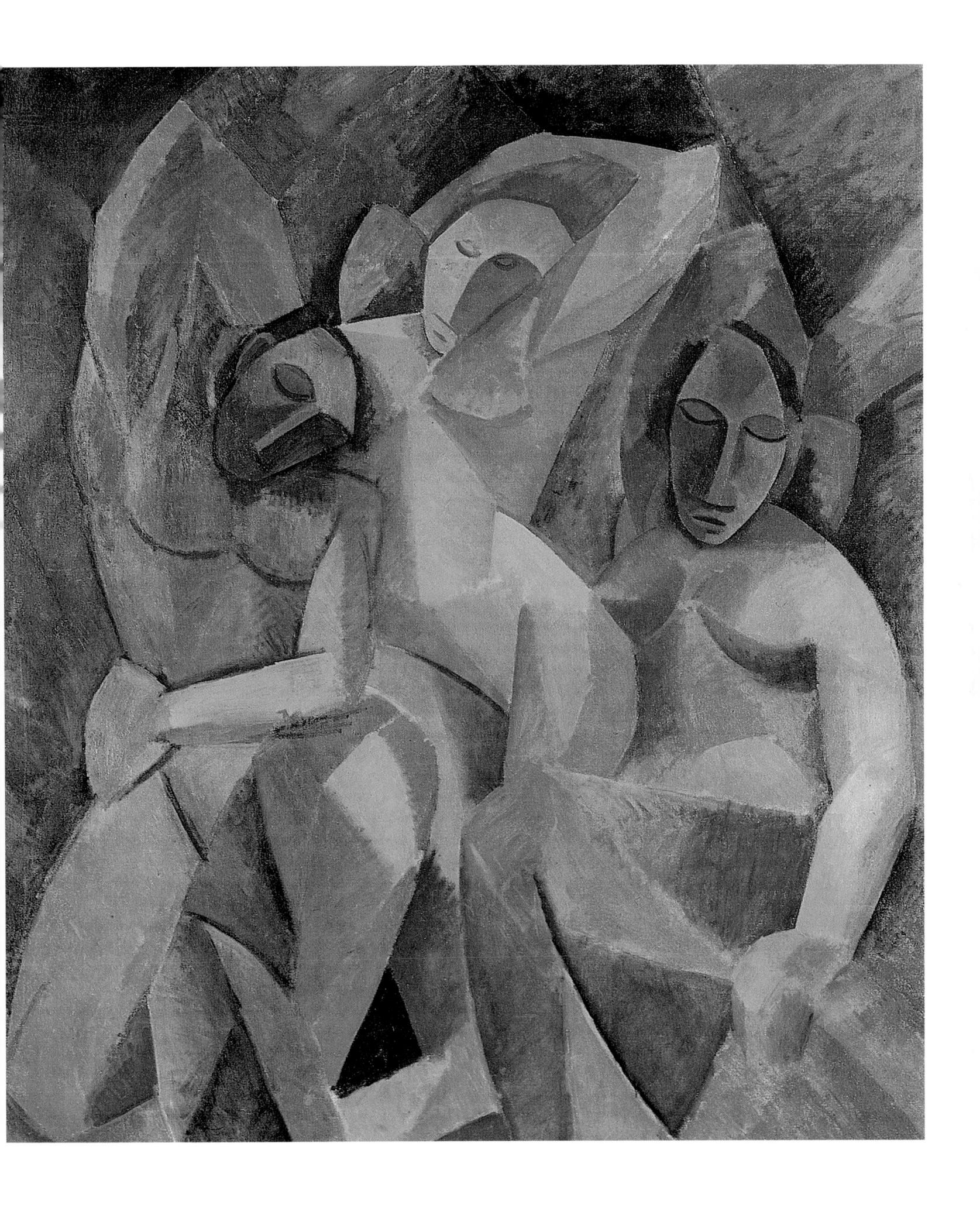

GEORGES BRAQUE

Large Nude

Spring 1908, oil on canvas, 140 x 100 cm Paris, Musée national d'art moderne, Centre Pompidou

b. 1882 in Argenteuil (Val-d'Oise),d. 1963 in Paris

"I couldn't portray a woman in all her natural loveliness ... I haven't the skill. No one has. I must, therefore, create a new sort of beauty, the beauty that appears to me in terms of volume, of line, of mass, of weight." With these words Georges Braque described his thoughts while creating the painting Large Nude (Grand nu). He began the picture after his first visit to Pablo Picasso's studio, where he had seen Les Demoiselles d'Avignon, already fin-

ished by then, and early drafts of *Three Women*. The first visit to Picasso induced Braque to produce figurative compositions, after having completed only a few figurative motifs before then.

Braque met, exactly as had Picasso, with strong rejection of his picture among visitors to his studio. On April 27, 1908, the feminist authoress Inez Haynes Irwin visited him and summarized afterwards in her diary: "A bare room. One fearful picture of a woman with exposed leg muscles; a stomach like a balloon that has begun to leak and sag; one breast shaped like a water pitcher, the nipple down in the corner, the other growing up near the shoulder somewhere; square shoulders. He talks a great deal of giving volume and three dimensions to things ..." The American writer Gelett Burgess, who had accompanied Inez Haynes Irwin to Braque's studio, goes so far as to say: "... the monster on his easel, a female with a balloon-shaped stomach".

After the jury of the "Salon d'Automne", consisting of Henri Matisse, Albert Marquet and Georges Rouault, rejected the six or seven works that Braque had submitted for the salon, his art-dealer Daniel-Henry Kahnweiler decided to show a solo exhibition of Braque's work. The presentation could be seen from the 9th to the 28th of November, 1908, and comprised 27 pictures, including many

landscapes created in L'Estaque, early Cubist still-lifes with musical instruments, and the *Large Nude*. Guillaume Apollinaire wrote the preface for the exhibition catalogue.

The critic Charles Maurice wrote a review for the "Mercure de France", the December 16, 1908 edition, about Braque's exhibition in the Galerie Kahnweiler: "Cries of horror could be heard before his figures of women: 'Ugly! Monstrous!' That is a rash judgement. If we want to see a female figure because we read 'nude portrait' in the catalogue, then the artist simply saw here the geometric harmony, which all of nature represents to him. For him this female figure was only a pretext to integrate it into certain lines and into relation with the corresponding colour values."

"Braque is a bold young man."

Louis Vauxcelles

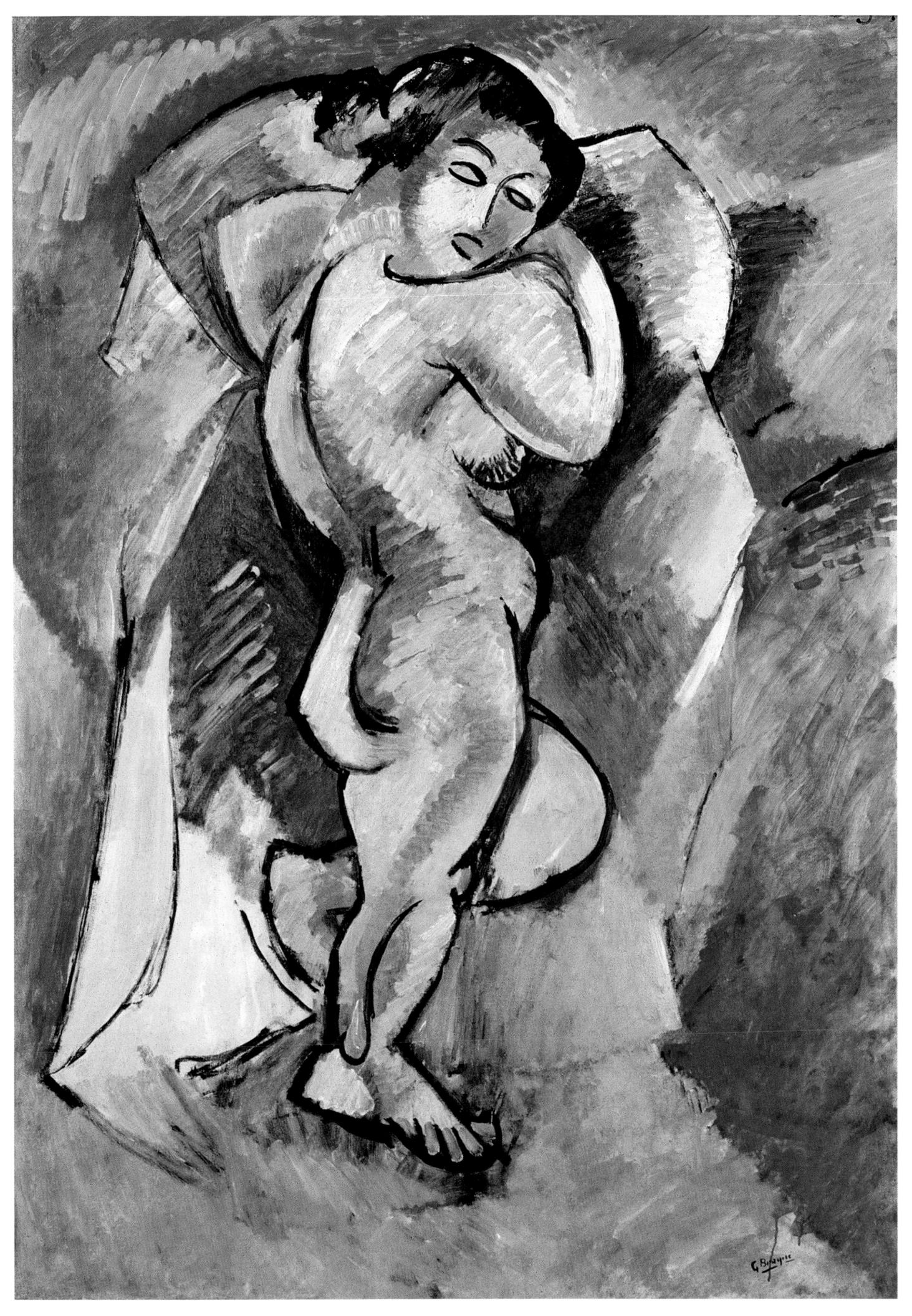

GEORGES BRAQUE

Houses in L'Estaque

1908, oil on canvas, 73 x 60 cm Bern, Kunstmuseum Bern, Hermann and Margrit Rupf Endowment

From the end of September to the middle of November, 1907, and with only a short interruption, Georges Braque lived in L'Estaque, a coastal town close to Marseille in which Paul Cézanne also lived at times. There Braque painted the first pre-Cubist landscapes. He interrupted his stay for a journey to Paris, where he must have visited the "Salon d'Automne" in which his picture *The Red Rock* was probably exhibited. Braque may have taken his rejected works back on this occasion.

Works by Paul Cézanne, who had died in 1906, were shown in a retrospective exhibition attached to the salon, and were seen by many artists who later worked in the Cubist style. The presentation comprised 49 paintings and seven watercolours. The poet and writer Rainer Maria Rilke, who from 1905 to 1906 was employed in Paris as secretary to the sculptor Auguste Rodin, regretted in a letter to his wife Clara Westhoff the late recognition of the quality of Cézanne's work: "Actually in two or three well-chosen Cézanne's one can see all of his pictures, and surely somewhere we could already have been able to progress in understanding, perhaps at [the art dealer Paul] Cassirer's, as I now see myself advancing. But one needs a long, long time for everything." Some other visitors to the exhibition would also have felt the same way.

Cézanne's influence on Cubism is undisputed. This had already become clear in the first exhibitions of Cubism, in which critics repeatedly referred to his significance for the young artists. The artists themselves also stressed his significance for their development. Thus Braque remarked: "It was more than an influence, it was an initiation. Cézanne was the first to turn away from the mechanized perspective being taught ..." André Masson noted in this regard: "You have divided Cézanne's apple into four parts in order to make it easier to eat."

Braque had already stayed in L'Estaque from October 1906 until February 1907. In 1908 he spent the summer months there. In this period Braque created the landscapes that he submitted to the autumn salon in Paris, the evaluation of which led Matisse to the description of a picture made up of little cubes: It was this comparison that prompted the critic Louis Vauxcelles to call the new art style "Cubism".

Houses in L'Estaque (Maisons à L'Estaque) from 1908 shows a landscape characterized by roofs and façades, with a tree superimposed diagonally across the painting's lower frontal area. Planes of green dominate at the lower edge of the picture, which render in perspective the view of the village landscape from a hill. The houses are depicted without windows or façade structure and are reduced to simple forms, just as are the greens and browns of nature emerging in a few places. Parallels with Cézanne's depictions of landscape can be recognized in the freedom to resolve colour placement through perspective.

It isn't known whether Daniel-Henry Kahnweiler acquired the first paintings by Braque in 1907 or 1908. It is certain that these included, in addition to other works, landscapes from L'Estaque. It is notable that Kahnweiler himself travelled in September 1910 from Paris to L'Estaque, in order to photograph the landscapes there that Braque had recorded in his paintings.

Paul Cézanne, The Cabin of Jourdan, 1906

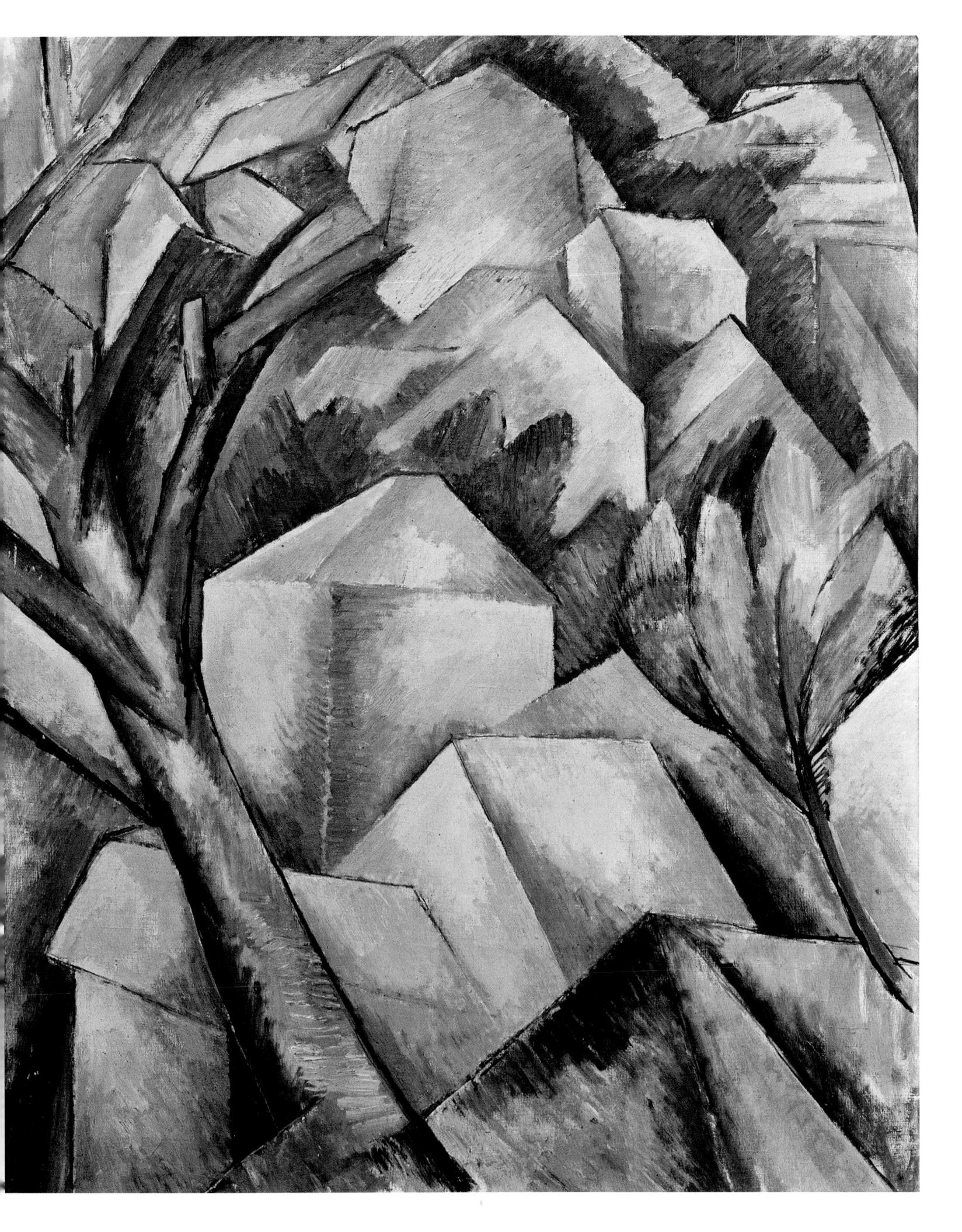

PABLO PICASSO

Fruit Bowl and Bread on a Table

Winter 1908/09, oil on canvas, 164 x 132.5 cm Basel, Öffentliche Kunstsammlung, Kunstmuseum Basel

This still life by Pablo Picasso is from the early phase of his Cubist work. He painted it just after completing those groundbreaking works for Cubism, *Les Demoiselles d'Avignon* and *Three Women*.

Daniel-Henry Kahnweiler recalls his first studio visit to Picasso at this time: "Rue Ravignan, 1907. This old wooden shack was built during the reign of the Commune. To what purpose, nobody knows any more. Today painters and poets live there. From little Ravignon Plaza one arrives on the top floor first; to reach the others one must descend. The hill namely falls away on the other side. Picasso's door is covered with inscriptions: 'Je suis chez le bistrot.' – 'Fernande est chez Azou.' – 'Manolo est venu.' He opens the door in his shirt, with naked legs. Then he slips into trousers. A window and a skylight illuminate the small shed. Old scraps of wallpaper stick on the walls. In front of the little iron stove, lava mountain, a heap of ashes higher than the oven. Pictures, innumerable pictures, stretched, rolled, lying around in the dust."

At that time this large-format picture was created after studies for *Carnival at the Bistro*. Picasso created two variations of the picture *Carnival at the Bistro*, which show a similar portrayal of the table in the picture. The version in watercolour and pencil, which he composed using open areas of white with light blue and brown, shows a group of people gathered around the table. A dancing woman with design similarities to the *Demoiselles d'Avignon* can be seen in the background. In a second version of *Carnival at the Bistro*, those behind the table blend together into one plane with the picture's background. In both works the table can be seen from two perspectives: The rear part of the table is shown in correct perspective, whereas one sees the front rounded section, which is done in far lighter colours, from above. The two views of the table are set off against one another, so that besides the brightly emphasized semicircular form the horizontal line of the break in perspective dominates the picture.

Out of both of these works Picasso developed the still life *Fruit Bowl and Bread on a Table (Pains et compotier aux fruits sur une table)* in which he composes the table identically. A comparison shows that the composition of the picture below the table is also iden-

tical: The suggestion of clothing worn by the figures standing behind the table in *Carnival at the Bistro* develops into draped curtains in the still life. The still life itself, which consists of a fruit bowl with a cloth, an apple, a cut loaf of bread and a bowl, clearly refers to Cézanne's work. At the same time Picasso also created a still life in which he even refers in the title to the artist of importance for him: *Still Life with Hat (Cézanne's Hat)*.

The white signature in the picture *Fruit Bowl and Bread on a Table* seems foreign to the painting. In all likelihood, the artist signed the picture only later. Picasso's retrospective statement may explain this: "People didn't quite understand at that time why we very often didn't sign our pictures. Of those that are signed, most were only signed years later. That happened because we felt the call for an anonymous art. We tried to develop a new order ... Nobody needed to know whether it was this person or that one who had painted this or that picture. But individualism was already too strong ... As soon as we saw that the collective adventure was a lost cause, every one of us had to find his own individual adventure."

Carnival at the Bistro, 1908/09
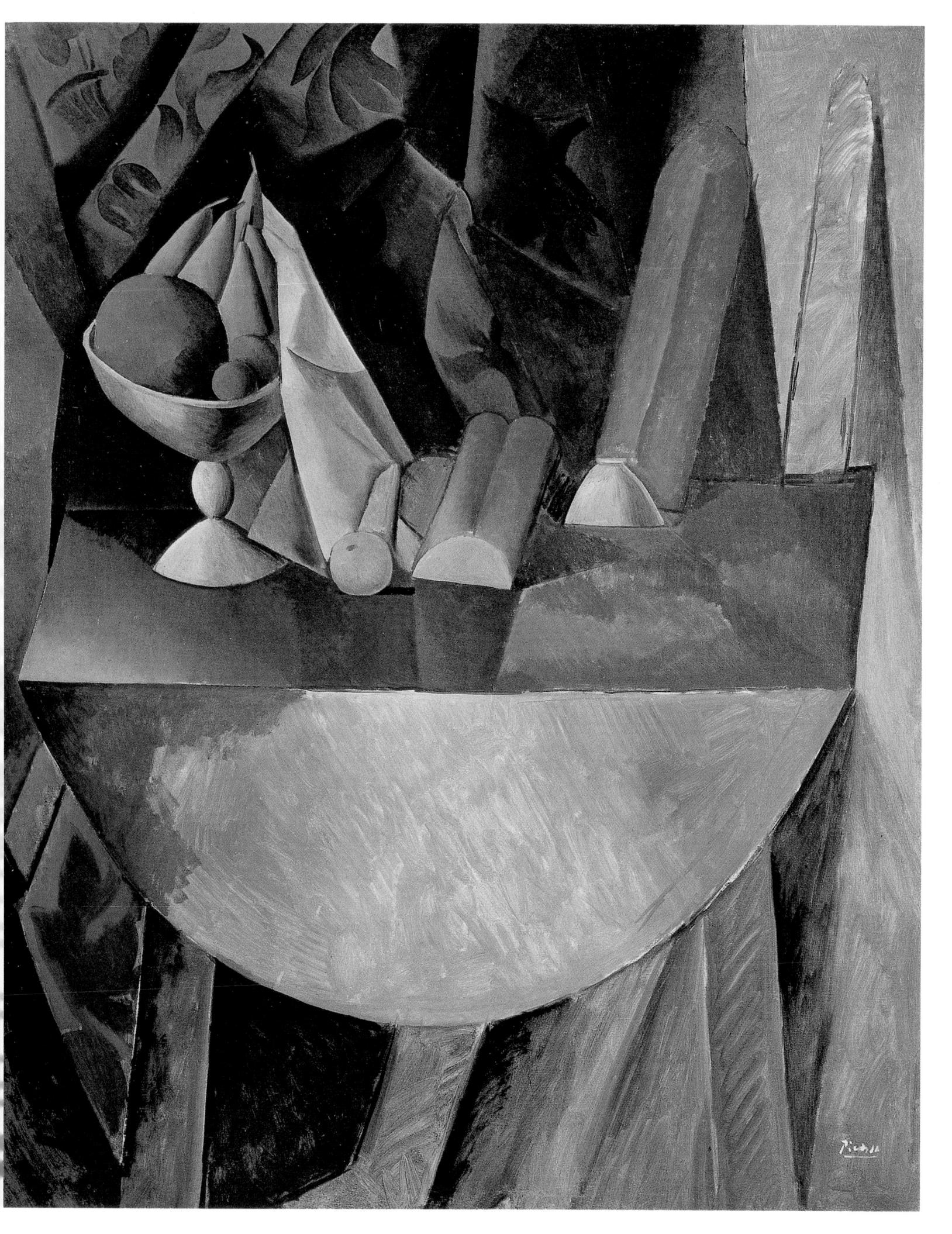

Castle at La Roche-Guyon

Summer 1909, oil on canvas, 81 x 60 cm *Stockholm, Moderna Museet*

In June 1909 Georges Braque travelled to La Roche Guyon – a charming area in the Ile de France in the Seine valley below Mantes – where Paul Cézanne had already stayed in 1885. Thus after L'Estaque, Braque already visits for a second time a place where Cézanne was also previously active as an artist. On the occasion of his visit Cézanne had stayed for about a month in the picturesque spot with August Renoir, with whom he was friends, and painted in the landscape there together with the other artist.

At La Roche-Guyon Braque tried to work in a concentrated manner and in complete isolation. He wrote to his dealer Daniel-Henry Kahnweiler in Paris: "I am very pleased to be here. The land-scape here is really beautiful ... I would like to remain as isolated as possible. I request that you communicate my address to no one."

Braque was fascinated by the high-lying ruins of the medieval castle of La Roche Guyon with the castle grounds around its base. By the end of August he had created five paintings with the title *Castle at La Roche-Guyon* (*Château de La Roche-Guyon*), which show a development in the way he dealt with the motif. The picture that today is in the Moderna Museet in Stockholm shows a composition corresponding to the natural conditions. The houses ascending the hill vertically as well as the castle with its fortifications rise parallel to the edge of this vertical-format painting. Thus this version of *Castle at La Roche-Guyon* communicates a static and thus more sedate rise of the architecture on the hill. The colour composition is very simplified and freed from the real objects. It is based on tones of ochre, grey and green. The brush strokes outlining the architecture are very restrained in comparison with the animated and dynamic application of the green paint with its suggestions of nature.

In the further painted versions of this motif the selection of colour becomes somewhat richer and more differentiated. To-day the version in the van Abbe Museum in Eindhoven displays the architectural structures through a window-like cutout, which offers nature to the viewer. The pallet of the nuanced greens varying between turquoise and olive green, and the brown tones of the architecture, also admit colours from dark grey to pure white. There is no

longer any line which runs parallel to the lateral edges of the picture. The built-up hill of La Roche Guyon becomes an unstable construction, which upon longer observation seems to break down into its individual parts.

Even the repetition of a picture motif, the ever-recurring attempt to capture the picture's subject in a different way, can be compared to Cézanne's series of pictures of the Sainte-Victoire Mountain, which he painted in numerous variations from about 1900 until just before his death in 1906.

Braque was trying to emphasize the difference between nature and art, whereby in his view nature should not serve for imitation, but rather that the experience of nature, in formal terms, should be reflected by art. Guillaume Apollinaire stresses in his catalogue text for the 1908 exhibition in the Galerie Kahnweiler: "Georges Braque knows no rest. Each of his pictures is a monument to an ambition, as undertaken by no one before him."

Castle at La Roche-Guyon, 1909

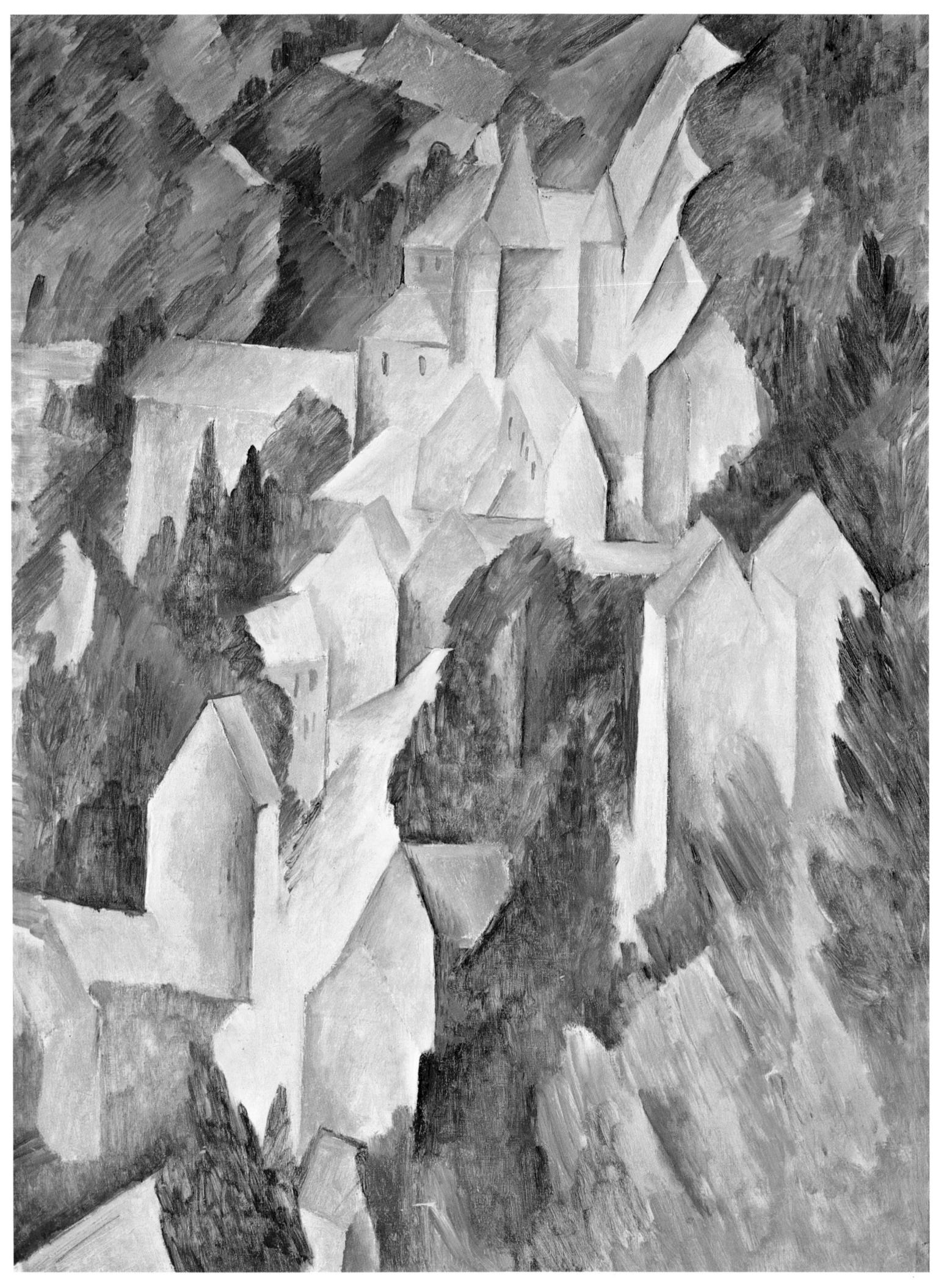

Reservoir at Horta, Horta de Ebro

Summer 1909, oil on canvas, 60 x 50 cm *Private collection*

"All I know I have learned in Horta."

Pablo Picasso

Pablo Picasso had already spent some time in the Catalonian town of Horta de Ebro in 1898 after having had scarlet fever. In June 1909 after spending a month in Barcelona he revisited Horta de Ebro with his partner at that time, Fernande Olivier. With the exception of a few outings they remained there until the beginning of September, 1909.

For Picasso it was a productive time, Olivier seemed not to feel well in the rural environment. In July she wrote to Gertrude and Leo Stein: "I most certainly would feel better in Paris, for there I could be treated. But to travel now would only make the illness worse ... Life is sad. Pablo is sullen and no comfort to me, neither mentally nor physically ... I have been in Spain for two months now and still have not had a single day to rest ... Everything fatigues me, and until now I have not been able to do anything. Pablo would let me die without suspecting the state I am in. Only if I feel really badly does he stop work for one moment to care for me." And Picasso also seems initially to experience the time in Horta de Ebro as tedious: "I have begun two landscapes and two figures, always the same", he wrote to the same addressees to whom Olivier had complained about him.

The designation "landscape" is difficult in view of some of the pictures created by Picasso in Spain's Horta de Ebro. In his picture *Reservoir at Horta (Le réservoir à Horta)* Pablo Picasso dissolves the landscape's realistic features completely in geometrical forms and structures. Spatial depth can only still be recognized by the overlapping of forms; the perspective lines of individual houses do not agree with those of the others. In the lower portion of the painting the structures disintegrate into fragments that are no longer clearly readable, while at the top of the hill they still seem steady and stable. Picasso's use of colour is not constrained by the object being painted. In *Reservoir at Horta* the colour of objects is ordained by green and ochre, and these are only blended with white or black if the objects demand volume in order to remain readable to the viewer.

When Picasso returned to Paris with Olivier on September 13, 1909, he carried a great number of completed pictures in his luggage; among them the paintings *Reservoir at Horta* and *Houses on*

the Hill, Horta de Ebro, as well as at least 15 pictures of Olivier such as Head of a Woman (Fernande) or Seated Woman. In the same month of his return to Paris, Picasso exhibited a series of the pictures created in Horta de Ebro in private rooms at the Bateau-Lavoir. Gertrude and Leo Stein were invited to the small viewing. Shortly thereafter Gertrude Stein showed a further exhibition in the rue de Fleurus, in which the 27 pictures depicting landscapes of Horta de Ebro were presented.

Self-portrait, 1909

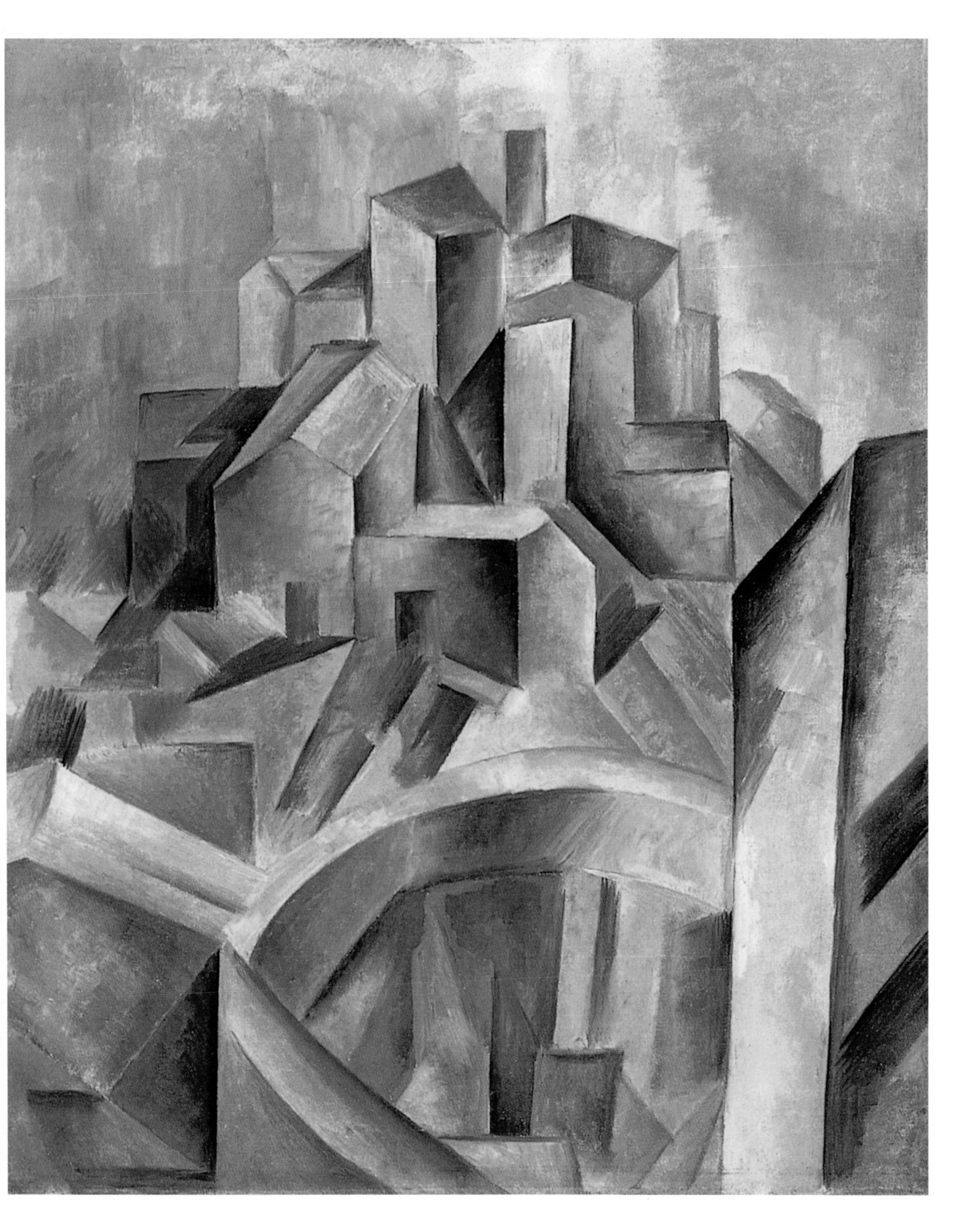

PABLO PICASSO

Houses on the Hill, Horta de Ebro

Summer 1909, oil on canvas, 65 x 81 cm *New York, The Museum of Modern Art*

The photograph from the year 1909, which Pablo Picasso entitled *Landscape*, *Horta de Ebro (The Reservoir)*, shows a view from an elevated position of sections of the small Catalonian village, with the large reservoir in the foreground surrounded by several brickroofed quarrystone houses with associated yards and farm buildings. The hilly open landscape with fields and light tree cover extends to the

It can be assumed that Picasso used the photograph along with studies done from the original landscape to refer to when working on his painting *Houses on the Hill (Maisons sur la colline)*, completed in the summer of the same year. The houses, similarly depicted from an elevated viewpoint, correspond in their basic arrangement and in many details with those that Picasso had photographed a short time earlier. The open, hilly Catalonian landscape also opens up behind the village in the picture. Only the large circular water reservoir, which was vitally necessary as the cistern for the village, was not included by Picasso in the painting. However, the reservoir with its thick basalt walls takes a central position in the picture *Reservoir at Horta, Horta de Ebro*, which was also painted there.

The photograph and painting are part of a small series of pictures, which were created during his stay in the Catalonian village from mid-June to the beginning of September, 1909. Picasso had once recovered from a lengthy scarlet fever illness there. During his Cubist work phase Picasso did not again visit the rural place although he had a great liking for the locality. In July he expressed to his collectors, the Stein siblings: "The landscape is wonderful here. I love it, and the route which leads here exactly resembles the overland route in the Wild West."

The American authoress, collector and patroness of the arts Gertrude Stein displayed 27 paintings created in Horta de Ebro in an exhibition in October of the same year in the rue de Fleurus in Paris. Picasso had already informed the Steins from Horta de Ebro about his current work. At the end of August he wrote to the siblings: "Let me know whether you received the photographs of my four pictures. I will shortly send you more of the landscape and of my other pictures. I

don't yet know when I will be in Paris again. I'm still making sketches and work pretty regularly. Kahnweiler is coming here at the beginning of September. That disturbs me. Perhaps I will see Pichot in Cadaqués on the way to Paris."

Gertrude Stein acquired *Houses on the Hill, Horta de Ebro* and *Reservoir at Horta* for the collection she was putting together with her brother Leo. The American artist Frank Haviland, who was a neighbour of the Steins, bought the picture *Factory at Horta de Ebro*.

Landscapes played a subordinate role in Picasso's work after his stay in the Spanish town of Horta de Ebro. Later trips to the countryside outside of Paris also no longer found expression in his work; instead he turned to subject matter that could be realized anywhere – independent of his spatial and scenic surroundings.

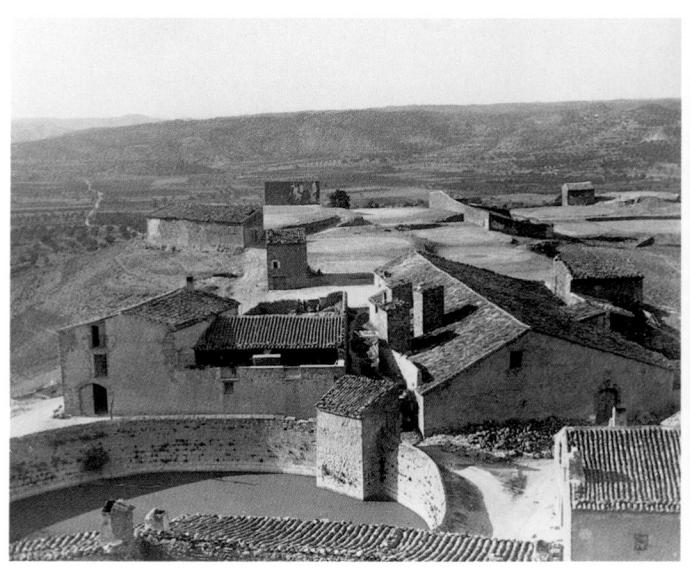

Landscape, Horta de Ebro (The Reservoir), 1909

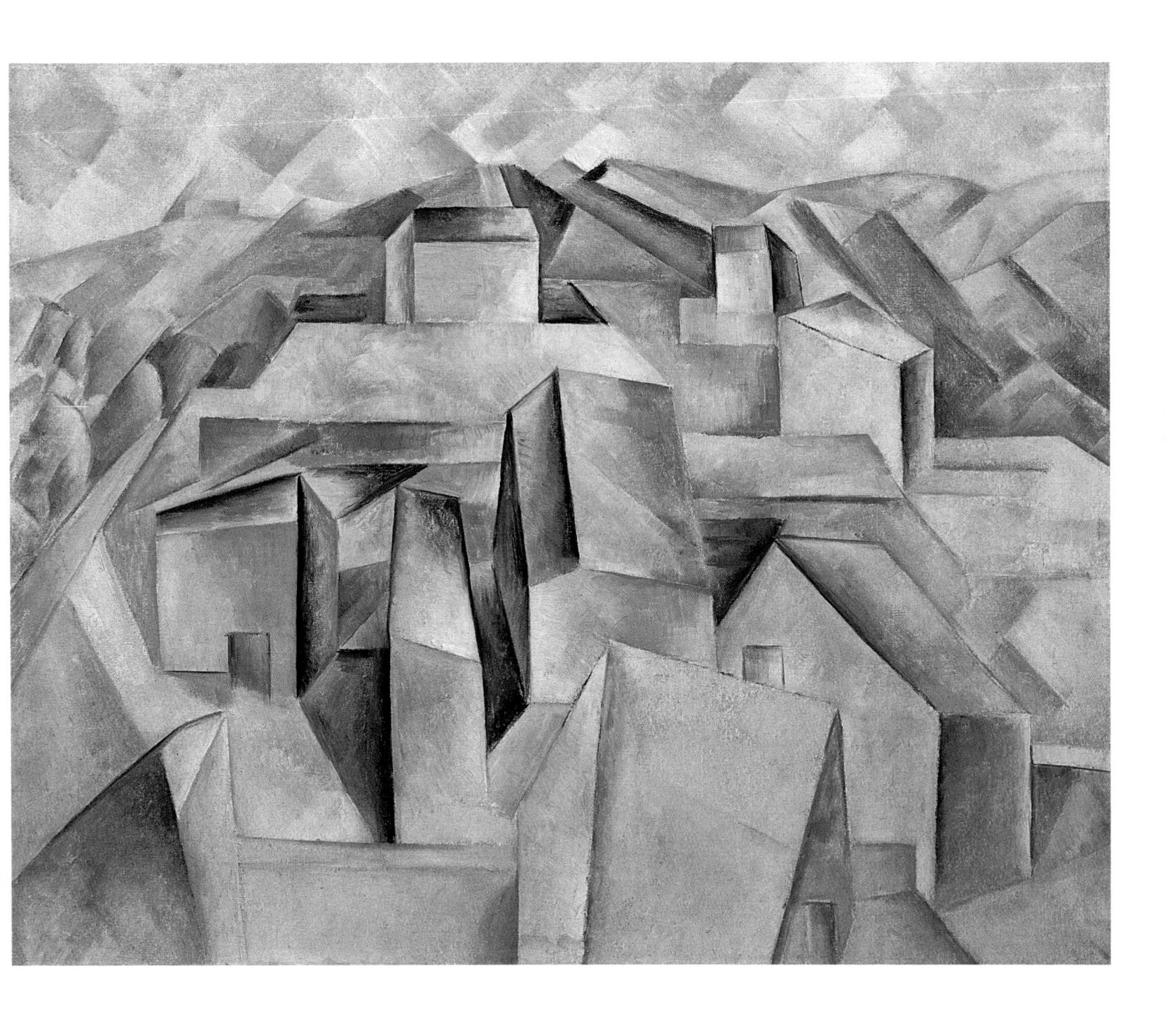

Violin and Palette

Autumn 1909, oil on canvas, 91 x 42.8 cm New York, Solomon R. Guggenheim Museum

> "Art is destined to disconcert; science creates certainty."

Georges Braque

Pablo Picasso stressed again and again in a series of inter- congenial cooperation a "coalition of inventors". Picasso had no closer views that music itself had played no role for him. In contrast, Georges Braque lived with music. In his studio he was surrounded by an array of musical instruments. Braque loved the shapes of the instruments and had mastered playing them. It therefore comes as no surprise that he was the first Cubist artist to integrate musical instruments into the compositions for his pictures. Braque worked well into the winter of the year 1909 on his series of large-format still-lifes with musical instruments. The subjects of these pictures can be seen in various photographs taken in his studio.

In his picture Violin and Palette (Violon et palette) from the fall of 1909, Braque used the method which would later be called Analytical Cubism to divide the total volume of forms and planes into smaller parts. The violin placed in the lower half of the picture can be clearly recognized by its bridge and the suggestion of strings. It is represented in brown colours, which are most certainly based on the real object's coloration. The instrument's form is divided into fragments; the strings are cut through above the opening in the sounding body. Above the instrument in Violin and Palette are pages of sheet music with a mask-like form behind, which turns out to be a pallet. It could send colours out onto a picture like tones.

The art critic Louis Vauxcelles had already stressed in 1908 in "Gil Blas": "He [Braque] constructs, distorts and simplifies terrible metallic figures ... He despises form and reduces everything places, figures and houses - to basic geometrical forms, to cubes."

Irrespective of differing subject matter, the close cooperation between Pablo Picasso and Georges Braque is obvious. Both artists make no secret of it and mutually orient themselves again and again by the work of the other. In this connection Braque reflects: "We both lived on Montmartre and saw each other every day. We were a little like climbers roped together in the mountains."

Picasso felt similarly about his closeness to Braque and later told their mutual dealer Daniel-Henry Kahnweiler, "that everything he had created in the years 1907 to 1914 came only into being through cooperation with others." The art historian Werner Spies called the confidant among the artists than Braque at this time, and also found no other after the First World War.

Braque in his studio at 5, Impasse de Guelma; early 1912 or thereabouts

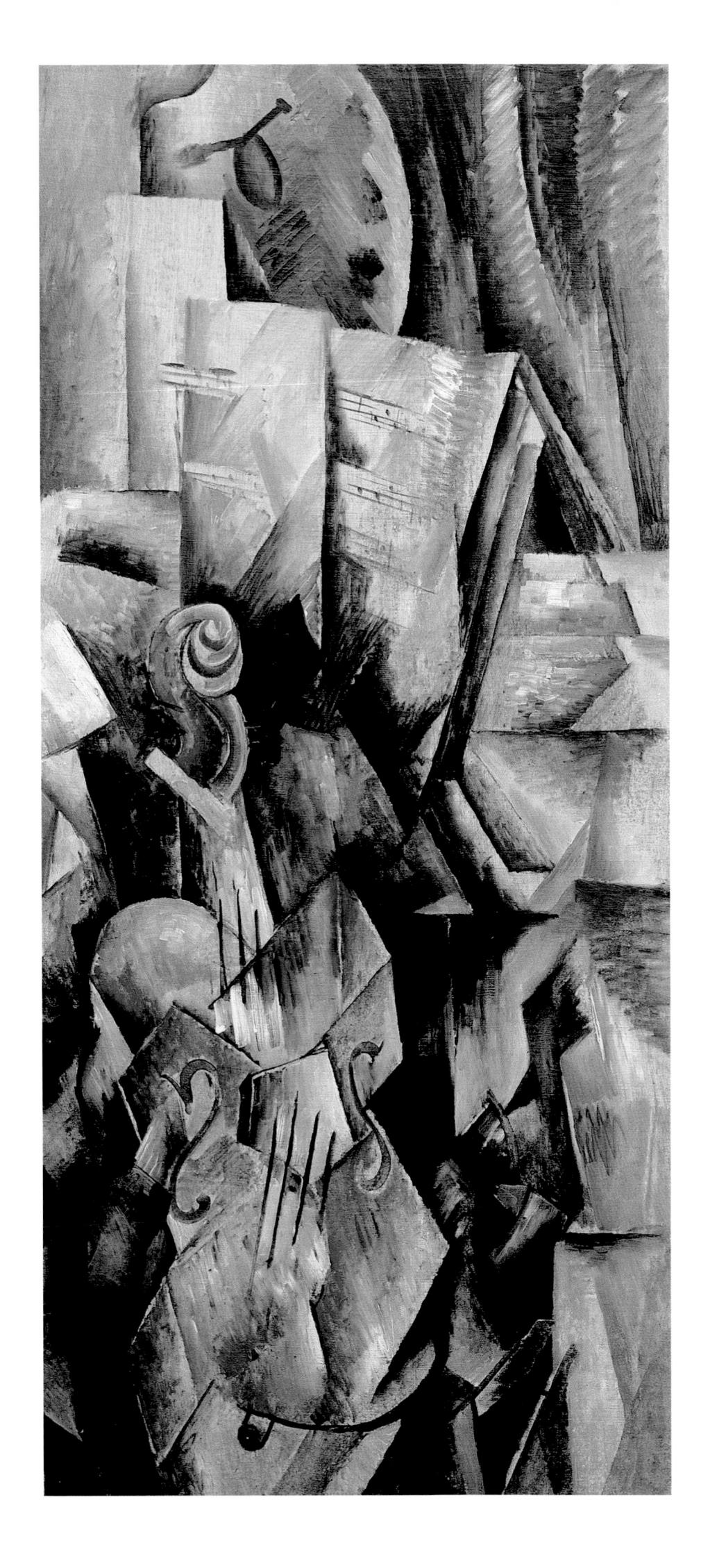

PABLO PICASSO

Head of a Woman (Fernande)

1909, bronze, 40.5 x 23 x 26 cm; photograph by Brassaï, 1943, gelatine silver print, 29.5 x 22.8 cm Düsseldorf, K20 – Kunstsammlung Nordrhein-Westfalen, on loan from a private collection

"I paint things as I think them, not as I see them."

Pablo Picasso

Pablo Picasso was occupied about ten months long with the head of Fernande Olivier in 1909. In particular during the stay in Horta de Ebro he created more than 15 pictures of his partner, who avowedly had not felt well in the rural environment.

The art historian Werner Spies stated that Picasso had created the famous head after his return from Horta de Ebro in the studio of his friend the Spanish sculptor Manolo (Manuel Hugué). Thus the sculpture can only have been created after the drawings and paintings produced in Horta de Ebro.

In August 1909 Olivier wrote to Gertrude Stein while still in Horta de Ebro: "We will leave Horta in approximately ten days ... Then we stay another two weeks in Barcelona. Pablo's sister got married some days ago; Pablo easily succeeded in extracting himself from having to participate in the ceremony. Perhaps we will follow Barcelona with a stay in Bourg-Madame, a border town near Puigcerda close to Céret, and remain there until September ... Manolo is there with Haviland ..."

In the following autumn Picasso modelled the bronze *Head of a Woman (Fernande)/Tête de femme (Fernande)* in Manolo's Paris studio. Starting with a clay model that is no longer extant, he produced two plaster castings. In about 1910 these ended up in the hands of the art dealer Ambroise Vollard, who commissioned a not completely documentable number of castings of the bust, but at least 15 copies.

The tectonic structuring of Olivier's head in the paintings he made of her is taken up again by Picasso in developing the bust. The compositions of the pictures and of the sculpture are related: Fernande's head, which Picasso had already strongly geometrically structured in the paintings and drawings, opens itself into the viewing space through such structures. Picasso thus transfers the formal problems tested in painting into three-dimensionality.

Picasso noted in this connection: "Cubism is not a mere seed or an art in the condition of pregnancy, which thus has yet to produce its true substance. It is at the stage of original, independent forms, which have the right to lead their own lives. If Cubism is in metamorphosis, then from Cubism itself a new form of Cubism will emerge. One must try to explain Cubism mathematically, geometrically and psychoanalytically. That is pure literature. Cubism has tangible goals. We see it only as a means of expressing what we perceive with the eye and the spirit, while utilizing all the possibilities that lie within the natural properties of drawing and colour. That became a source of unexpected joy for us, a font of discoveries."

One of the cast bronze copies was lent by Alfred Stieglitz from February 17th to March 15th, 1913 for the legendary Armory Show, in which eight works by Picasso were shown. It was also the lender Stieglitz who first presented Picasso's sculpture in the December edition of "Camera Work". The art historian Doris Krystof suspects that this was the copy Stieglitz himself had acquired. For the exhibition's further stops in Boston and Chicago Stieglitz seems to have turned down a further loan. The bronze bust was not to be seen in those shows.

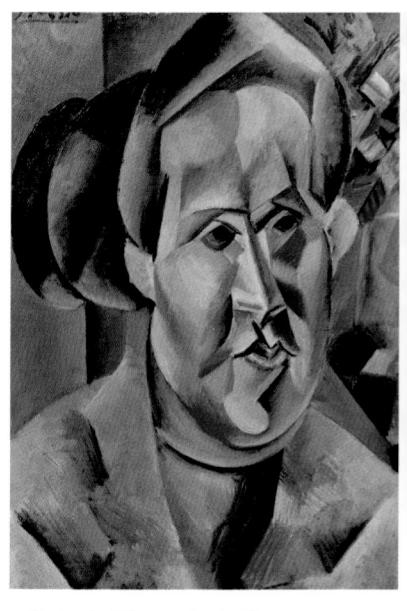

Portrait of Fernande, 1909

FERNAND LÉGER

Nudes in the Forest

1909/10, oil on canvas, 120 x 170 cm Otterlo, Kröller-Müller Museum

b. 1881 in Argentan (Normandy),d. 1955 in Gif-sur-Yvette

In the "Salon des Indépendants" of 1911 Fernand Léger drew much attention to himself with his picture *Nudes in the Forest (Nus dans la forêt)*. In connection with Léger's art the art critic Louis Vauxcelles no longer spoke of Cubism, but of "Tubism" (tube art). Léger was not happy with the reformulation: "With all my energy I have aligned myself in opposition to Impressionism. I was obsessed by it; I wanted to fragment the bodies. Now someone has called

me a 'Tubist', right? That didn't go by without causing discouragement. For two years I have been struggling with the plasticity of this *Nudes in the Forest*, which I finished in 1910. I wanted to carry the volumes to the extreme." After the exhibition Pablo Picasso remarked to his dealer Daniel-Henry Kahnweiler: "You see, this boy brings something new, they are already calling him something different than us."

By 1910 Léger had already been introduced by his friends, the journalists Max Jacob and Guillaume Apollinaire, to Galerie Kahnweiler, where he saw the Cubist work of Picasso and Georges Braque for the first time. After Léger's appearance at the "Salon des Indépendants" Kahnweiler was quickly convinced of his abilities. As early as 1912 the first of Léger's pictures hung in his gallery. A solo exhibition of his work, as published in some places, never took place here however, since after a solo exhibition of Braque's work Kahnweiler stopped presenting exhibitions. Thereafter he showed only the work freshly produced by his artists. At the beginning of the year 1913 Kahnweiler concluded an exclusive contract limited to three years with Léger, and bought all of his new work from him.

Kahnweiler was so confident in his new artist that he said: "Léger was a Cubist. It was, certainly, a Cubism that was unique to

him, bearing the mark of his temperament. What is really different with him is the philosophical basis; in short, his world view." After the end of the First World War Léger, like many other artists as well, worked together with the gallery owner Léonce Rosenberg.

In retrospect, Léger described his picture *Nudes in the Forest* as the result of a two-year effort or struggle: "I wanted to carry the volumes to the extreme. The *Nudes in the Forest* were for me only a dispute between body forms. I had felt that I could not yet bring the colour to bear, the volume was enough for me." Elsewhere he calls his picture "a fight of volumes".

The art historian Werner Spies calls it a "tactile investigation of Cézanne's new pictorial space". Like many of his contemporaries, Léger had viewed Paul Cézanne's retrospective in the year 1907 with great enthusiasm. Cézanne's work and that of his friend Henri Rousseau exerted a large influence on Léger. Léger was perfectly conscious of the importance of these role models when he declared in retrospect: "Cézanne is the mediator between Impressionism and modern painting (as Manet was between the school of 1830 and Impressionism), for genius does not fall from the sky: It develops slowly, laboriously from all that has gone before; it must free itself from initial influences and create new, different values. I myself needed three years to free myself from Cézanne's influence ... The enthralment was so strong that I had to go as far as abstraction to escape it."

To be sure, with his salon painting *Nudes in the Forest* Léger makes clear reference to the *Bathers* by Cézanne, but here he does succeed in reducing the objects to cones and spheres.

Woman with a Mandolin

Spring 1910, oil on canvas, 92 x 73 cm *Munich, Pinakothek der Moderne*

The painting *Woman with a Mandolin (Femme à la mandoline)* is the first Cubist painting in oval format. In the year 1910 Georges Braque created two versions of a female half-nude with mandolin. He created one of the pictures in the usual rectangular portrait format, while he selected an oval for *Woman with a Mandolin*.

Braque's painting, which is restricted to discreet brown-grey and grey-blue colours, shows a woman playing the mandolin. Both woman and instrument are treated equally in the picture composition. The avoidance of bright primary colours concentrates the viewer's attention on the conservatively modelled depiction, which is put together as if from a tightly-woven network of geometrical forms viewed through an optical prism. In the lower third of the picture the circular opening of the mandolin's resonating body emerges clearly. The outlines of the stringed instrument held by a delicate arm can be surmised, and through the position of the playing woman's left arm they gain in contour. The torso, neck and head with a seemingly feminine hairstyle can be guite clearly discerned. The latter is one of the picture's few gender-specific characteristics. Only now can the dark circular formation in the rectangle above and to the left of the opening in the mandolin's resonating body be interpreted as a nipple. Braque often delimited non-objective colour planes with a black line.

For both pictures it can be assumed that figures playing music by the French painter Camille Corot (1796–1875) were a substantial influence. In the year 1909 Corot was prominently represented at the "Salon d'Automne" with several works from his œuvre, including some depictions of women playing music. Among the visitors to the Parisian presentation who obviously allowed themselves to be inspired by his work were Pablo Picasso and Braque.

Soon after Braque had completed his picture *Woman with a Mandolin*, Picasso also painted a picture with this subject. The general assumption that Braque was principally influenced by Picasso is at least partly disproved here. In the early phase of Cubist painting Picasso's influence may have been considerable. Thus for example it is reported that Picasso was indignant about the change in direction by Braque when he exhibited his art with a "large picture of Cubist

construction" at the Indépendants, painted "secretly", and without betraying the "source of his inspiration" to anybody. The collector Gertrude Stein also reported: "When Picasso exhibited for the first time publicly, it was together with Braque and Derain who had been completely influenced by Picasso." Over the course of time each influenced the other and cultivated an extremely close cooperation. In relation to some selected subject matter in their Cubist period, the two seem to have joined in a synthesis.

"Nature stimulates a feeling, and I translate this feeling into art. I would like to reveal the absolute in a woman, not just her outer body."

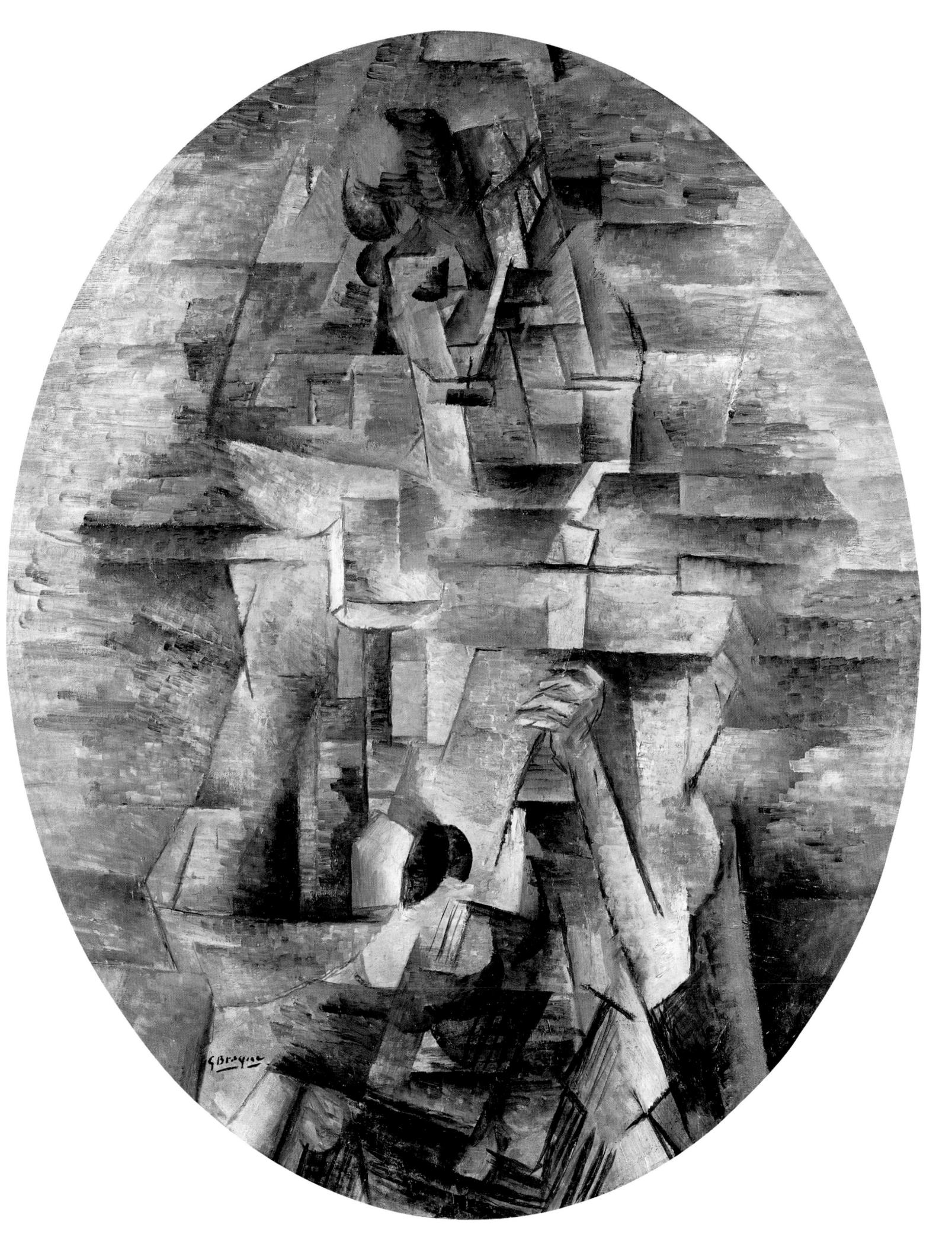

Girl with a Mandolin (Fanny Tellier)

Spring 1910, oil on canvas, 100.3 x 73.6 cm New York, The Museum of Modern Art, Nelson A. Rockefeller Bequest

Soon after Georges Braque had created the oval painting Woman with a Mandolin in 1910 in Paris, Pablo Picasso produced two pictures which testify to the closeness and friendly exchange between the two artists: his first oval picture and his Girl with a Mandolin (Fanny Tellier)/Jeune fille à la mandoline (Fanny Tellier), which certainly is to be understood as his answer to Braque.

Picasso had already applied himself to the same subject matter in *Woman with a Mandolin* from 1908 (today in the Hermitage Museum in Saint Petersburg) and from 1909 (today in the Kunstsammlung Nordrhein-Westfalen in Düsseldorf). According to his own statements, Picasso used the mandolin due to its formal identification with the female body. The guitar and the violin in his work are also to be understood in this way.

Unlike Braque's depiction, the figure playing the instrument in Picasso's work is recognizable as a female nude at first glance. The choice of colour in both artists' pictures is dominated by green and grey tones. It is a tranquil choice of colours, which by itself develops no expressiveness. The female body and the musical instrument are equivalently represented here as well, and merge into a whole due to their identical colour composition.

As before, it continues to be puzzling that Picasso repeatedly claimed that music had never seriously moved him. It is also made no more comprehensible through the fact that Picasso experimented pictorially with various other musical instruments, such as the violin and the piano for example. It is possible that colour harmonies corresponded (at least in the artists' minds) with those of music – in addition to the sounding body's affinity to the female body.

In an interview with Marius de Zayas, which was published on May 26, 1923 in the American magazine "The Arts", Picasso emphasized: "Mathematics, trigonometry, chemistry, psychoanalysis, music and what-not, have been related to Cubism to give it an easier interpretation. All this has been pure literature, not to say nonsense, which has only succeeded in blinding people with theories. Cubism has kept itself within the limits and limitations of painting, never pretending to go beyond it. Drawing, design and colour are understood and prac-

tised in Cubism in the spirit and manner in which they are understood and practised in all other schools. Our subjects might be different, as we have introduced into painting objects and forms that were formerly ignored. We have kept our eyes open to our surroundings, and also our brains."

Postcard from Pablo Picasso to Daniel-Henry Kahnweiler, August 13, 1911

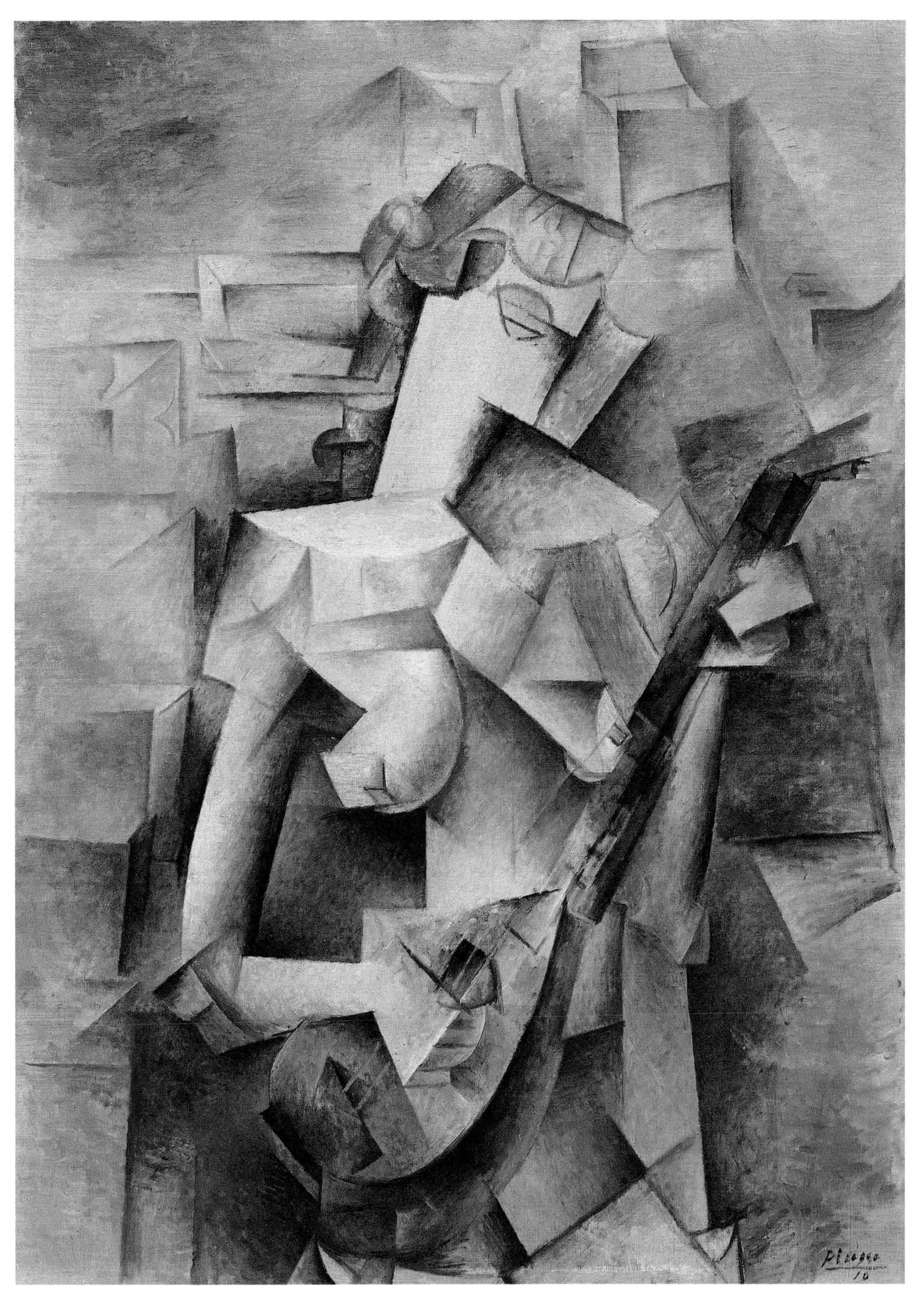

Bottle and Fishes

Autumn 1910, oil on canvas, 61 x 75 cm *London, Tate Modern*

On the occasion of the first large solo exhibition with works by Georges Braque in the Galerie Kahnweiler in the year 1908, the writer Charles Morice (1861-1919), who had come to prominence with treatises about Paul Cézanne, wrote: "The audacity of a van Dongen appears downright 'reasonable' if we compare it with the work of Mr. Georges Braque. But here it is a matter of more than just the difference in degree of boldness - it's not better or worse, but something different. Mr. van Dongen remains in good taste insomuch as he remains faithful to the traditional motto that forms should generally be 'understandable'; Mr. Braque has freed himself from these final chains. In pictorial terms, he assumes a concept of geometry that is understood a priori and to which he subjects the entire field of his visions; he then tries to represent all of nature as a combination of just a few absolute forms. ... nobody is less concerned with psychology than he is, and I believe that a stone moves him just as strongly as a face. He has created an alphabet in which each letter has an extensive meaning. Before you call his spelling primer hideous, tell me whether you were able to decipher it and whether you have understood its decorative intent."

In 1910 Braque begins to paint still-lifes becoming ever more abstract. The painting *Bottle and Fishes (Bouteille et poissons)* was created during the late summer or early autumn in the southern French coastal town of L'Estaque, where Braque repeatedly stayed from the end of August to the end of October. A standing bottle can be made out beneath a network of interwoven planes on the left side of the picture. A bar of white on the bottle's neck lends the object plasticity; overall the coloration is dominated by blue. In the lower region of the painting only fragments of fish can be made out; fish heads, no entire bodies. The arrangement of bottle and fishes is not embedded in a spatially recognizable background. The objects are dispersed and shown in a range of colours that do not correspond with their colours in reality. Spatial integration of the objects in the picture develops only in the viewers' minds.

It is characteristic for most Cubist still-lifes that they combine only a few objects. Sometimes these reveal something about the habits of the artists, such as Braque's picture *Bottle and Fishes* which creates associations with living conditions on the Mediterranean coast. Objects loaded with meaning were avoided very consciously in order to try out the new representation of reality with everyday objects.

Braque expressed himself about his work much less often than did Picasso or other Cubists. One of his surviving statements is dedicated to his still-lifes: "It isn't enough to make visible what one paints; it must also become tangible. A still-life ceases to be a still-life the moment it can no longer be reached with the hand."

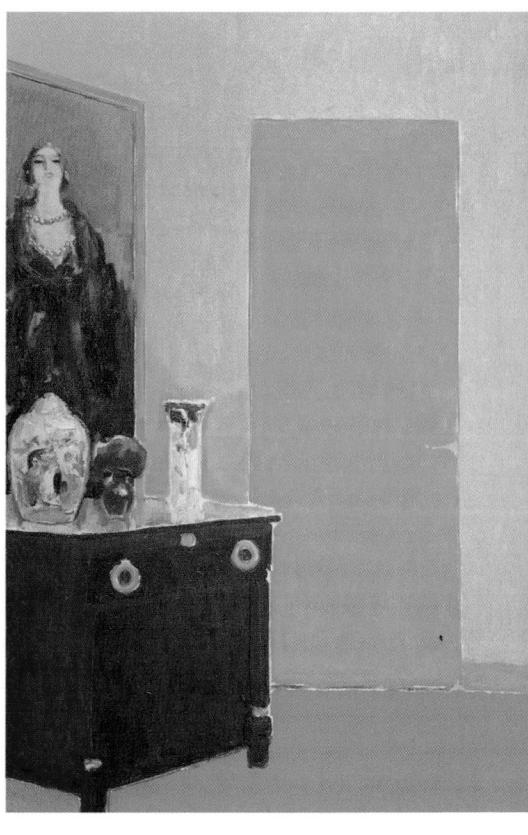

Kees van Dongen, Interior with Yellow Door, 1910

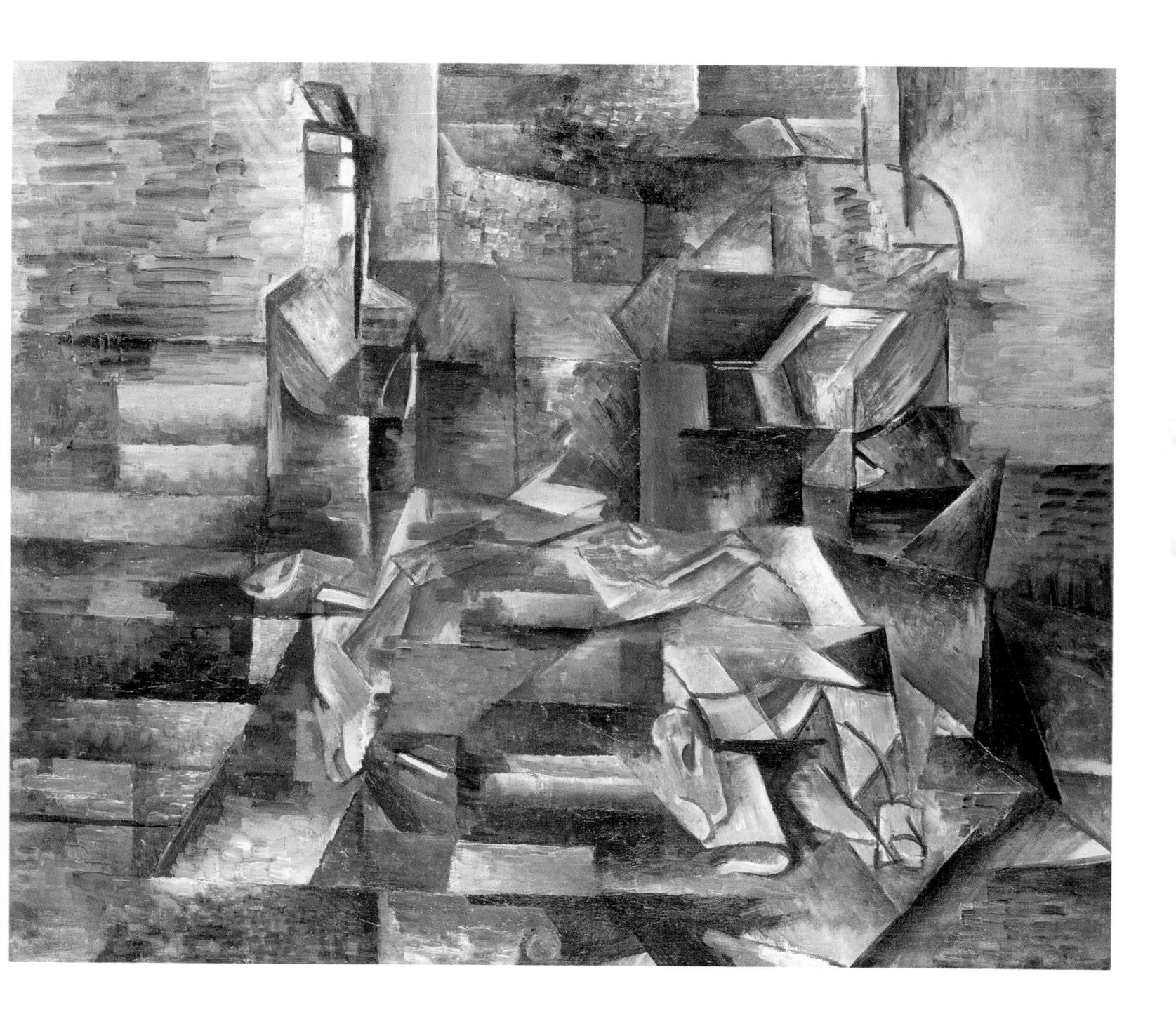

ROBERT DELAUNAY

The Tower behind Curtains

1910, oil on canvas, 116 x 97 cm Düsseldorf, K20 – Kunstsammlung Nordrhein-Westfalen

"I live. Art is a way to enjoy oneself or to live, and that's that."

Robert Delaunay

b. 1885 in Paris,d. 1941 in Montpellier

Robert Delaunay worked on his first sequential series of pictures *Saint-Séverin* as early as 1909/10. For Delaunay it was his first series of pictures produced in independence from artistic role models. Comparable to the Eiffel Tower pictures created a short time later, they show different versions of an identical motif; the gothic church of Saint Séverin in Paris. In both series Delaunay varied his position and the perspective only minimally or not at all.

In the years from 1909 to 1912 while he was still working on the *Saint-Séverin* series, Delaunay began his series of Eiffel Tower paintings. It would later comprise over 30 pictures, among them oil paintings and works on paper. Delaunay took up the subject again from 1920 to 1930. We have already seen the method of approaching a pictorial subject in several steps or exploring its spectrum of variations: in early Cubist works by Georges Braque with his pictures *Castle at La Roche-Guyon*, and even earlier in Paul Cézanne's *Bathers* and his approach to painting Sainte Victoire Mountain, for example.

For a young artist living in Paris the modern iron construction of the Eiffel Tower, built from 1885 to 1889 and which became a symbol of technical progress in architecture, must have been a fascinating subject. Delaunay records the Eiffel Tower in the picture *The Tower behind Curtains (La Tour aux rideaux)* through a window that permits a view both of the roofs of Paris and of the imposing tower construction. The curtains pulled to the side of the window take up almost half of the picture on its right and left borders. The background of the perspectively distorted architecture is formed by clouds that resemble ascending soap bubbles, and that are in remarkably clear formal contrast to the soaring spike of the tower construction.

The view of the Eiffel Tower portrayed within a window frame, in which the window becomes the picture and the picture the window, was the prelude to an extensive series that occupied Delaunay in his subsequent phase of work. Soon thereafter his interest in colours was to take priority above problems of form in his work. This was accompanied by his abandonment of natural, object-bound coloration and manner of representation. After a relatively short Cubist practice Delaunay came to the conclusion: "As long as art does not free itself from the object, it condemns itself to slavery."

Delaunay decided upon a pure colour architecture for which Guillaume Apollinaire coined the term "Orphic Cubism", and later "Orphism". Delaunay, who initially rejected the term, defined the new direction as follows: in Orphism, colour relationships are employed as independent construction materials; they "form the basis for painting that is no longer imitative". He states elsewhere: "Colours express performances, modulations, rhythms, counterbalances, fugues, depths, oscillations, chords, monumental accords; that is to say order."

While the Cubists were creating a sensation with their presentation in the "Salon des Indépendants" in 1911, Delaunay took part

with three paintings in the first "Blue Rider" exhibition in Munich. Even thereafter, Delaunay became an important propagator in the spread of Cubist ideas: In 1912 Paul Klee, Franz Marc, August Macke and Hans Arp visited Delaunay in his studio. Delaunay and Apollinaire in turn met Macke in Bonn. In addition, participation in exhibitions abroad contributed to the international understanding of Cubism.

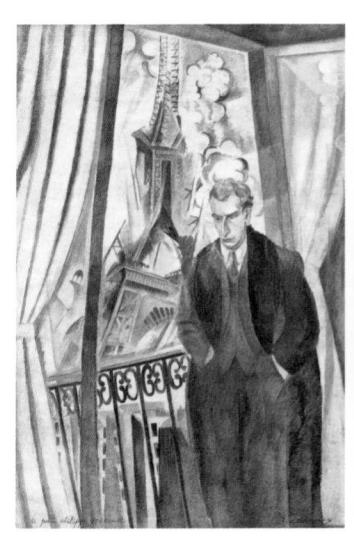

The poet Philippe Soupault, 1922

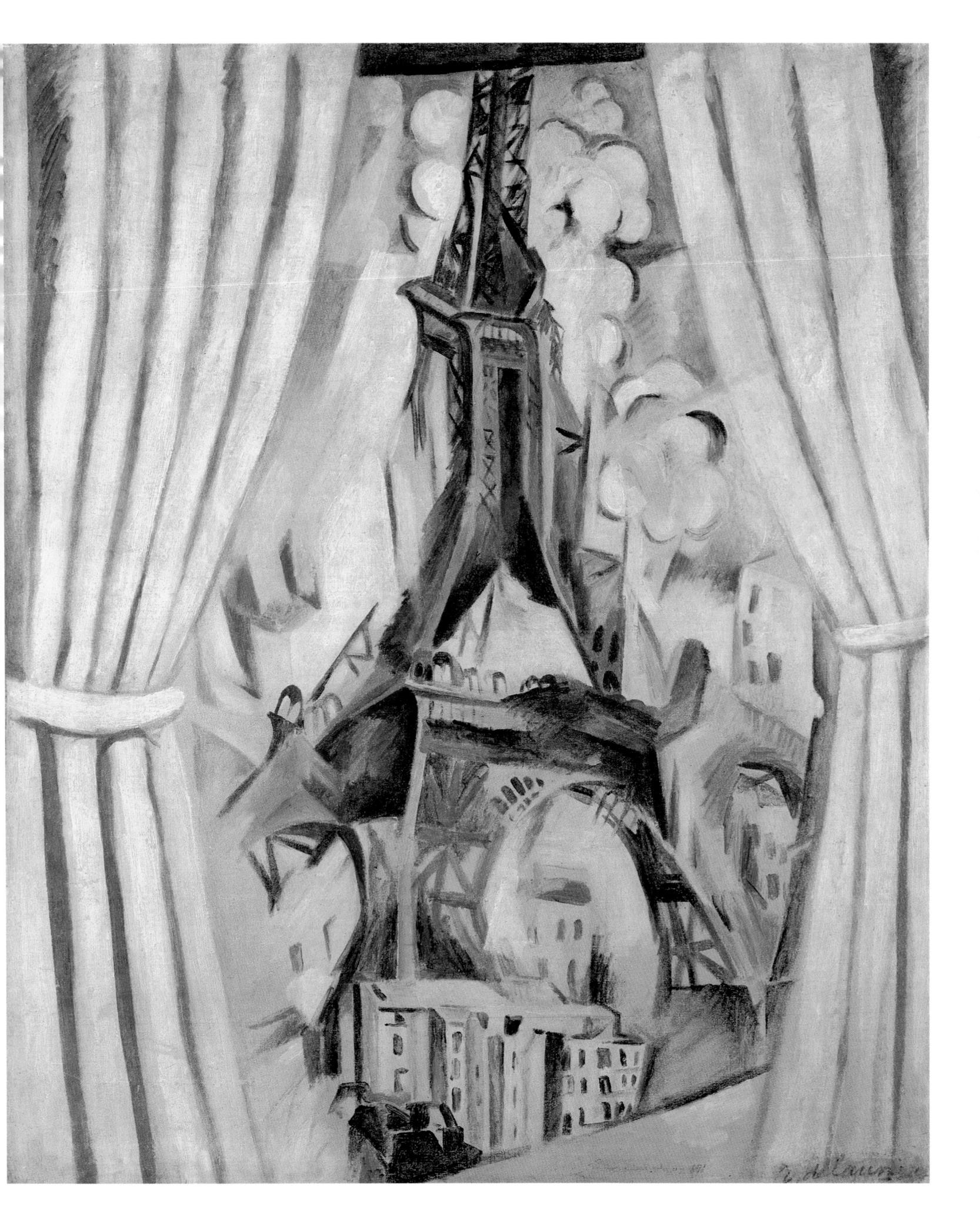

Houses in Paris

1911, oil on canvas, 52.4 x 34.2 cm New York, Solomon R. Guggenheim Museum

b. 1887 in Madrid,d. 1927 in Boulogne-sur-Seine

"Cubism is above all a product of urban culture. In Cubist painting the city can be found both as picture and as motif for a reorganisation of space," states Irina Vakar on the occasion of the exhibition "Kubismus. Ein künstlerischer Aufbruch in Europa 1906–1926" (Cubism. An artistic departure in Europe 1906–1926). Unlike the Expressionists and Futurists, the Cubist artists do not subject the motif "city" to a valuation. Just like a still-life, a portrait, a land-

scape or even a nude, the city is a subject that the artists use to examine the perspectival variety of forms and volumes as well as their representational and perceptual possibilities.

Juan Gris painted the picture *Houses in Paris (Maisons à Paris)* at a time in which, despite his physical proximity to Picasso, he was still preoccupied with the work of Paul Cézanne. Gris, who also originated from Spain (actually José Victoriano González), came to Paris in the year 1906 after studying painting and graphics in Madrid. He was 19 years old when he began his affiliation with Pablo Picasso, whose studio neighbour he became. By 1913 he was already among the artists represented by Daniel-Henry Kahnweiler.

Kahnweiler met Gris several times during visits to Picasso's studio. On those occasions he repeatedly saw works by Gris, who at that point in time could not yet be counted among the Cubists. Gris' appearance in the "Salon des Indépendants" in the year 1912 completely convinced Kahnweiler. Still in October of the same year Kahnweiler offered Gris an exclusive contract, which was recorded in writing in February 1913. Kahnweiler later recalled: "Since I was convinced I had discovered an important painter in this artist whose development I had already long since followed, I came to an agree-

ment with him in the winter of the same year to buy his entire future production, plus all of the works that were in his studio."

In each work Gris concentrated on contrasting a few richly gradated colour values. His work *Houses in Paris* can be cited as an example here. Gris did not proceed intuitively, instead seeking legitimacy in his art. Even in his early production around 1911/12, Gris anticipated stylistic innovations of later Synthetic Cubism, as Kahnweiler also states in his comprehensive monograph about Gris.

In 1925 the theoretician Gris published the following statement in his essay "Chez les cubistes" (At home with the Cubists) in the "Bulletin de la Vie Artistique": "Cubism? Since I did not adopt it in a conscious way after careful consideration, but rather worked in a certain spirit that classified me as being aligned with it, I have not thought about its causes and its character as someone would who had observed it from afar and preoccupied himself with it before adopting it. Today it is clear to me that Cubism, at its beginning, was nothing more than a new way of rendering the world ... I mean that in the beginning Cubism was an analysis that had no more to do with painting than the description of physical phenomena has to do with physics. But now, because the technique of painting sets a standard for all elements of the so-called Cubist aesthetic, now, because through the rendition of the relationships between objects, the analysis of yesterday has itself been recast to synthesis, one can no longer make this accusation. If that which one called Cubism was only a certain aspect, then Cubism has disappeared; if it is an aesthetic, then it has merged with painting."

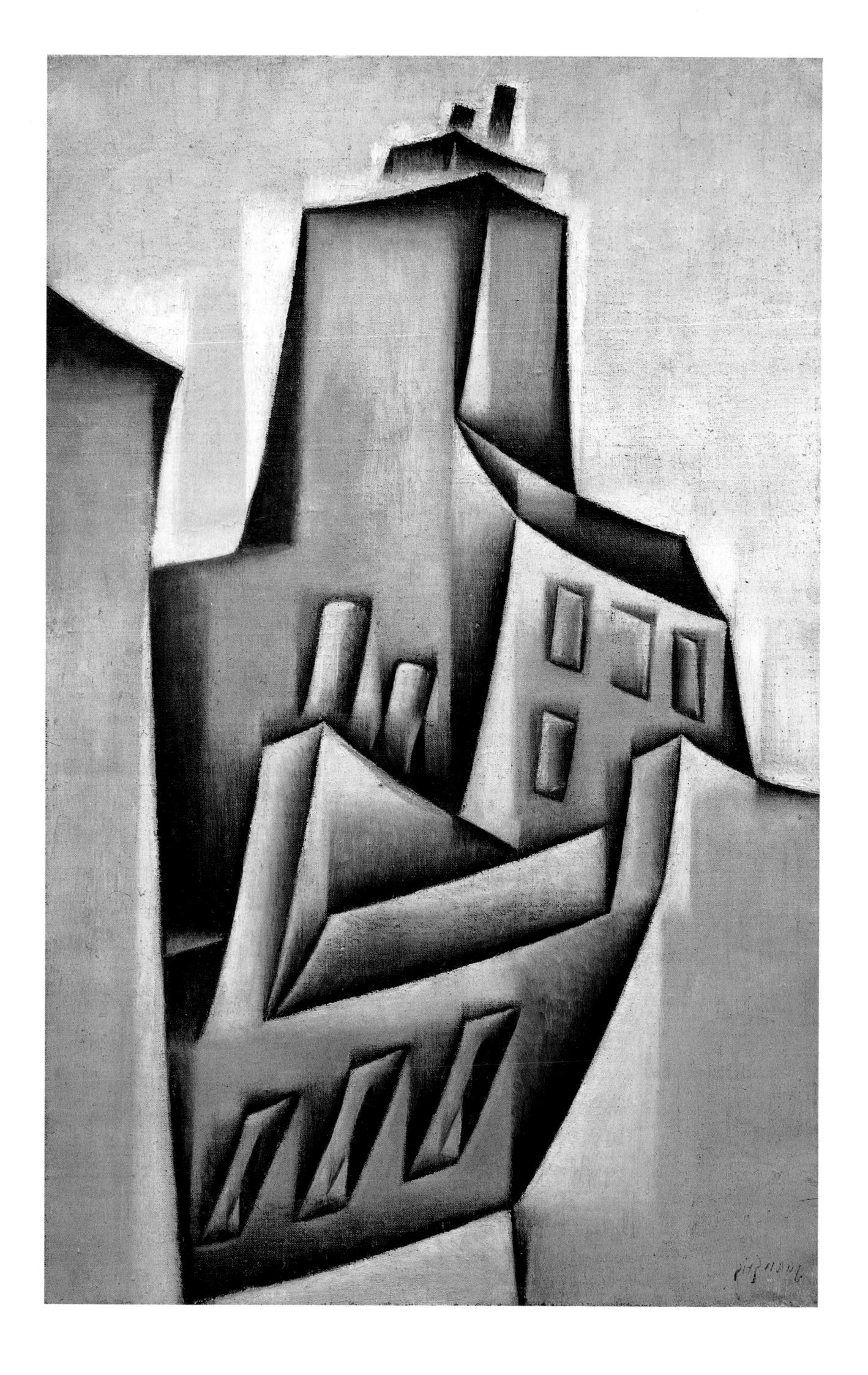

JEAN METZINGER

Tea Time

1911, oil on cardboard, 75.9 x 70.2 cm Philadelphia, Philadelphia Museum of Art, The Louise and Walter Arensberg Collection

b. 1883 in Nantes, d. 1956 in Paris

André Salmon reported in the "Paris-Journal" about the 1910 "Salon d'Automne": "Since Georges Braque is not represented in the exhibition, Jean Metzinger alone defends Cubism with a nude and a landscape."

Jean Metzinger studied at the local academy of arts in his hometown of Nantes around 1900. There he took painting instruction from Hippolyte Touront, a well-known portrait painter who taught the academic, conventional manner of paint-

ing. Even during his studies, Metzinger was receptive to the upheaval taking place in painting at that time. From Nantes he sent several oil paintings to Paris, in order to participate there in an exhibition at the "Salon des Indépendants". Success was not lacking. In 1903 Metzinger moved to Paris, where he worked successfully in the Neoimpressionist style and took part in various exhibitions. Between 1905 and 1908 he created pictures with mosaic-like coloured patterns, which with their adjacent, carefully placed flecks of colour led directly into his later, Cubist-influenced pictures.

By 1906 Metzinger had already met Pablo Picasso, Georges Braque and Juan Gris. In 1908 he also became affiliated with the Cubists in an artistic sense. In this year he participated in the Cubist exhibitions at the "Salon des Indépendants" and the "Salon d'Automne".

In his picture *Tea Time* (*Le goûter*) Metzinger shows a female nude drinking tea. Frontally and as a half-figure he depicts a woman sitting at a table. Only around her lower torso is wrapped a cloth, which she has thrown over her right arm. In her right hand she holds a spoon and with her left hand she lightly touches the cup before her. The objects in the picture, which are quickly readable, are only minimally, almost scholastically fragmented, such as the vase in the back-

ground to the left, for example. The depiction communicates a rather hesitant, almost uncertain approach by the artist.

In October/November 1910 Metzinger wrote in his "Bemerkungen über die Malerei" (Remarks about painting) about Picasso: "It is useless to paint, while it is possible to describe. Equipped with this thought Picasso reveals to us the real face of painting. By forgoing all decorative, anecdotal or symbolic intention, he achieves a previously unknown purity in painting. I know of no pictures from the past, not even the best of them, which so clearly belong to painting. Picasso does not deny the subject; he illuminates it with his intelligence and his emotions. Cézanne showed us things as they exist in real light; Picasso gives us a concrete depiction of reality as it arises through his perception — he uncovers a mobile perspective."

In 1912 his cooperative work with Albert Gleizes led to the theoretical treatise "Du cubisme" (On Cubism). Metzinger was appointed as a lecturer at the renowned Parisian Académie de la Palette, and later at the Académie Arenius.

"We laugh out loud when we think of all the novices who expiate their literal understanding of the remarks of a Cubist and their faith in absolute truth by laboriously placing side by side the six faces of a cube and both ears of a model seen in profile."

Albert Gleizes and Jean Metzinger

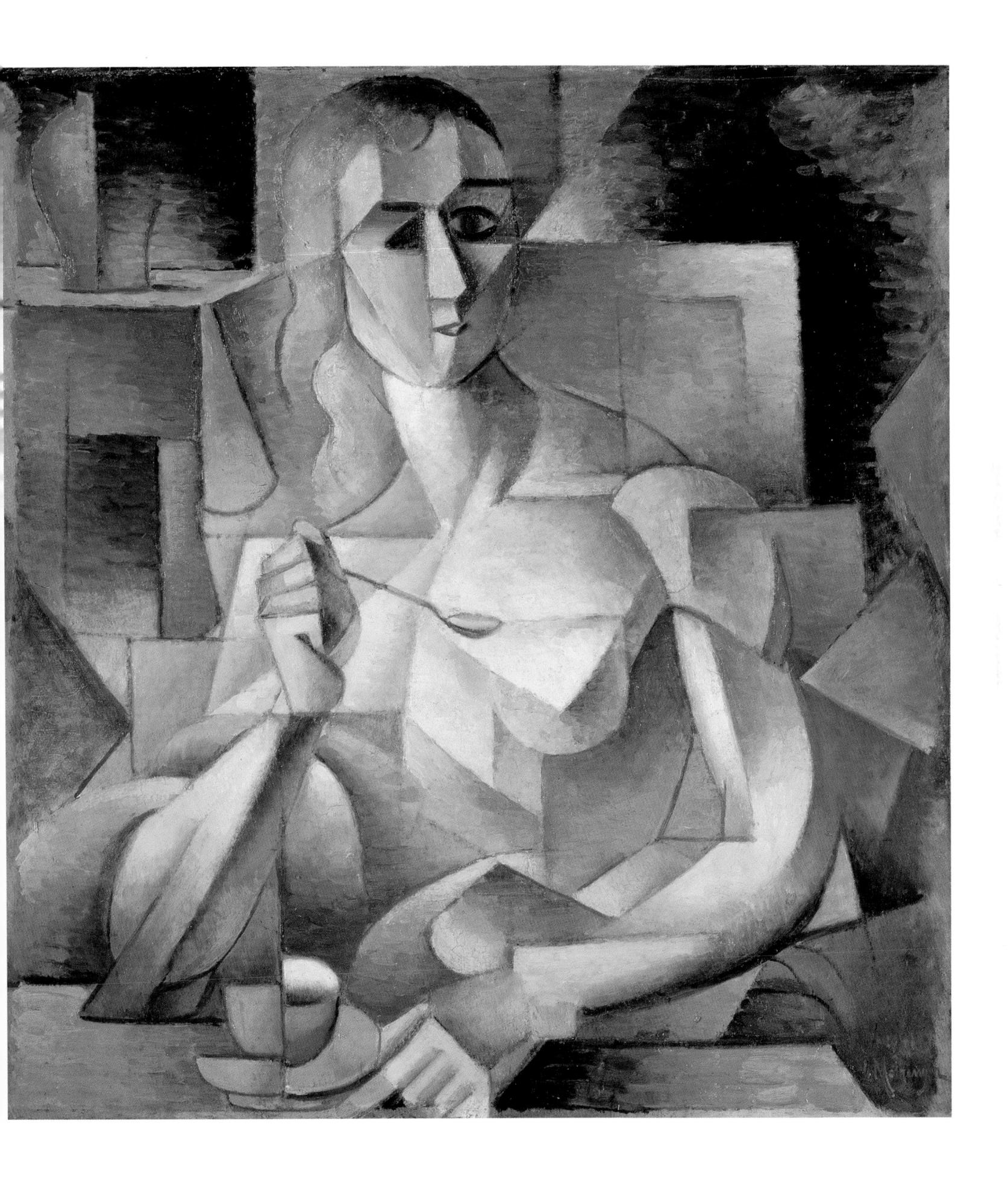

HENRI LE FAUCONNIER

The Huntsman

1911/12, oil on canvas, 203 x 166.5 cm Den Haag, Haags Gemeentemuseum

b. 1881 in Hesdin (Pas-de-Calais), d. 1946 in Paris In his book "Histoire du cubisme" (Chronicles of Cubism) of 1928 Albert Gleizes judges

Henri le Fauconnier's picture *The Huntsman (Le chasseur)*: "Second stage of Cubism. One of the masterpieces of this epoch. All problems dealt with: volume, perspective displacement, circular arrangement, rhythmic repetition. Strives toward a new creative order that corresponds to an attitude of mind based upon the mobility of the world."

Le Fauconnier was among the artists who exhibited their pictures in the 1911 "Salon des Indépendants", and who were understood as a group by Metzinger and Gleizes. Le Fauconnier was represented in this legendary salon exhibition with his picture *Abundance* of 1910/11. He was able to present the equally large painting *The Huntsman* in the following "Salon des Indépendants" in the year 1912.

Clearly recognizable and with inflated volumes, the figure of the huntsman is located in the centre of the picture. He appears to viewers in full-figure side profile, his gun held with both hands. The trigger of his weapon is particularly emphasized, being additionally framed in black. Compared to the dimensions of the huntsman's body, the trigger of the weapon appears enlarged; the square frame becomes a magnifying glass that accentuates the moment of the shot and the huntsman's concentration. He aims at mallard ducks, which flee in the smoke of the rifle or already lie on the ground, fatally hit. This selfenclosed action space is surrounded by a colourful pattern of details that are only recognizable at second glance, and are only displayed in truncated form: a modern and complex bridge structure, a church, a view of a village surrounded by fields, the head of a woman and directly behind the huntsman - a woman propped up on a construction, who attends the event like a spectator. Only the figure of the huntsman lends the picture readable stability; the fragments accompanying him could be read as references to the social situation as le Fauconnier saw it. Unlike with Fernand Léger, who often used the theme of smoke in his pictures to stand for a progressive element of

industrial growth, the smoke in Le Fauconnier's painting accompanies the destructive act of hunting.

Guillaume Apollinaire highlighted the work of Le Fauconnier in his critique of the salon exhibition, which appeared on March 20, 1912 in "Le Petit Bleu", a newspaper distributed in the north of France: "Le Fauconnier's picture *The Huntsman* shows the greatest artistic effort in the Salon. If he had dared to tackle a larger topic, he would have had to be counted among the very best artists because of his originality, and the strength and variety of the colours."

Between 1909 and 1911 Le Fauconnier was a member of the group of artists Neue Künstlervereinigung München, which organized three important exhibitions in the Galerie Thannhauser in Munich. After the Neue Künstlervereinigung München broke up, the Blauer Reiter developed out of the international group around Alfred Kubin, Vladimir von Bechtejeff and Erma Bossi, which in 1911/1912 likewise had its first exhibition in the Galerie Thannhauser, but to which Le Fauconnier did not belong.

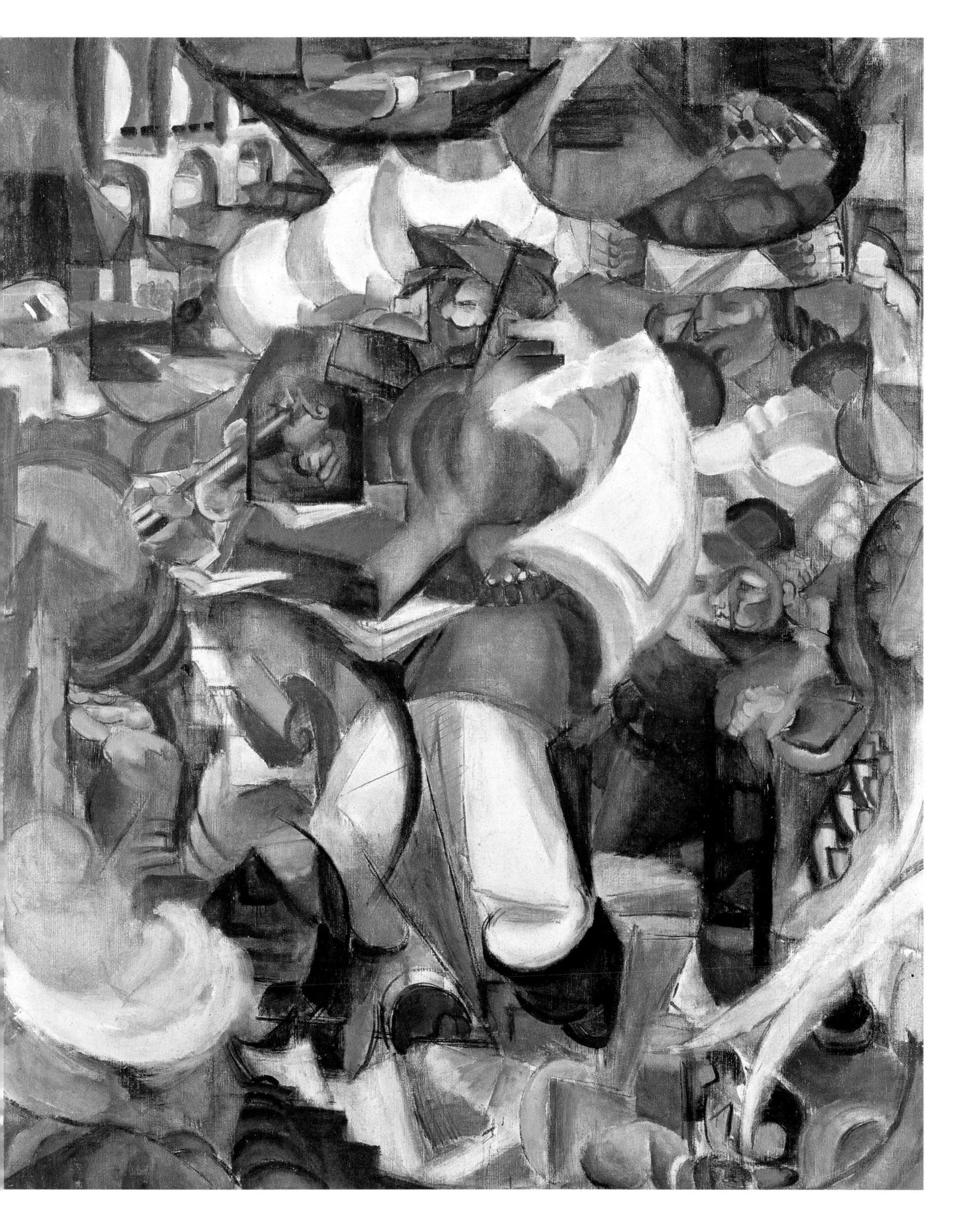

PABLO PICASSO

Maquette for Guitar

October 1912, cardboard, with string and wire (restored), 65.1 x 33 x 19 cm

New York, The Museum of Modern Art, Gift of the artist

Georges Braque and subsequently also Pablo Picasso experimented with mixing sand with their paint. In October 1912 Picasso created his first open-form construction, *Guitar (La guitare)*. In the same month Picasso completed a model made of cardboard, string and wire; the final version of *Guitar* made of sturdier sheet metal, string and wire was completed in the winter of 1912/13. The guitar is a motif that appears frequently in Picasso's work. With the object sculpture *Guitar* of 1912 Picasso again paid tribute to the instrument, which represents, as formulated by the art historian Werner Spies, the "visual world of the female body".

Guitar was created before the first series of "papiers collés", on which Picasso began work in the autumn of 1912. In a letter of October 9, 1912 Picasso wrote to Braque: "I am availing myself of your newest paper and sand process. Right now I am devising a guitar and am using a little earth on our hideous canvas. I am very pleased that you feel well in your Bel-Air villa. As you see, I have begun to work a little." Even today it is still not known whether Picasso's statement referred to his "papiers collés" or to the object sculpture.

The draft version of Guitar hardly differs from the final version. Since Picasso left the maquette and the object sculpture to the New York Museum of Modern Art as donations, it is possible today to compare both works directly with one another. In the final version the unstable cardboard material gives way to sturdier sheet metal, which brings the most obvious change with it. The intersections and cut edges in sheet metal are clearly discernable and have led to jagged areas, which in places divert the gaze upon the entirety of the construction. Thus only slight differences, mostly attributable to differences in materials, can be made out. The material of the maguette permits a more animated play of light and shadow on the surface, while the sheet-metal version seems to swallow the light. It's unclear whether Picasso had already finished both versions at the time about which the art critic André Salmon reports: "As Picasso, before the 'papier collé', hammered the sheet metal in order to produce the famous 'Guitar', three times as large as a genuine guitar and with wire strings, he said to me: "You will see; I will keep the large Guitar for

myself, but I will sell the model; everybody else will be able to do the same."

With the exception of *Head of a Woman (Fernande)* and the different versions of his *Absinthe Glasses*, Picasso's sculptural works from the Cubist period are wall mounted. They must be hung or installed in the corner of a room. Picasso found himself in the process of granting the objects or materials the space they were entitled to again. In the "papiers collés" the materials and incorporated fragments only stand for what they actually are. In the objects the materials are given the space they would have to take up, as related to the body they are supposed to represent. If André Salmon recalls a Guitar "three times as large", it has to be considered whether Picasso possibly tried to make the maquette far larger at first than we see it now in the surviving version in the Museum of

Modern Art.

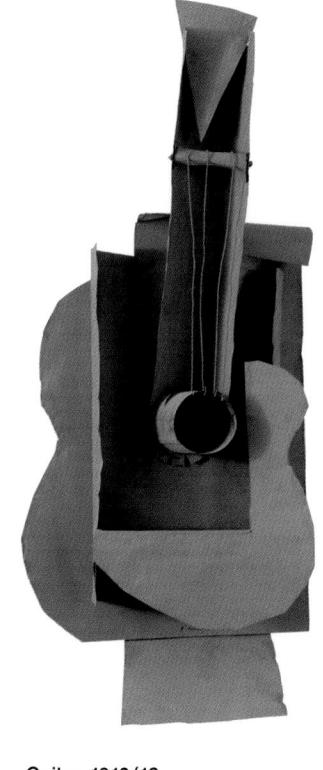

Guitar, 1912/13

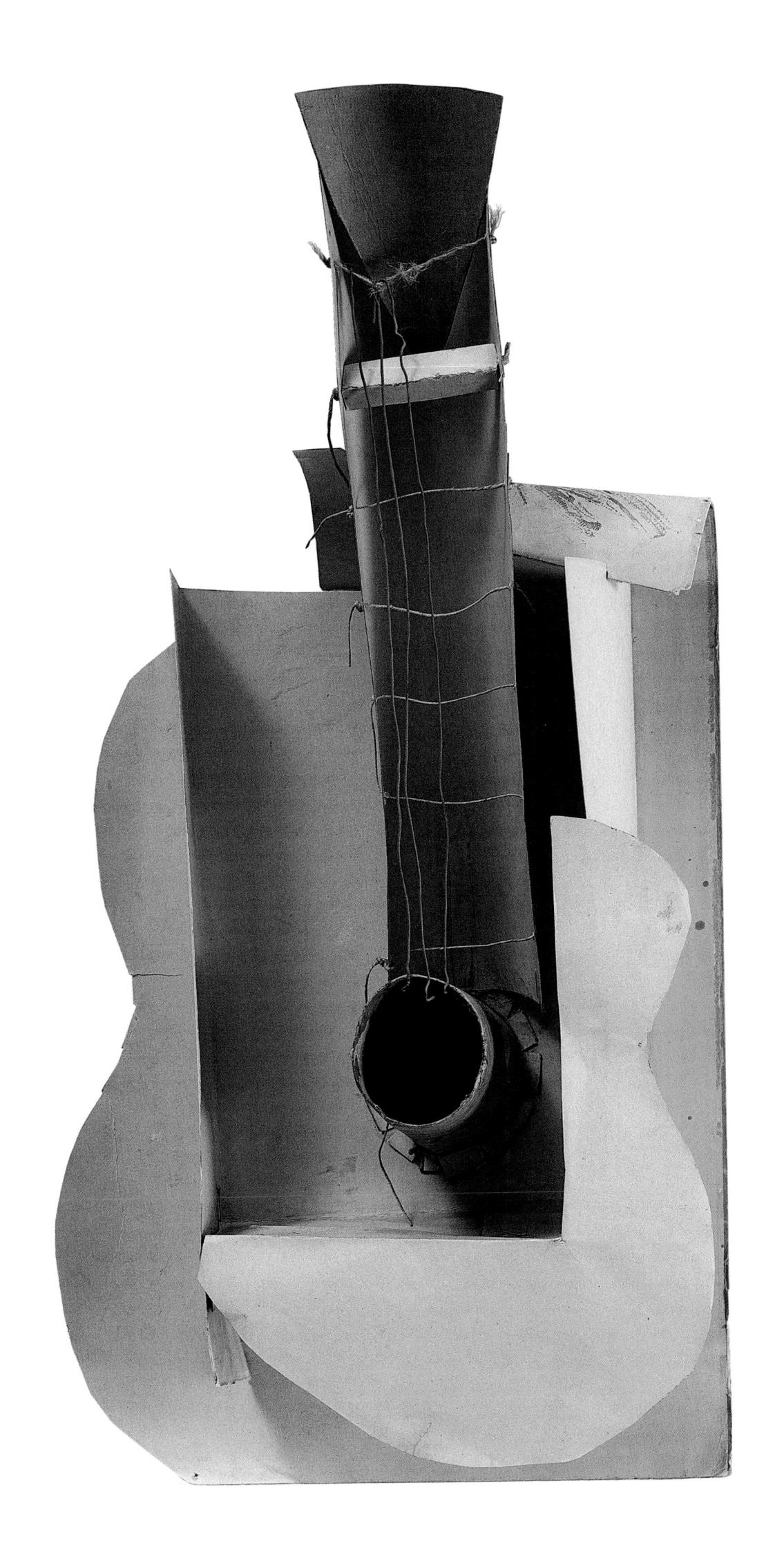

Bowl of Fruit, Bottle and Glass

1912, oil and sand on canvas, 60 x 73 cm *Paris, Musée national d'art moderne, Centre Pompidou*

At the end of July or beginning of August 1912, Georges and Marcelle Braque reached the town of Sorgues in the South of France, where Pablo Picasso and his girlfriend Marcelle Humbert were as well. From then on Picasso called his companion Eva, to avoid confusion.

From there Georges Braque wrote on August 16, 1912 to his dealer Daniel-Henry Kahnweiler in Paris: "I have now settled myself here, after looking around a little in Marseille. I have returned to Sorgues, it lies in Provence and that is enough for me. I live on a farmstead with beautiful old, whitewashed walls, as is usual in France. I spend pleasant evenings with Picasso by the fire. The only thing missing is Prince Borghese. We bought some African sculptures in Marseille. They are not bad, as you will see. I have begun to work again with great enthusiasm, for I had not had a brush in my hand for ten days. I have begun a figure and a still-life, but allow me to be discreet about this (as Massenet would say)."

The still life *Bowl of Fruit, Bottle and Glass (Compotier, bouteille et verre)* was created in 1912 in Sorgues, which the word fragment "SORG" that Braque integrated into the work in stencilled lettering also refers to. Letters and words become part of the artist's paintings again and again after August, 1911. They serve as spatial points of reference, to mark planes.

In Sorgues Braque first began to include different materials besides paint in his pictures – such as paper with imitation woodgrain and sand. To be able to make these experiments in peace, he waited until Picasso had left for a few days. After his return, Braque initiated his friend into his newly discovered techniques. Relatively soon thereafter Picasso began comparable experiments. Silvia Neysters remarked in the exhibition catalogue "Die Sammlung Kahnweiler. Von Gris, Braque, Léger und Klee bis Picasso" (The Kahnweiler collection. From Gris, Braque, Léger and Klee to Picasso) regarding Braque's work: "The still life 'Bowl of Fruit, Bottle, and Glass' is one of the first works in which oil paint was mixed with sand, to give the painting a new material quality."

It is possible that this picture was one of the works the dealer Daniel-Henry Kahnweiler reacquired in the forced auction of his

seized works of art. In 1914 Kahnweiler had had to leave Paris because of his German origins. His art collection was confiscated as enemy property; about 700 works were sold in the Hôtel Drouot auction house in the years 1921, 1922 and 1923. Braque was very upset about this action by the French state and according to witness reports he took Kahnweiler's side in his own, thoroughly physical manner, Isabelle Monod-Fontaine of the Centre Pompidou reconstructs the scene: "On June 21, 1921, on the day before the first auction, he punched Léonce Rosenberg in the nose. In his opinion Rosenberg, who was to become his art dealer in 1923, was responsible for this overhasty sale of artworks. Braque was taken away to the police station. Perhaps this was the reason that he preferred not to participate in the following auctions."

Monder and das grand
Chose de nouveau a garques.
Le calme le plus complet
Mous fairens brancoup
de Cuisine avec d'icasso
Mons avons en l'entre doir
l'ajo Hanco" plat spagnol come
son nonl'indique nous avons
beau coup regretté que nous n'ayo
procété la pour partager avec
rous cette modestes mais succelente
l'ajollanco est un l'escricie prisent, siglei
pour aucis contre les mondes,

Page of a letter from Georges Braque to Daniel-Henry Kahnweiler, 1912

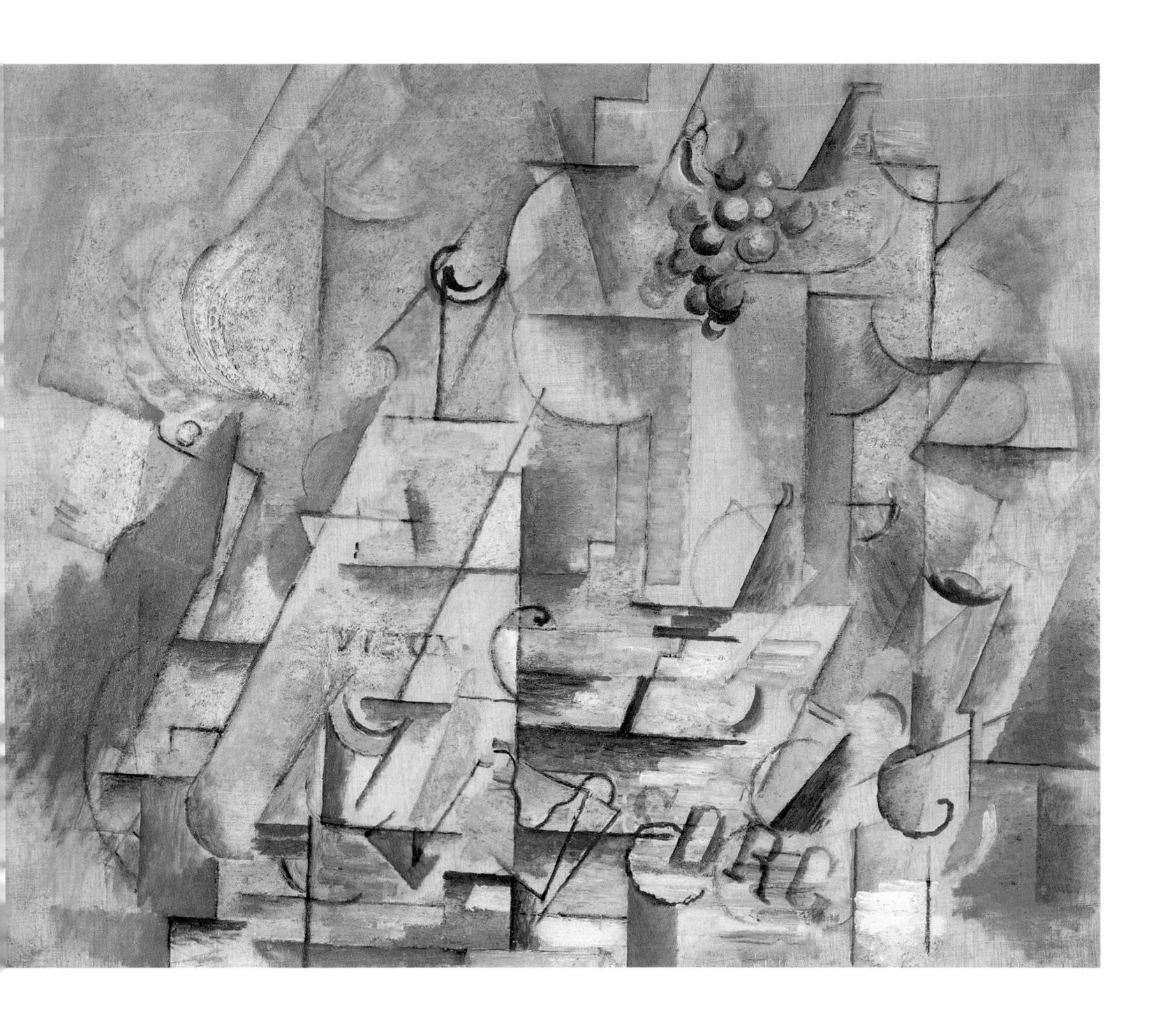

ALBERT GLEIZES

The Cathedral of Chartres

1912, oil on canvas, 73.6 x 60.3 cm *Hanover, Sprengel Museum*

"People crowded into our room, they shouted, they laughed, they got worked up, they protested, they luxuriated in all kinds of utterance."

Albert Gleizes on the exhibition at the "Salon d'Automne"

b. 1881 in Paris,d. 1953 in Avignon

Albert Gleizes had been involved in the important Cubist exhibitions since 1910: That was the year he had participated for the first time in the "Salon des Indépendants" as well as the "Salon d'Automne" presentation. In 1911 some of his pictures were to be seen in the "Karo Bube" exhibition in Moscow, and Gleizes also exhibited together with Fernand Léger in the presentation "Les Indépendants" in Brussels. Together with Jean Metzinger he authored the

book "On Cubism", which appeared in 1912 from the Parisian publishing house Figuière, and is considered the first comprehensive publication about Cubism. In their writings, they both stress the difference between the so-called "Salon" and "Gallery" Cubists.

Thus in his text "Chronicles of Cubism" from 1928 Gleizes writes: "Braque and Picasso exhibited only in the Galerie Kahnweiler, where we ignored them." As the group of Cubists he names only Jean Metzinger, Le Fauconnier, Fernand Léger, Robert Delaunay and himself. Moreover he noted: "On the one hand there is the work of a Braque or a Picasso, to whom one must also count Juan Gris; who live and work for themselves, who have already been ensnared by the art dealers, who have gone through the analysis of volume and of the object, and who are getting close to the actual substance of painting, the plastic nature (nature plastique) of the flat plane. On the other hand, in the breach, in the midst of the commencing turmoil of battle, are Jean Metzinger, Le Fauconnier, Fernand Léger and I myself; we are internally preoccupied with investigations about weight, density, volume, analysis of the object; we study the dynamics of line; we finally capture the true nature of the plane."

The book "On Cubism" by Albert Gleizes and Jean Metzinger made them more widely known than their paintings had been able to achieve previously. In their book they state programmatically: "At the risk of condemning the whole of modern painting we must consider only Cubism as suitable to lead painting forward. We must see it as currently the only possible conception of compositional art. To express it differently: Cubism at present is painting itself."

Gleizes' painting *The Cathedral of Chartres (La cathédrale de Chartres)* of 1912 is comparable with Georges Braque's series *Castle at La Roche-Guyon.* In choosing the famous High Gothic Cathedral of Chartres, located approximately 80 kilometres southwest of Paris, Gleizes also selected a prominent building as a pictorial subject, which he depicted in a reduced colour range of grey and green tones. The architectural forms are only very hesitantly reduced or fragmented. The shadows painted in dark green appear to reproduce the real effects of the fall of light.

Although their pictorial language was generally less radical than that of the so-called "Gallery Cubists", Metzinger and Gleizes saw themselves induced again and again to defend their art: "Some people – and not only the least intelligent – see the intentions of our methods as exclusively the study of volume. If they would add that it would suffice to reproduce an outline, since the planes delimit volumes and the lines delimit planes, then we could admit that they were right; but they restrict themselves to a pursuit of the impression of relief, which we judge to be insufficient. We are neither geometricians nor sculptors. For us lines, planes and volumes are only nuances of the experience of abundance. To simply copy the volumes would mean to deny these nuances in favour of an extraordinary monotony. We could just as well immediately renounce our yearning for variety."

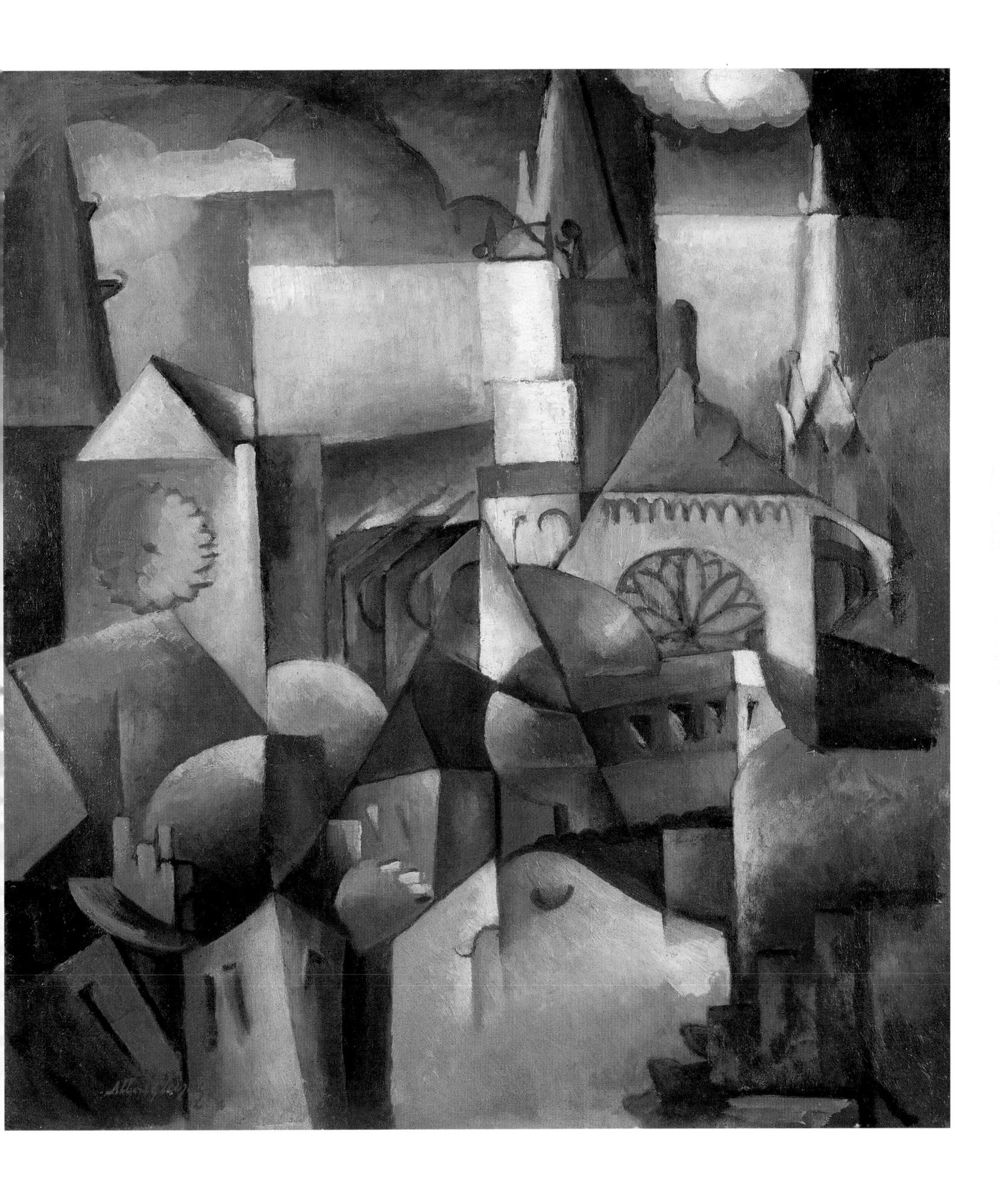

JEAN METZINGER

The Bathers

1912, oil on canvas, 148 x 106 cm Philadelphia, Philadelphia Museum of Art, The Louise and Walter Arensberg Collection

Albert Gleizes and Jean Metzinger wrote in 1912 in their book "On Cubism": "To understand Cézanne is to foresee cubism. Even now we can assert that between Cubism and the previous methods of painting there is only a difference of intensity, and that – in order to assure ourselves of this – we only have to study the process of the interpretation of this reality, which beginning with Courbet's superficial reality, plunges ahead with Cézanne to a deeper reality by pushing back the absolute."

Metzinger later qualified these remarks in his text "La naissance du cubisme" (The birth of Cubism): "Thus for example while writing our work 'On Cubism' Gleizes and I gave in to general opinion and placed Cézanne at the beginning of this way of painting."

Metzinger painted his picture *The Bathers (Les baigneuses)* in 1912. In this year 31 artists joined together to form a Cubist exhibition group called Section d'Or, from the Golden Section theories of proportion. These included, for example, Robert de la Fresnaye, Albert Gleizes, Juan Gris, Auguste Herbin, Fernand Léger, André Lhote, Jean Metzinger and Jacques Villon. Pablo Picasso, Georges Braque and Robert Delaunay did not take part in the movement. Gleizes recalled in 1928: "Also in the winter of 1912 the 'Section d'Or' exhibition took place in Paris, the most important private event of that time, which united the best forces of the generation who all consented to appear under the banner of Cubism."

Metzinger's painting testifies to the artist's intensive preoccupation with the different variations of Paul Cézanne's *Bathers* as well as with the Cubist depictions of nudes by Pablo Picasso, above all the picture *Les Demoiselles d'Avignon*. The bathers from which the picture takes its name, however, occupy only a small section of the vertical-format picture. Two female nudes in front of a landscape can be recognized at the lower edge of the picture. In the upper third of the picture a railway bridge pierces the natural space. Behind it extend a number of architectural details, the outside forms of which in turn become horizons, upon which isolated trees stand.

With *The Bathers* Metzinger took up a motif from art history, which he used to test new design possibilities. True to the stylistic

devices of Analytical Cubism, he fragmented the closed volumes of bodies, trees and architecture. The inclusion of the train bridge refers to a corresponding detail in Henri le Fauconnier's picture *The Huntsman*, produced a short time previously. Comparable to Le Fauconnier's intention, Metzinger may also have been using the architectural fragments in the picture, which form a counterbalance to the bathing women, to refer to the diversity of social and technical progress.

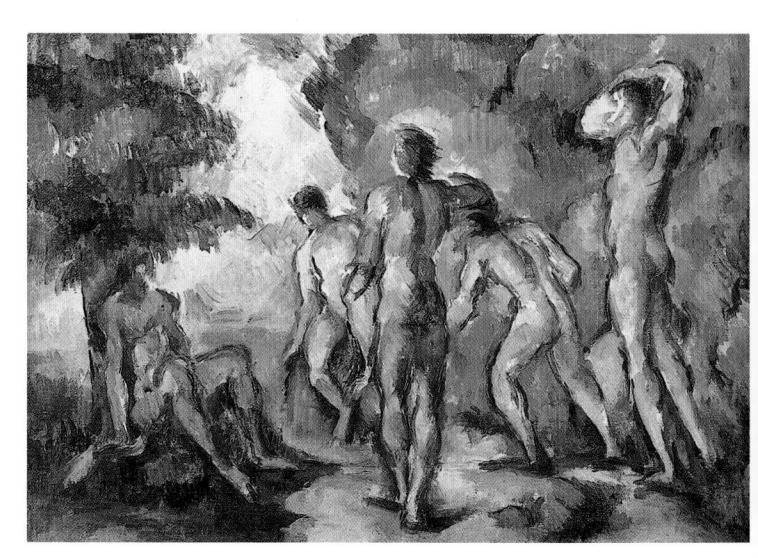

Paul Cézanne, Five Bathers, 1892-1894

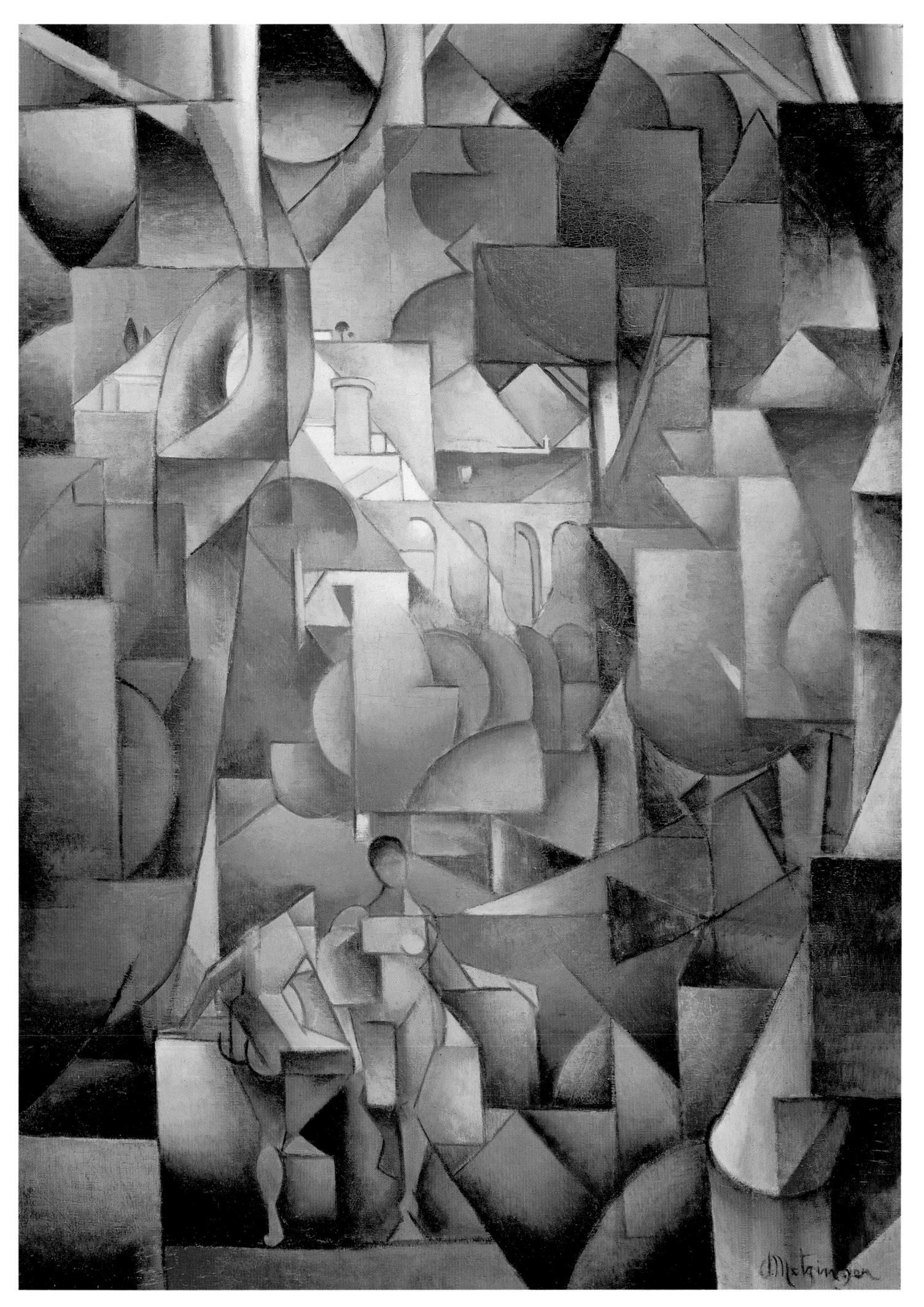

FERNAND LÉGER

Smoke

1912, oil on canvas, 92 x 73 cm Buffalo, Albright-Knox Art Gallery, Room of Contemporary Art Fund, 1940

The subjects of Fernand Léger's paintings, which were geared to technology and contemporary life, enrich the Cubist vocabulary of motifs. Léger was receptive and positively inclined towards urban industrial society. In 1913 he emphasised: "Since painting is part of the visible world, it is necessarily a mirror of external conditions and not psychological ones. Every work of painting should contain this value in contemporary life and an eternal value that constitutes its validity, even independently of the epoch of its creation." Léger made this subject matter public in his pictures even before the time of his dynamic Futurist works. In contrast to the analytical fragmentation of industrial forms, which Léger carried out with Cubist stylistic means, his handling of colour must be seen as unique within Cubism.

In 1910, together with his artist friend Robert Delaunay, Léger visited the Galerie Kahnweiler where they saw a number of Cubist pictures: "There, in surprise before their grey pictures, we cried out together with the great Delaunay: 'But these guys paint with cobwebs!' That gave a bit of relief to the situation. When I spoke to Apollinaire and Jacob, I saw the contrast between them and me."

Elsewhere Léger remarked: "Cubism, which is to be understood as a necessary reaction, began as grey in grey and became open to colour only a few years later. But local colour with its far more powerful colour intensity then recaptured its old position. If Impressionism, for example, plays red against blue it doesn't 'colour', rather it constructs, and its frail construction is not capable of fulfilling two functions at the same time (namely those of colour intensity and hue); the result is 'grey."

Léger did not necessarily feel secure about his handling of colour, which must be interpreted as contrary to that of the other Cubists. He recalls: "When I had captured the volume the way I wanted it, I began to place the colours. But that was difficult! How many pictures have I destroyed ... Today I would be happy to look at them again."

At the end of 1910 or beginning of 1911 Léger left the Parisian artist colony La Ruche. He then lived and worked in a loft studio in the rue de l'Ancienne Comédie. The series *Smoke over Rooftops* is clearly influenced by the view out of his new window of

the Notre-Dame church and buildings in his neighbourhood. This is where he encountered the smoke rising from the chimneys, which gave the pictures name: *Smoke (La fumée)*.

Regarding his vocabulary of form for representing smoke amongst the rigid architecture, Léger wrote: "Contrasts = dissonances, and consequently maximum effectiveness. I take the visible impression of rounded smoke masses rising between buildings and transform this impression into plastic values. That is the best example for the application of the principle of self-augmenting, multifaceted physical dimensions. I place these curves in as diversely eccentric a manner as possible without, however, their unity becoming lost; I interleave them into the hard and dry structure of building walls, of dead surfaces, which nonetheless are made dynamic by the fact that they form a colour contrast with the mass in the middle and a counterpoint to the animated forms: this results in maximum effectiveness."

"Art is subjective. We are agreed on that. But of a controlled subjectivity, based on an 'objective' raw material. This at least is my unshakable conviction."

Fernand Léger
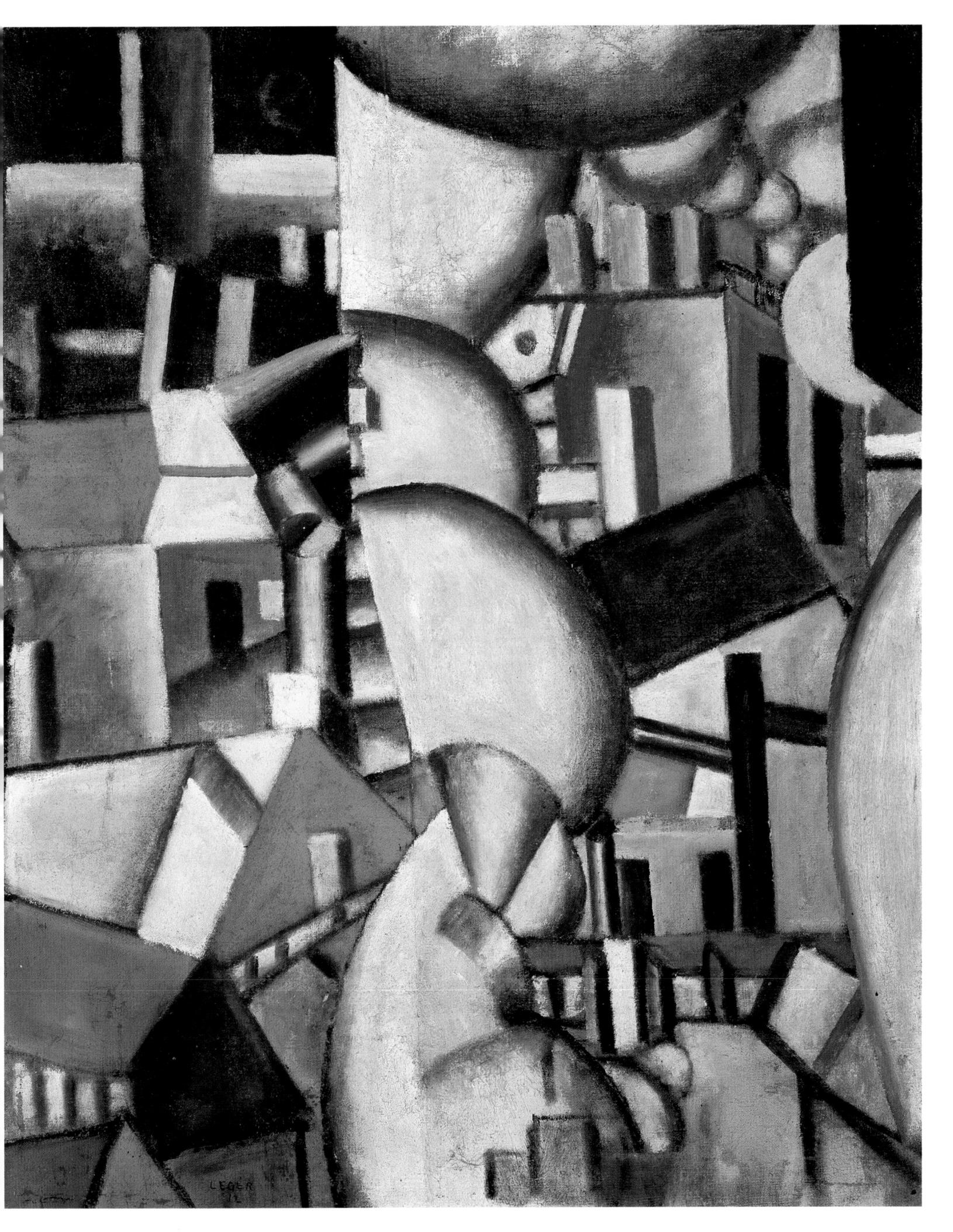

The Smoker

1913, oil on canvas, 73 x 54 cm Madrid, Museo Thyssen-Bornemisza

During August 1913 Juan Gris left Paris and travelled to Céret, where he met Pablo Picasso and the Spanish sculptor Manolo. During this time Gris began an intensive exchange of letters with his dealer Daniel-Henry Kahnweiler. Kahnweiler used the letters, which he quoted in excerpts, for his famous book "Juan Gris. Sa vie. Son Œuvre. Ses Écrits" (Juan Gris. His life. His œuvre. His writings), which appeared in 1946 in the Paris publishing house Gallimard.

By Kahnweiler's estimation, Gris' work gained in simplicity and clarity during his stay in Céret. About the pictures that the artist brought back with him from his summer sojourn, Kahnweiler noted: "How strictly Gris adhered to the theories to which his reflections had led."

The Smoker (Le fumeur) is one of the pictures created in Céret. Intensely bright colour planes are arranged around an imaginary picture centre, which is approximately at the height of the nose. Dismembered fragments of a head can be guickly recognized such as, for example, an eye with eyebrow, the auricle of an ear, and a hat. The hat appears composed in black in the left half of the picture, interrupted by a green plane of colour, and then formulated in blue somewhat further to the right. This suggests a radius of movement for the head. The white collar at the head's neck is portrayed once frontally, and a second time from the side with the inclusion of a hairline. In this way the picture unites different perspectives with one another and records the movement. The colours are applied without strong shading, so that the colour planes appear to be arranged next to each other equivalently. The surface ornamentation only gains volume if the readable details are pieced together to form a head. Only the smoke of the cigar moves upward without being affected by the segmented colour planes.

The art historian Werner Hofmann stated appropriately: "The problem of making all picture zones equivalent, thus eliminating the formal and objective rank difference between the 'intended' forms and the intervals lying between them; this problem would occupy Analytical Cubism from then on and first experience its solution in the work of Juan Gris."

A sketch created in the design phase of this picture contains a dedication to the American amateur painter Frank Burty Haviland,

During August 1913 Juan Gris left Paris and travelled to Céret, who had also been portrayed smoking by Amedeo Modigliani in 1914. he met Pablo Picasso and the Spanish sculptor Manolo. During It is very probable that Haviland was also Gris' smoker.

Following Gris' stay in Céret Kahnweiler and he became even closer, as the dealer recalls: "From that time on I saw Gris frequently. He often picked me up in the evening from the rue Vignon and accompanied me to the Place de la Concorde, where I took the Seine steamer to Auteuil. He visited us in the rue George Sand, and I spent whole mornings with him in the rue Ravignan. ... The better I got to know the modest but determined Gris, the greater became my admiration and affection."

The Smoker, 1912

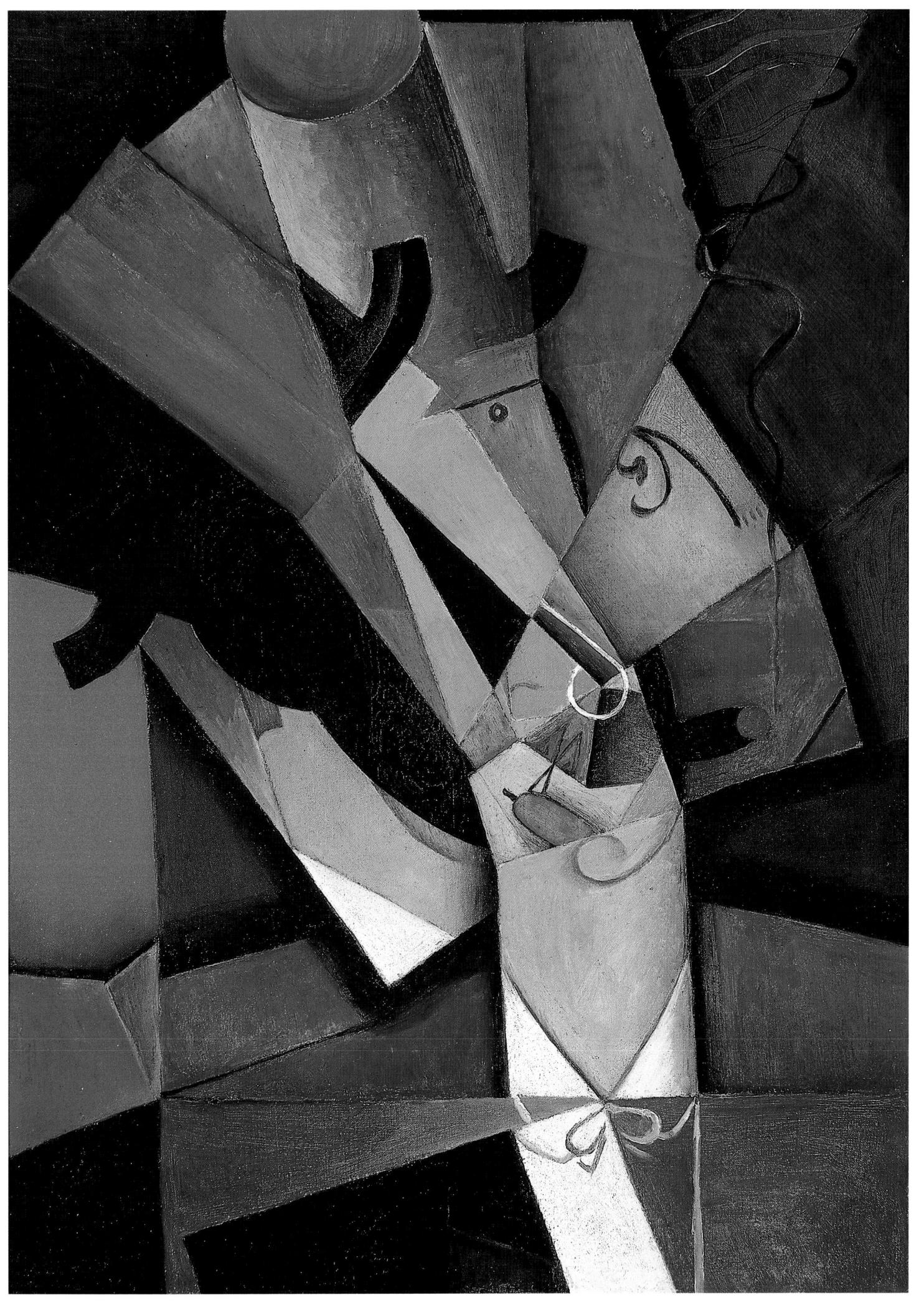

JUAN GRIS

The Guitar

May 1913, oil and paper on canvas, 61 x 50 cm *Paris, Musée national d'art moderne, Centre Pompidou*

Juan Gris created the painting *The Guitar (La guitare)* in May 1913, even before his departure for Céret where he was to work together for some weeks with Pablo Picasso and the Spanish sculptor Manolo. The picture is dominated by a structure of vertical lines; the parallelism with the strings of the guitar, which is standing upright, lets the viewer find his way back to the picture's subject again and again. The strips, triangles and rectangles composed in muted colours fragment and shift the instrument, and finally the outer contours of the sounding body manifest themselves as a background contrast. Only the colour planes in the right lower area of the picture and the fragment of a 19th century steel engraving mounted in the upper left distract from the simple legibility of the picture's title.

The marbled planes in red-brown tones make up the only area in the picture that is not structured clearly and straightforwardly. Only the outside contours follow the shape-defining forms. The picture within a picture is in alignment with the arrangement of longitudinal strips, and at the original right and left edges of the painting it has been cut off or overpainted. The longitudinal strip on the left bordering the edge of the picture is overlaid by a triangle and thereby, like an open curtain, allows a view of the rural scenery in which a mother and child move. The concept, invented by Gris himself, of a "planar architecture" can be particularly well understood in this work.

There are comparable works by Gris in which he inserts materials whose real presence is retained in the picture — which is different again from imitation wood paper or a piece of wallpaper intended to represent the materiality of something else. Another example is Gris' painting *Violin and Engraving* of 1913, which today is in the Museum of Modern Art in New York. As announced in the title, Gris has also mounted an old engraving into this picture. In this connection Kahnweiler asked appropriately: "Why simulate things, which one can really show?"

After Picasso and Georges Braque, Gris is considered one of Cubism's main exponents. His achievement lies in the continuation of Analytical to Synthetic Cubism, in which he integrated the newly developed principles of design into a rational system.

In his book "Grundlagen der modernen Kunst" (Foundations of modern art) Werner Hofmann describes an aspect of Gris' significance for Cubism: "In its analytical phase Cubism takes a vacillating position towards both the object and the picture. The Spaniard Juan Gris made a crucial contribution to the clarification of this ambiguous situation, where no clear decision was made either for material content or form content. Together with Picasso and Braque he tried from about 1913 on to reconcile the requirements of picture geometry with those of the world of experience. That meant that the now-independent design techniques were to be reintroduced to something objective, without forfeiting their autonomy thereby. This 'turnabout' from one function to the other is ultimately carried out and sanctioned by the viewer's perception: it is his decision whether he wants to refer a certain structure of lines or planes to material content or not."

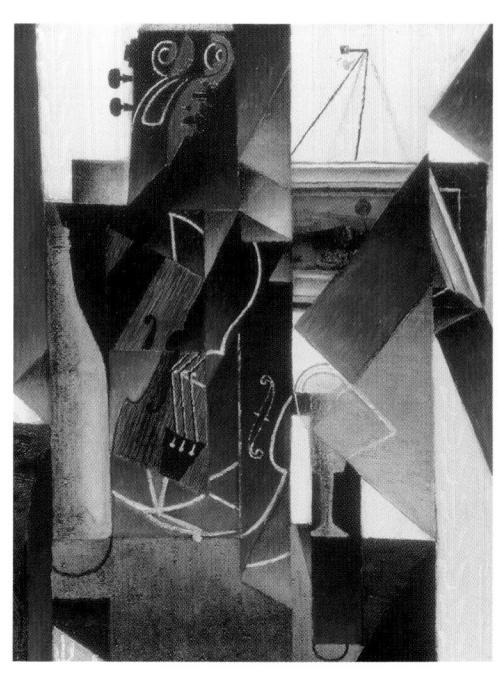

Violin and Engraving, 1913

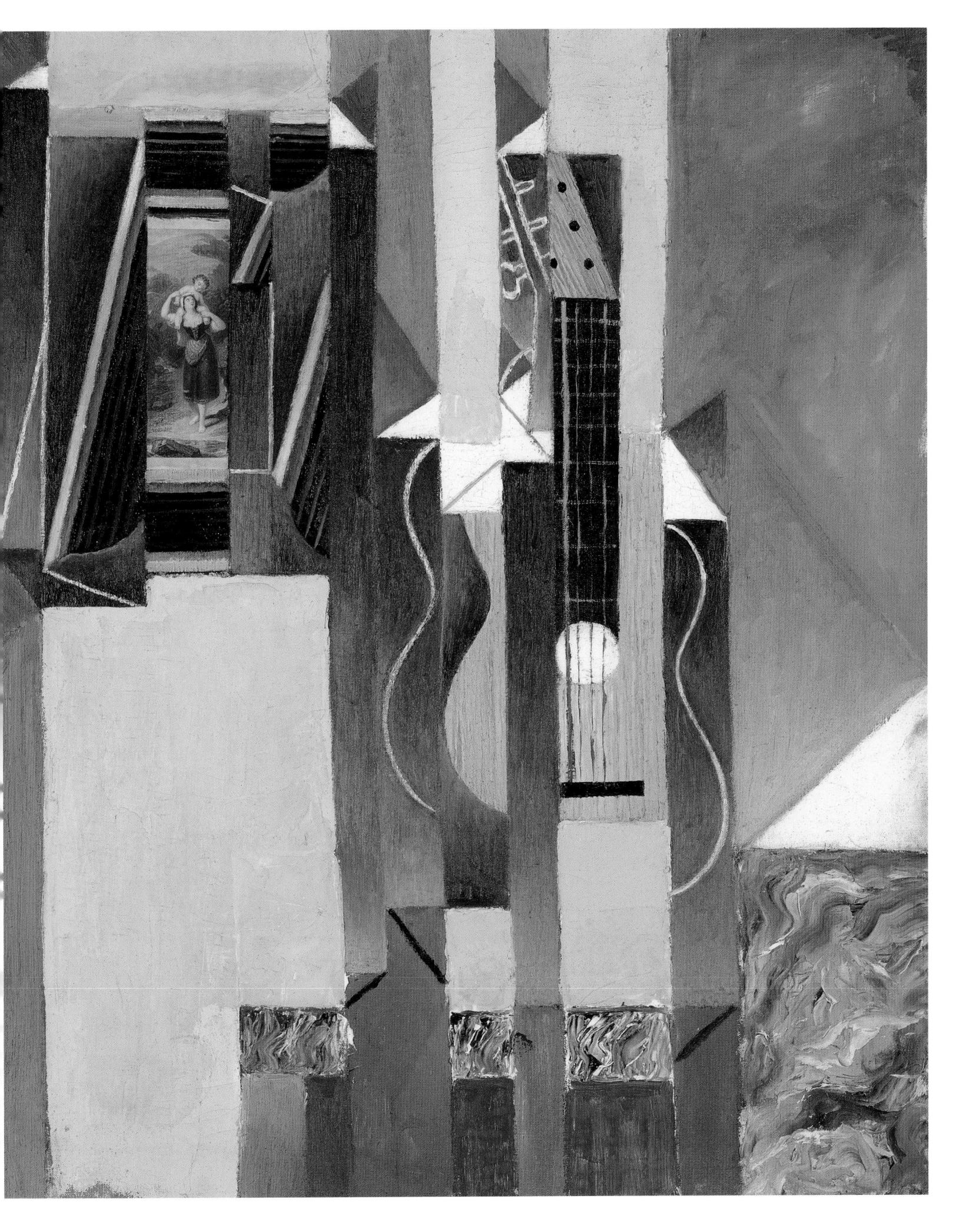

PABLO PICASSO

The Guitar

1913, oil on canvas, 116.5 x 81 cm Düsseldorf, K20 – Kunstsammlung Nordrhein-Westfalen

It is notable that Pablo Picasso and Georges Braque, in their close friendship and artistic exchange, worked on the same picture motifs at the same time. In the year 1913 musical subject matter predominates. After the *Guitar* that Picasso created as a wall object the previous year in cardboard and subsequently in sheet metal, he produced a whole sketch book, a series of drawings and collages, and several paintings depicting the instrument.

In this series the picture *The Guitar (La guitare)* of 1913, today in Düsseldorf, is particularly noticeable for its coloration and design. Picasso here transfers the techniques of collage into oil painting. The planes of colour arranged in contrasting red and violet tones are provided with a cast shadow in a few places, creating the impression of an elevated material mounted on the canvas. In this picture Picasso makes reference to the previously developed "papiers collés", with which he and Braque had intensively occupied themselves in 1912.

Now Picasso composed his picture using variously formulated colour planes, as if they had been set one upon the other, as though glued or mixed with various materials such as sand. Picasso only suggests the title motif with clearly placed outlines. In this work Picasso takes leave of the illusion of pictorial space, there is only a spatiality left which the laid-down colour planes appear to take up, and which gives the image a relief-like character. The picture shows Picasso's renewed interest in coloration, which was to become typical of so-called Synthetic Cubism.

Throughout his life Picasso remained unimpressed by the breakdown of Cubism into different phases. In retrospect he emphasised: "The various methods that I used in my art should not be understood as a development or as stages toward an unknown painting ideal. Everything I ever made was made for the present and in the hope that it would always remain vital in the present. I never bothered myself thereby with investigations. If I found something I wanted to express, then I did it without thinking of the past or the future. I do not believe that I used entirely different elements in the various methods of my painting. If the objects that I wanted to represent required

another mode of expression, then I never hesitated to adopt it. I never made trials or experiments."

Picasso's effect on his contemporaries was immense; thus Max Raphael wrote in 1913 in his text "Von Monet zu Picasso" (From Monet to Picasso): "We have a man before us, whose work is an inner necessity; a spirit who has the courage to recognize his own depths and requirements, and the strength to approach them step by step. I do not know whether the deep honesty of the man and artist, or this uninterrupted consistency in his development is to be the more admired."

Photographic composition, 1913

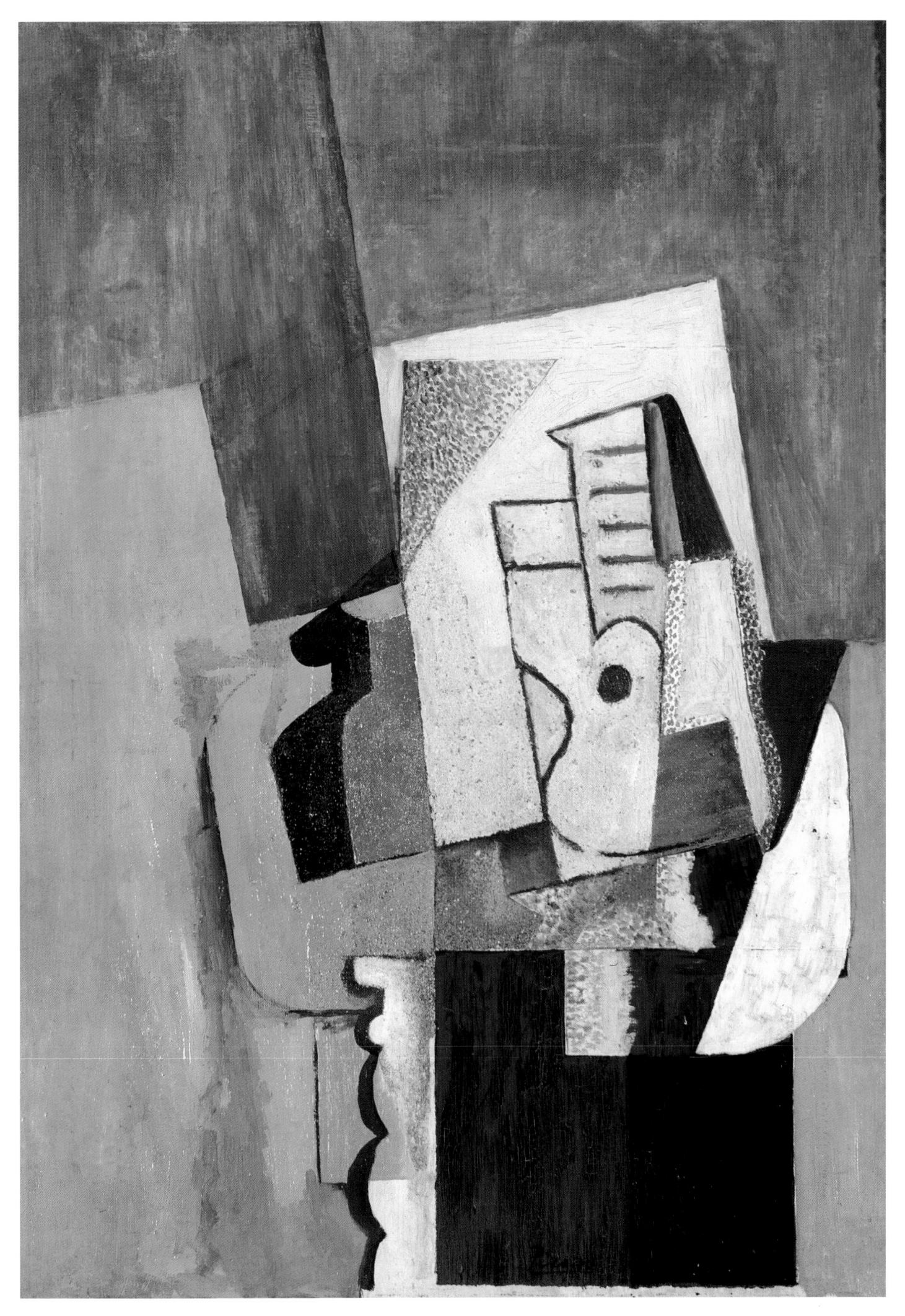

FERNAND LÉGER

Still-life with Colourful Cylindrical Forms

1913, oil on canvas, 90 x 72.5 cm *Riehen/Basel, Fondation Beyeler*

Fernand Léger occupies an important position within Cubism, since he extends Cubism's simple subject matter with a new, contemporary topic: the relationship between humans, machines and technology. For him the tube and roller forms stand for the innovations and achievements within a technically oriented society at the beginning of the 20th century. In this sense the "contrasts of forms" frequently appearing in his work are simultaneously still-lifes of machinery. Léger's fondness for integrating basic geometrical forms into his works led to them occasionally being called "Tubism".

In this connection it should be mentioned that Léger was employed until 1904 as a draughtsman with an architectural firm located in Paris. Thus he was thoroughly familiar with the geometrization of architectural forms. Out of this he developed a system using forms composed in primary colours and producing, as singular bodies, a rhythmic structure with the other forms.

Due to the relatively small vocabulary of form with which Léger worked, the coloured versions of the forms were an extremely important design tool for him. Léger stressed: "Colour was a necessary augmentation device for me. In this respect we, Delaunay and I, are sharply different from the others (Cubists). They painted monochromatically; we, polychromatically. But then came my disagreement with Delaunay himself. He continued the line of the Impressionists by using complementary colours, one beside the other, red beside green. I did not want to set two complementary colours next to each other; I wanted to find colours that isolate themselves, a very red red, a very blue blue. If one places yellow beside blue, then that readily produces the complementary colour for red again, namely green. Thus Delaunay arrived at nuance, and I strove directly toward the independence of colour and volume, toward contrast. A pure blue remains blue if it lies beside a grey or beside a non-complementary colour."

In his Still Life with Colourful Cylindrical Forms (Nature morte avec cylindres de couleurs) Léger groups tubes, funnels, cubes, discs and drop-like forms with one another. With the exception of white and black shading, which lends the forms their volume, they are composed exclusively in the primary colours red, blue and yellow.

Placed one upon the other the forms represent imaginary machines, resembling futuristic architecture. In these pictures Léger completely renounced figurative and natural forms of representation, and placed the dynamics of the new technology into the focus of his pictures. The machines gain aesthetic charm in his works, they are simply beautiful.

Léger had success with his work. Beginning in 1912 he worked closely together with the dealer Daniel-Henry Kahnweiler. In regard to the exclusive contract concluded in 1913 between these two, the artist remarked: "I believe, however, that my mother was never really convinced of the validity of this contract."

"I really wonder: to what do all those more or less historical or dramatic pictures in the French salons want to lay claim, in view of the first cinema screen."

Fernand Léger

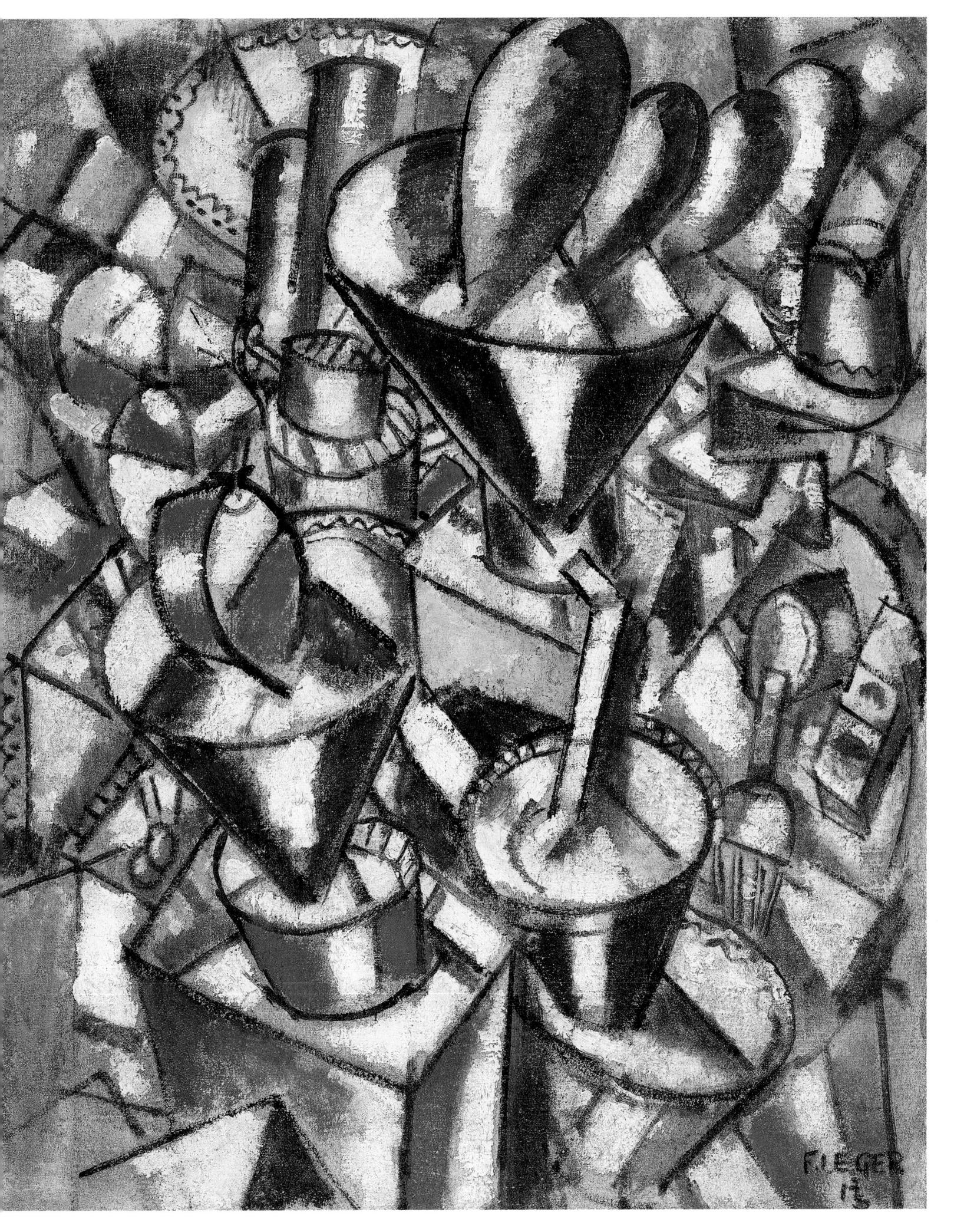

Pipe, Glass, Bottle of Vieux Marc

After January 1, 1914, paper collage, charcoal, india ink, printer's ink, graphite, gouache on canvas, 73.2 x 59.4 cm *Venice, Peggy Guggenheim Collection*

In November 1912 under the influence of comparable works by Georges Braque, Pablo Picasso created one of his first "papiers collés", which carries the title *Pipe, Wineglass, Newspaper, Guitar and Bottle of Vieux Marc.* Picasso composed the picture from various collaged papers and a design of oil and chalk on canvas. The colour of the underlying canvas matches the brownish tones of the papers and the yellowed newspaper. On the canvas Picasso united papers of various former uses: thus at the right edge can be found a piece of wallpaper, whose coloured pattern constitutes the only spot of colour in the picture, which is otherwise dominated by brown tones with black. The other papers applied to the left half of the picture are overlaid upon each other and strengthen the perspective levels in which the guitar is portrayed.

By mid-March 1913 Picasso had already begun work on a new series of "papiers collés", including *Bottle of Vieux Marc, Glass and Newspaper* (charcoal, pasted and pinned paper). For two "papiers collés" created at the beginning of 1914, Picasso used newspaper cuttings from the futuristic magazine "Lacerba" published in Florence, as also in the *Pipe, Glass, Bottle of Vieux Marc (Pipe, verre, bouteille de Vieux Marc)* now in the Peggy Guggenheim Collection in Venice. Braque also used a newspaper cutting from "Lacerba" in his picture *Glass, Bottle and Newspaper* of January 15.

The stencilled lettering and newspaper cuttings that Braque and Picasso liked to integrate into their work at this time were described by Guillaume Apollinaire in his 1913 article "Modern painting": "Picasso and Braque began using lettering from signs and other inscriptions, because in the modern city the inscription, the sign and the advertisement play a very important artistic role and are suitable for use in a work of art. Sometimes Picasso dispensed with the usual paints and made relief pictures from cardboard or from pieces of paper stuck together; he proceeded according to a three-dimensional inspiration, and these strange, rough materials that were not well suited to each other became noble, because the artist gives them his gentle and strong personality."

The last months before the outbreak of the First World War were among Picasso's most productive working phases. Nikolai A.

Berdyaev notes in his text "Picasso" from 1914: "Today we are not approaching a crisis in painting – a crisis, such as there has sometimes already been – but the very epitome of painting crises, of art itself. In front of Picasso's pictures I came to the realization that something evil is at work in the world, and I felt mourning and pain over the downfall of the old beauty of our world, but also joy over the birth of something new. That is high praise for Picasso's creativeness."

"I am always in movement. I look around. I am assigned a place, but I have already changed, I am already somewhere else. I never stand still. Down with style! Does God have a particular style?"

Pablo Picasso

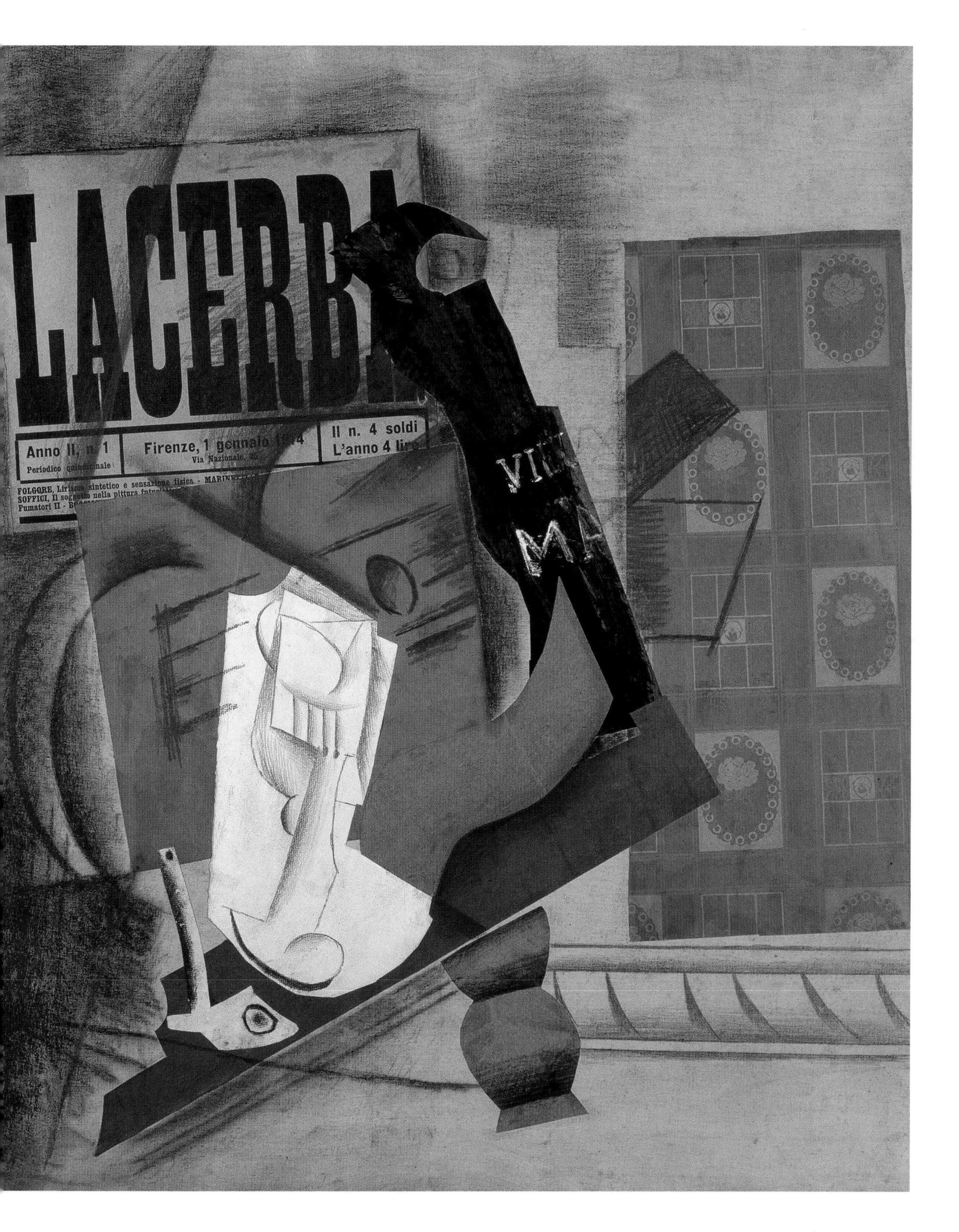

GEORGES BRAQUE

Pipe, Glass, Dice and Newspaper

After January 26, 1914, charcoal and pasted paper, 50 x 60 cm *Hanover, Sprengel Museum*

Since the work of Georges Braque and Pablo Picasso in the year 1914 did not enjoy great demand to be exhibited, monographic publications about their work must have been of singular importance to the two artists. In April 1914 to accompany a text about him in the magazine "Soirées de Paris", Guillaume Apollinaire published eight pictures by Braque. Included among these was also a series of his latest still-lifes. Previously, both Picasso and Braque had constructed pictures from rigorously outlined colour planes. Superimposed upon one another, these were intended to suggest spatial depth to the viewer.

Braque's still life *Pipe, Glass, Dice and Newspaper (Pipe, verre, dé et journal)* testifies to Braque's unusual skilfulness in the stylistic idiom and in the picture's overall construction. The detail motifs: the selected fragment of a newspaper page, drawn pipe, dice depicted from several perspectives, and glass drawn across two pieces of coloured paper, are rendered in a much reduced form. The art historian Werner Spies emphasizes the different uses which Braque and Picasso made of pasted newspaper clippings: "With Braque, such models from the material world must primarily replace brushwork; they remain facsimiles of the small-sectioned Cubist geometrization. With Picasso the same move leads very quickly to semantic conversions and visual jokes. ... Picasso resorts directly to the accidental."

At this time Braque began to compose his pictures such that they no longer filled their formats. On this horizontal-format picture the objects presented to the viewer are placed economically and in a concentrated manner within an open oval area. While this plane suggests a table it is given no spatial context, since it is embedded in a grey-beige colour plane. Realistic motifs combine here with initial abstractions.

The poet Pierre Reverdy, Braque's friend, recalls: "In 1917 I visited him in southern France near Avignon. One day, as we went from Sorgues through the fields to the small village in which I lived, Braque carried one of his paintings on a stick over his shoulder. We stopped. Braque put the picture on the ground between stones and grass.

Something baffled me, and I said to him: 'Amazing, the way it holds its own against the colours of reality and the stones'. Since then it's been clear to me that it was above all a matter of finding out whether it would continue to hold its own, even against hunger. Today I can say yes, it could persevere, even against a whole range of other things because pictures are afraid of nothing."

In August 1914 Braque, who was now 32 years old, was also called up to military service. He was severely wounded in the war and recovered only slowly. Braque did not begin working artistically again until 1917. His close friendship with Picasso dissolved.

Mandolin, 1914

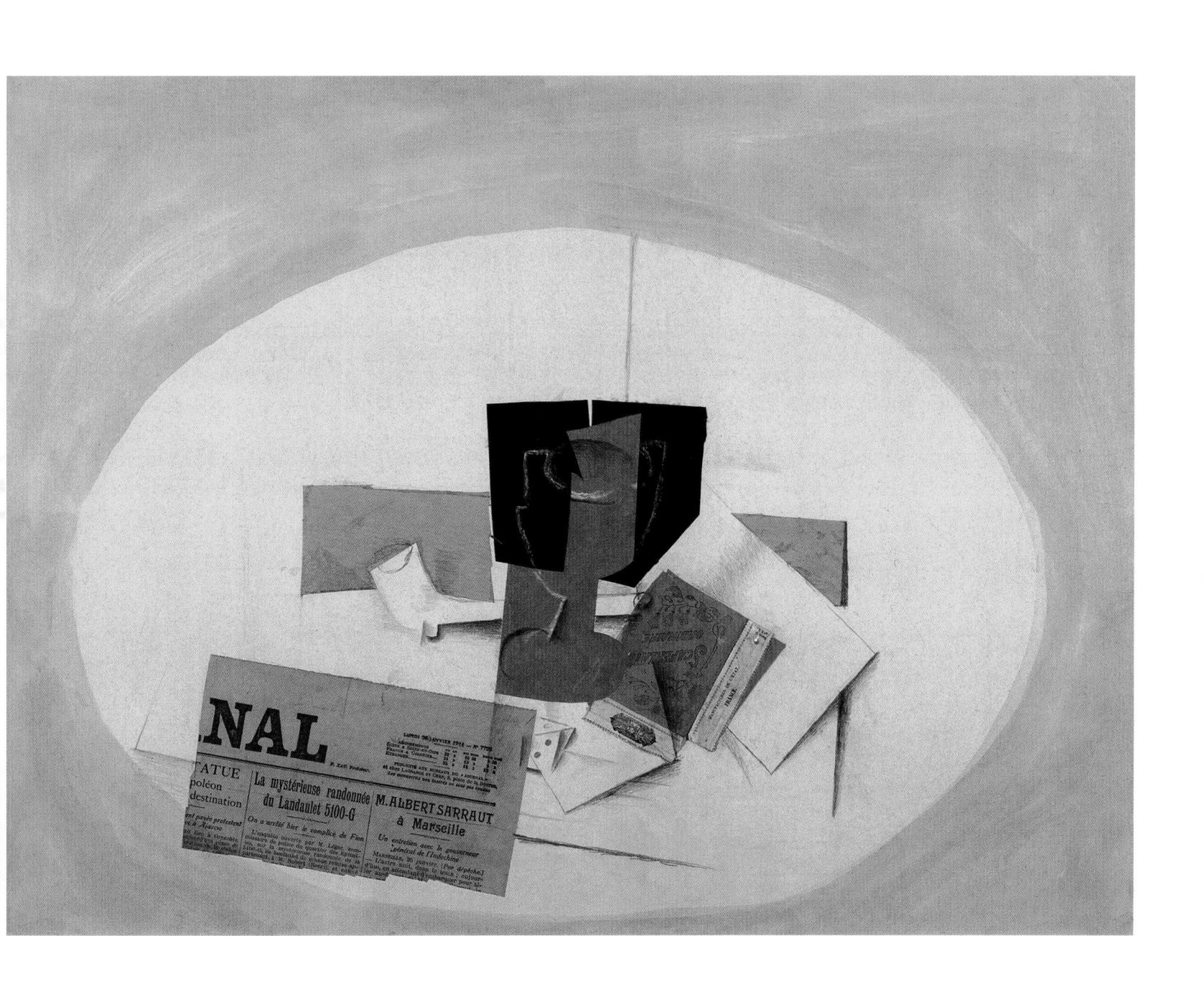

Tea Cups

1914, collage, oil and charcoal on canvas, 65 x 92 cm Düsseldorf, K20 – Kunstsammlung Nordrhein-Westfalen

The picture Tea Cups (Les tasses de thé / Verres, tasse de thé, bouteille et pipe sur une table) by Juan Gris is among those works which found buyers during the third auction of the works of art seized after the First World War from the Galerie Kahnweiler. The sale took place in the Hôtel Drouot in Paris in May 1923. There Paul Eluard acquired the collage. Less than a year later Eluard undertook a seven month journey to India, without having taken leave of anybody. The rumour went around that he had died, and this led to the "Vente Eluard" (Eluard sale) in the summer of 1924, where the work changed owners again. After having different owners in France, Switzerland and the United States, and being twice in the Galerie Beyeler in Basel, among other places, it was finally acquired in 1963 for the Kunst-sammlung Nordrhein-Westfalen in Düsseldorf.

Among his friends, Gris developed the purest version of Synthetic Cubism. He began with abstract picture elements made up of forms and colours, and using these means succeeded in depicting conceptually identifiable objects. Most of his compositions from the time after 1911 are based either on the Golden Section or on strict mathematical numerical relationships.

While Gris may have still painted a collage illusionistically in 1913, his 1914 picture *Tea Cups* consisted almost exclusively of actually collaged elements: wallpaper patterns, pieces of newspaper and various other kinds of paper are to be found on the canvas. Only the black and white areas are directly painted. Besides oil paint, some passages are laid out in charcoal. The picture testifies to a reduced colour range, which is comparable with works from the phase of Analytical Cubism. For the viewer the articles highlighted in the picture's original title – glasses, tea cup, bottle and pipe – tower out of the picture. Other areas of the picture are dominated to a greater extent by architectural design elements, such as stairs, for example. In his picture, Gris playfully switched between reality, illusion and abstraction. Thereby the represented objects generally unite different perspectival views.

Throughout his career, Gris endeavoured to communicate his artistic methods theoretically as well. Retrospectively, he published

the following in "L'esprit nouveau" in February 1921: "From a bottle Cézanne makes a cylinder, whereas I begin with a cylinder to create an individual item of a particular type; from a cylinder I make a bottle, a particular bottle. Cézanne tends toward architecture, I, on the other hand, begin with it. That is why I compose with abstract elements (colours) and arrange the objective elements only when the colours have became objects. I compose e.g. with a white and a black and come only to arrangement if this white has became a paper and that black a shadow. With this I want to say: I arrange the white in such a way as to let it become a paper. This painting relates to past painting as poetry does to prose."

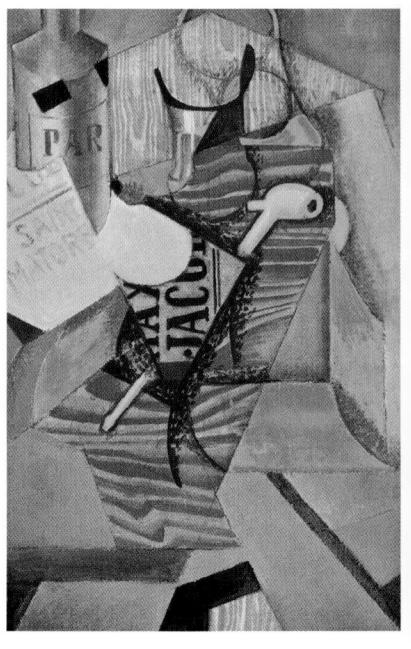

Still-life with book (Saint Matorel), 1912/13

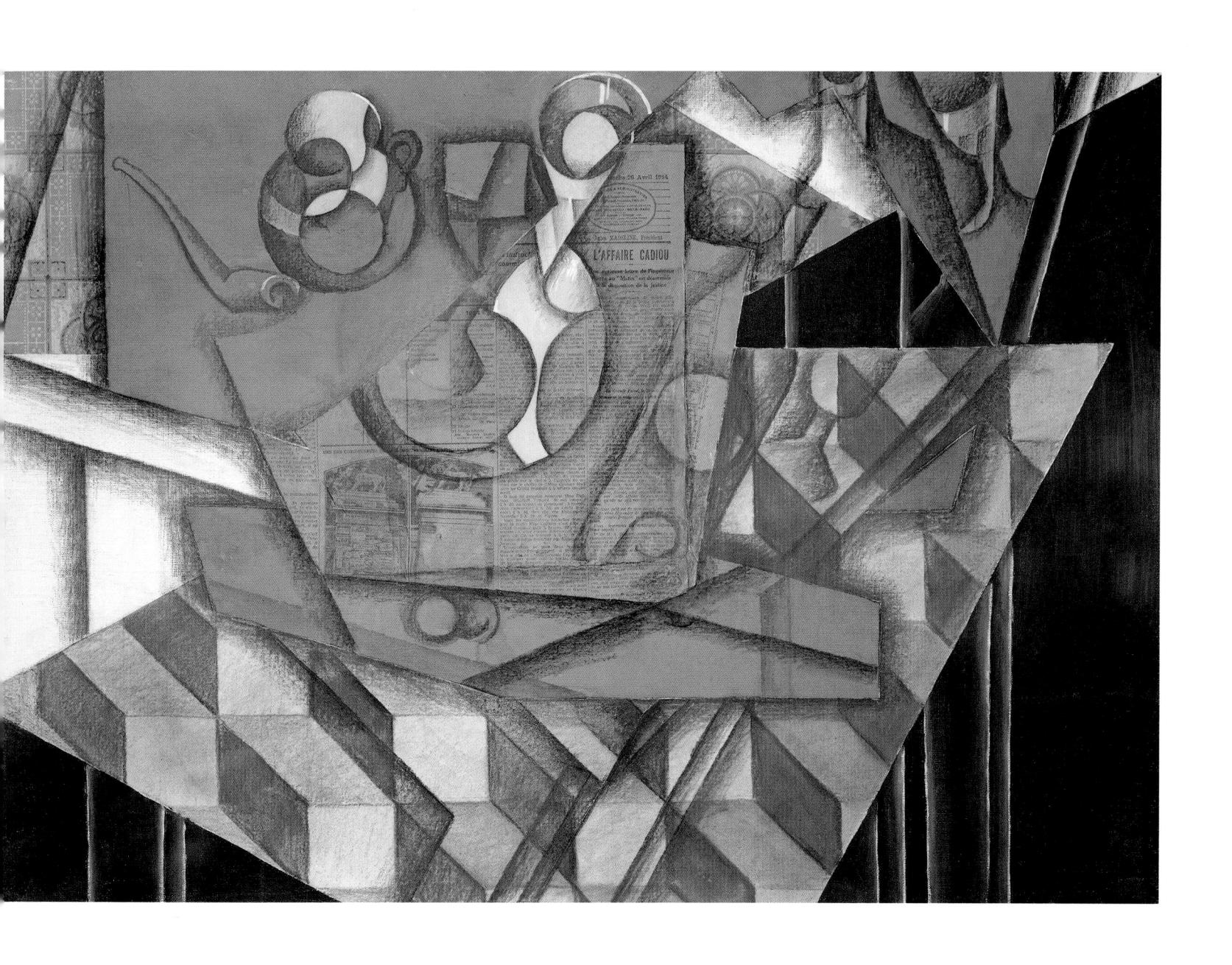

FERNAND LÉGER

The Balcony

1914, oil on canvas, 130 x 97 cm Winterthur, Kunstmuseum Winterthur

Fernand Léger was in close contact with several sculptors whom he had met in the artist colony La Ruche. In particular, however, it was his friendship with Alexander Archipenko (1887–1964) that led him to develop and strongly emphasize volume in his pictures.

perfection of certain types of people, their sure instinct for the really useful and its correct application in the middle of this drama of life and death in which we had submerged, and still more: poets and inventors of daily varying pictures – to speak in the jargon of our profession –

Léger's picture *The Balcony (Le balcon)*, created in 1914, shows robot-like figures, whose bodies are put together from tubes and whose heads seem to be helmeted. The painting was probably created following the work of the same name from 1868/69 by Édouard Manet, whom he greatly admired. The viewer encounters a group of figures, which seem to be closely crowded together into the narrowest of spaces. The boundaries of this minimally available space can be made out only in the background or to the right and left of the group. The group seems uniform; no figure stands out from the others either formally or in colour composition.

On May 9, 1914, during the period in which he was creating this picture, Léger gave a lecture at the Académie Vassilieff in Paris. Its title was: "Les Réalisations picturales actuelles" (Contemporary picture production). In this regard on May 13, 1914, Guillaume Apollinaire published the following in the "Paris-Journal": "He is one of the most interesting Cubists, because he has taken his own path parallel to that of Picasso, Braque or Derain, and because he has taken up modern painting with a certain fierceness, whereby he was careful, however, not to lose the inheritance of Impressionism."

Léger's artistic work suffered — as did that of numerous other artists — from the outbreak of the First World War. Due to his conscription he had to interrupt his work abruptly. "The war was an unbelievable event for me. On the front there was a kind of super-poetic atmosphere, which moved me deeply. My God, what muzzles! And then the cadavers, the mud, the cannons. I have never made drawings of cannons; I had them in my eyes. During the war I came back down to earth with both feet ... I had left Paris in the middle of a period of abstraction, of painterly liberation. Without transition I found myself shoulder to shoulder with the whole French populace; set out among the pioneers, my new comrades were miners, excavators, woodcutters and metalworkers ... The rough clay, the diversity, the humour, the

perfection of certain types of people, their sure instinct for the really useful and its correct application in the middle of this drama of life and death in which we had submerged, and still more: poets and inventors of daily varying pictures – to speak in the jargon of our profession – so dynamic, so colourful; since intervening in this reality, I never again lost my connection with things. I learned more from the 75-cm cannon for my sculptural development than from all the museums in the world. After the war I used what I had learned at the front. For three years I used geometrical forms, a period which they will call 'mechanistic."

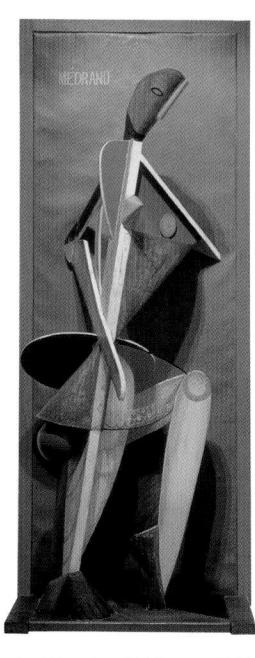

Alexander Archipenko, Médrano, 1913/14

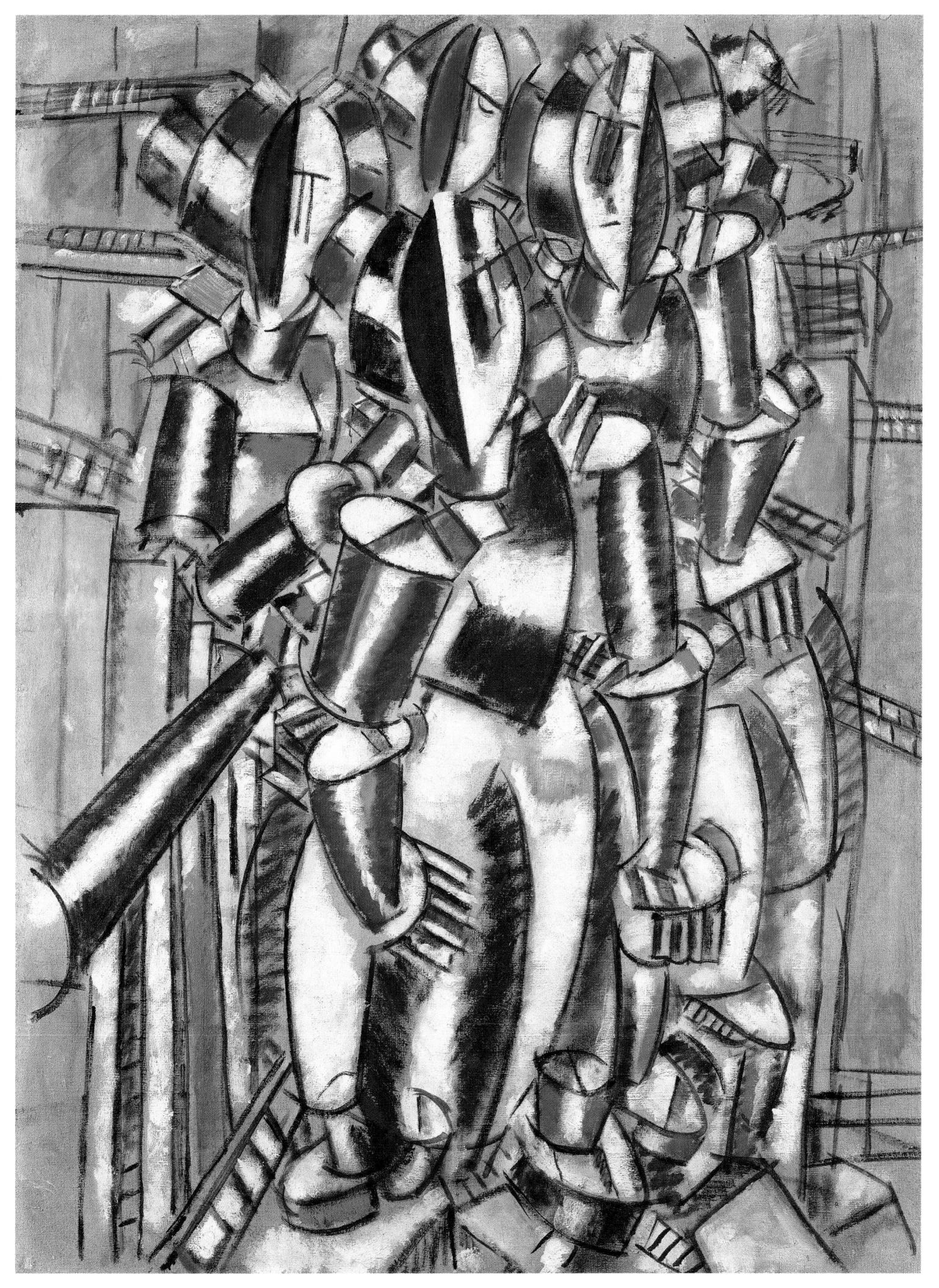

RAYMOND DUCHAMP-VILLON

The Great Horse

1914/1955, bronze, 100 x 55 x 95 cm Paris, Musée national d'art moderne, Centre Pompidou

b. 1876 in Damville, d. 1918 in Cannes

Raymond Duchamp-Villon ranks beside Alexander Archipenko and Jacques Lipchitz as one of the few sculptors of Cubism. In 1898 Duchamp-Villon had abandoned his study of medicine to devote himself to sculpture. He initially worked under the influence of August Rodin and then turned to Cubism. In 1907 he was on the sculpture jury for the "Salon d'Automne". In the 1954 publication "Moderne Plastik. Von Auguste Rodin bis Marino Marini"

(Modern sculpture. From Auguste Rodin to Marino Marini) Eduard Trier declared: "Cubist sculpture was initially made by painters. The sculptors joined the movement at a time when other phenomena important for sculpture had already coalesced with early Analytical Cubism."

Regarding the autumn salon in 1911 Guillaume Apollinaire wrote in the Paris daily paper "L'Intransigeant" of October 14: "Marque's Baigneuse, Bourdelle's Buste, the carved wooden bust Maurice Denis by Lacombe, the busts by Pimienta and Niederhausern-Rodo, Andreotti's Gorgone, Duchamp-Villon's Baudelaire, and the work by Archipenko are among the better pieces in this salon, which has only a rather small sculpture section." In the same newspaper, the October 19, 1911 edition, Apollinaire again called upon his readers to view the "Sculptures of Mr. Archipenko and Mr. Duchamp-Villon". On October 10, 1912 he wrote in "L'Intermédiaire des chercheurs et des curieux": "At the end of 1911 the Cubist exhibition in the Salon d'Automne raised a lot of dust. Neither the pictures La chasse and Portrait Jacques Nayral by Gleizes, nor Metzinger's La femme à la cuillère, nor Fernand Léger were spared from the mockery of the critics. These artists had also been joined by a new painter, Marcel Duchamp, and a new architect and sculptor, Duchamp-Villon."

The sculpture The Great Horse (Le grand cheval) created in 1914 ranks among the most important sculptures of Cubism. Eduard Trier describes it in his monograph "Figur und Raum" (Figure and space) from the year 1960: "Raymond Duchamp-Villon has subjected the animal to its first radical transformation. His Horse, a horse machine or a machine horse, combines in half-abstract forms the static and dynamic elements of the general notion of horse. Thereby this part-animal, part-technical element of form finds itself in a peculiar state of suspension or waiting, somewhere between resting and furious movement. While well into the 19th and even the 20th centuries the horse was still being used by sculpture as a symbol of sovereignty on the pedestals of memorials or even made into the pedestal itself, Duchamp-Villon relegates it, still in advance of the approaching hypertrophic technocracies, into the sphere of mechanics. His sculpture symbolizes, as it were, 'horse power' or the dynamism of its movement."

Apollinaire felt vindicated by the reception of some Cubist artists in Germany; in the "Paris-Journal" of July 3, 1914 he wrote: "There is no doubt – from Germany comes enlightenment, as concerns French art. No day passes in Berlin, Munich, Düsseldorf and Cologne without the opening of a new exhibition dedicated to the work of the new French artists. Currently running in the Galerie Der Sturm in Berlin is an exhibition of Gleizes, Metzinger, Duchamp-Villon and Jacques Villon ... Duchamp-Villon is a very modern sculptor, one who has best succeeded in giving the movement a concrete form. He begins work without preliminary deliberation, with only his strength and instinct, and is thereby related to Mexican art. The ancient Mexicans created a marvellously abstract ideogram to represent movement; the sculptural goal of Duchamp-Villon. The sculptures in terracotta, plaster and wood will open the eyes of the Germans, and I hope that they profit from it."

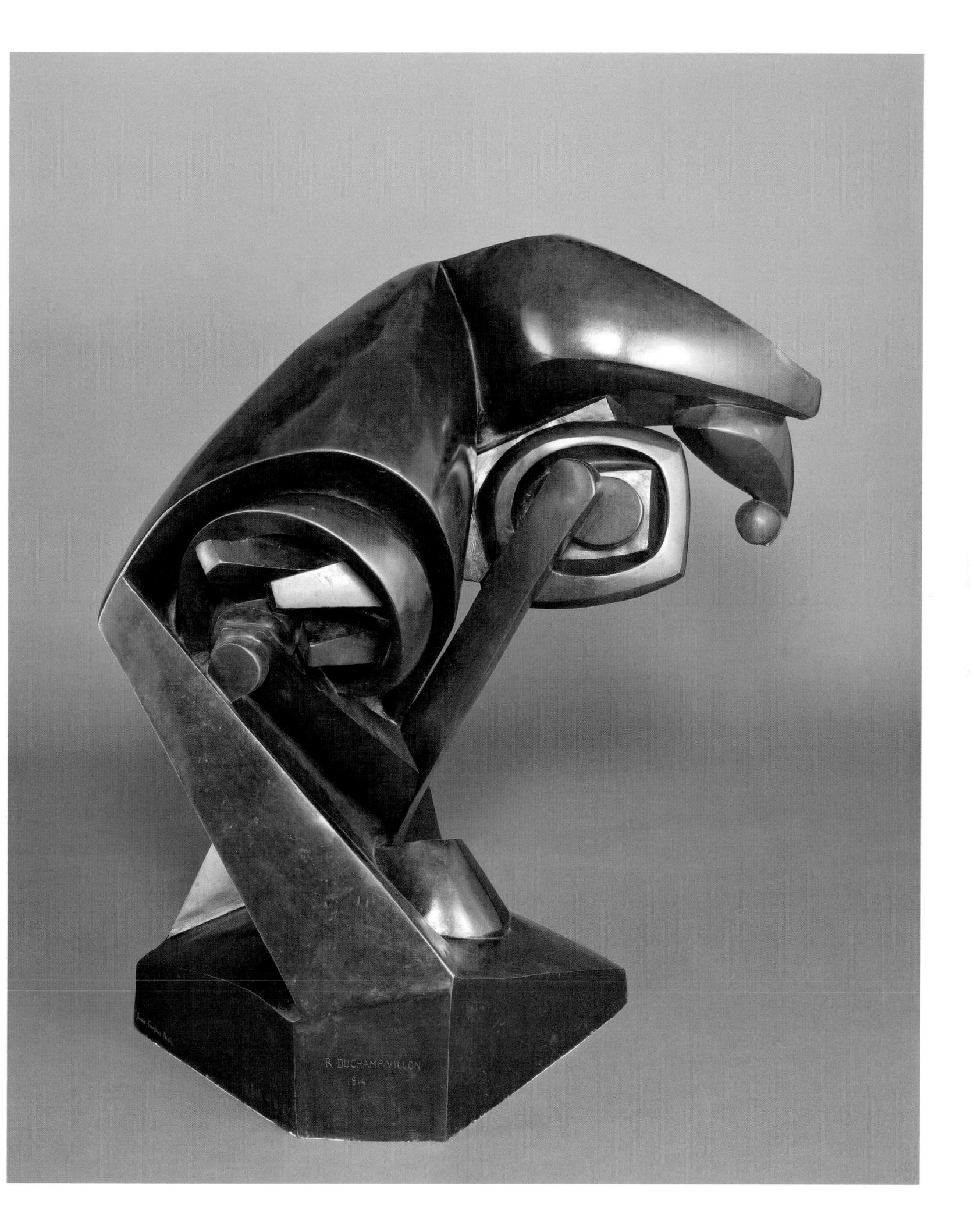

The Breakfast

1915, oil and charcoal on canvas, 92 x 73 cm *Paris, Musée national d'art moderne, Centre Pompidou*

The still-life *The Breakfast (Le petit déjeuner)* by Juan Gris was created at a time in which he lived in relative isolation and in financial straits in Paris. The relationship between Gris and his two important collectors Gertrude Stein and Michael Brenner, who supported him financially and were compensated with pictures for this, had come to a rupture at the end of December 1914. Prior to this and by arrangement with his dealer Daniel-Henry Kahnweiler, Gris had no longer been prepared to sell his pictures directly to the collectors. Kahnweiler continued to send money to Gris from his Swiss exile. In return Gris reported to him on the events in Paris. However at the end of the year 1915 contact between Gris and Kahnweiler was interrupted for approximately four years. Gris concluded a contract with Léonce Rosenberg in November 1917. He did not allow Daniel-Henry Kahnweiler to represent him again until the summer of 1919.

In composing the picture, Gris made reference to the already well proven stylistic devices of "papier collé". Despite the tense political situation since the outbreak of the First World War, Gris addressed a subject that combined everyday objects: a folded-up piece of newspaper, a bowl, a cup, a coffeepot and finally a bottle. All objects are depicted in various techniques or on different types of underpainting. The bowl and the cup are drawn. The coffeepot suggested in the centre background is divided into three segments: a centre section painted in grey, a continuation of the outlines on the green strip of colour, and finally the remaining outline of the spout in the blue block of colour. The bottle, on the other hand, is sketched on green colour fields; it seems to be growing out of the folded strips of the sculpturally rendered newspaper.

The colour planes in the picture are arranged beside one another as if they were different supports. Beyond their colour composition they represent a material such as ochre wood veneer or green newsprint. The field composed in bright ochre and grey in the lower area of the picture is reminiscent of Georges Braque's land-scapes from L'Estaque in the south of France, and in this way Gris' still-life suddenly becomes a summary of everything up to this point,

The still-life *The Breakfast (Le petit déjeuner)* by Juan Gris a résumé of the history of Cubist stylistic devices in the absence of treated at a time in which he lived in relative isolation and in most of its protagonists.

In his book "Foundations of modern art" the art historian Werner Hofmann emphasizes Gris' special contribution: "Such is the gain that Cubist composition obtains from renouncing the unambiguous readability of its material content that it cannot be valued highly enough: the objects become metamorphic, they intertwine, participate in certain progressions of form that reach from the primary qualities to the secondary qualities and vice versa ... The Cubist reduces the multiplicity of the viewing data to just a few families of form, in which he then can accommodate a certain stock of reality: those are things that can 'communicate' in an interrelated manner with one another. What we can derive from the Cubist picture is not a scientific, but a poetic illumination of things."

"I want to proceed to the production of new individual things by starting from general basic forms. In my opinion the general is the purely pictorial, the artistically law-based, the abstract side."

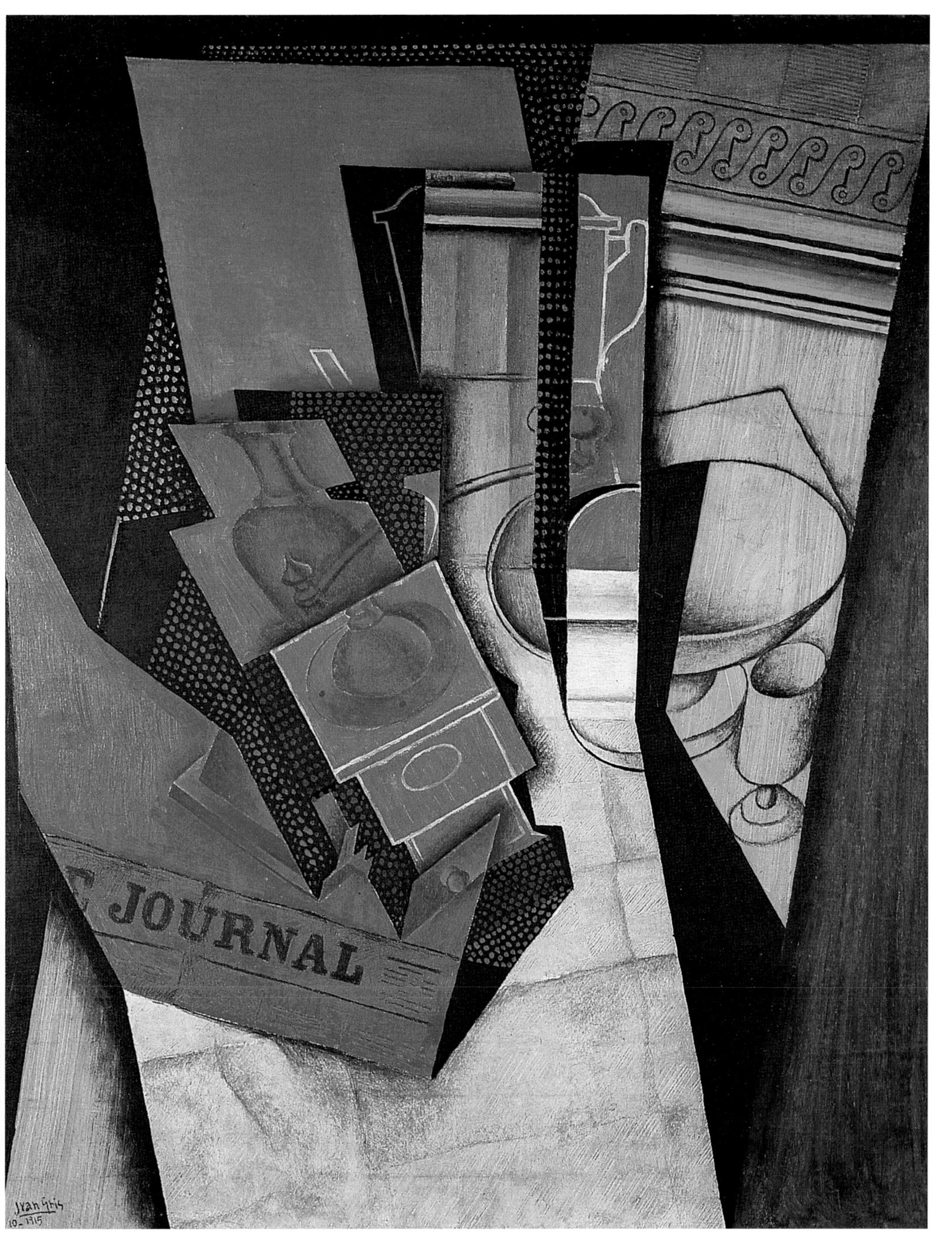

JEAN METZINGER

Still-life

1915, oil on canvas, 55 x 46 cm *Hanover, Sprengel Museum*

Together with Albert Gleizes, Jean Metzinger worked to establish a well-founded theoretical basis for Cubism. With their book published in 1912 "On Cubism" the two artists tried to bestow the style, which until then had been subject to unconstrained growth, with a manifesto. The book was announced as early as March in the "Revue d'Europe et d'Amérique" and again in the "Paris-Journal" in October. It finally appeared at the end of November or beginning of December 1912. Cubists such as Georges Braque, Pablo Picasso, Juan Gris and Fernand Léger remained more or less unaffected by it. The book, which today is to be viewed rather critically, nonetheless had great success in its time. As early as 1913 an English-language edition appeared in London, as well as two Russian editions in Moscow.

Metzinger's ambition to disseminate Cubism to a larger audience may have been the incentive for him to teach as early as 1912 at the Académie de la Palette in Paris together with Henri Le Fauconnier and André Dunoyer de Segonzac. Among his students was, for example, the Russian Constructivist Lyubov Popova (1889–1924). Metzinger was obviously working towards a programmatic definition of Cubism when he wrote in his publication "The birth of cubism": "That Juan Gris dissolves the objects; that Picasso replaces them with forms of his own invention; that another replaces conical perspective with a system based on the interrelationships of vertical lines: this all proves that Cubism could by no means be considered a watchword, and that for some painters it denoted solely the will to repudiate a type of art."

With his *Still-life* (*Nature morte*) of 1915 Metzinger took up subject matter with which Pablo Picasso and Georges Braque – also in preoccupation with the still-lifes of Paul Cézanne – had already concerned themselves before the year 1910. In his picture Metzinger combines different articles on a table: playing cards, a glass, a teapot, a bottle and a bowl of fruit. As is the case in most Cubist still-lifes these could have been items out of the artist's immediate environment. The selection of objects is not determined by allegories or a higher level of meaning. The objects do not convey meaning, but

rather are portrayed in terms of their most important functions and essential characteristics.

In the background the wall is decorated with a blue meander pattern on a yellowish green background. In reversed colours, it protrudes from under the right-hand edge of the table as the floor covering. The viewer initially encounters the tabletop in the picture as an upright-standing rectangle, oriented parallel to the picture's edges. Another rectangle of identical format lies upon the first, skewed diagonally and to the right. All objects with the exception of the playing cards are – like the lower desk top – positioned perpendicularly in the picture. With slightly geometricized outlines, their overall forms are still recognizable. This still-life by Metzinger, which for Cubism was quite late, makes clear that his language of form still retained its ties to Analytical Cubism.

Lyubov Popova, Still-life, 1915/16

ALBERT GLEIZES

In the Port

1917, oil and sand on wood, 153.3 x 120.6 cm *Madrid, Museo Thyssen-Bornemisza*

Albert Gleizes, who was active as a painter, illustrator and art writer, travelled to the United States of America as early as 1915. Two years later in New York he produced his picture *In the Port (Dans le port)*. Inspired by the "papiers collés" created by Georges Braque and Pablo Picasso, Gleizes used oil paint mixed with sand on wood.

Gleizes summarized his diverse impressions of the port of New York in this panel painting. Variously suggested frames create associations of pictures within the picture, one tipped diagonally to the right, another to the left – further fan-like structures can be described within this decomposition of the vertical format. There are layers of variously fragmented and identifiable details: ship hulls, building gables, smoke ascending from chimneys and much more. These are the turbulent events and careful observations in a large transatlantic harbour. The shifted formats in the picture allow the viewer's gaze to jump back and forth, thus creating an impression of the movement, dynamics and speed within the large city. Possibly being documented here is the feeling of being overwhelmed, as experienced by a traveller just arriving.

Gleizes' pictures clearly show that the cubistically working artists had found stylistic techniques that were too diverse. In 1913 Gleizes himself wrote about his intentions: "Since (creating) my pictures, which were shown in the first comprehensive exhibition of the modern movement at the Salon des Indépendants in 1911, I have striven to develop the new possibilities of picture composition, which at that time I had made only indistinctly visible. In the pictures exhibited in this year's Salon d'Automne I have tried to assert the main principles clearly: 1. In the composition, an equilibrium created by the play of lines, planes and volumes. 2. In the associations of the forms among themselves, the interrelationships they adopt through their position in the pictorial space. 3. In the reality of the object that is no longer viewed from one particular point, but instead constructed on the basis of a selection of successive aspects, which I can discover through my own movement."

Gleizes' theoretical statements refer to an analytical approach to picture creation, which was not always conducive to the comprehension of Cubism. Jean Metzinger expressed Gleizes' intention much more simply in his text "The birth of Cubism", however he did not touch on some of the points Gleizes emphasized: "The canvas stretched on the wooder frame before the first brush stroke, the frame that will confine it, and the application of paint that later gives it form in varying degrees of intensity and differentiation: Those were the elements that allowed Gleizes to fulfil his intentions. These are, incidentally, the only true things which the painter encounters in the practice of his art. For him it is sufficient to carry out a few simple steps of elementary geometry on the rectangle in front of him, in order to allow a rhythm, a poetic means of expression to develop."

Georges Braque, The Port, 1909

To stay informed about upcoming TASCHEN titles, please request our magazine at www.taschen.com/magazine or write to TASCHEN America, 6671 Sunset Boulevard, Suite 1508, USA-Los Angeles, CA 90028, contact-us@taschen.com, Fax: +1-323-463.4442. We will be happy to send you a free copy of our magazine which is filled with information about all of our books.

© 2009 TASCHEN GmbH

Hohenzollernring 53, D-50672 Köln

www.taschen.com

Original edition: © 2004 TASCHEN GmbH Editorial coordination: Sabine Bleßmann, Cologne

Design: Sense/Net, Andy Disl and Birgit Eichwede, Cologne

Production: Ute Wachendorf, Cologne **English translation:** Sean Gallagher, Berlin

Printed in China ISBN 978-3-8365-1392-0

Copyright:

© for the works of Alexander Archipenko, Georges Braque, Kees van Dongen, Albert Gleizes, Henri Laurens, Fernand Léger, Jean Metzinger: VG Bild-Kunst, Bonn 2009

© for the work of Salvador Dalí: Salvador Dalí, Fundació Gala-Salvador Dalí/ VG Bild-Kunst, Bonn 2009

© for the work of Pablo Picasso: Succession Picasso/VG Bild-Kunst, Bonn 2009

Photo credits:

The publishers would like to express their thanks to the archives, museums, private collections, galleries and photographers for their kind support in the production of this book and for making their pictures available. If not stated otherwise, the reproductions were made from material from the archive of the publishers. In addition to the institutions and collections named in the picture captions, special mention is made of the following:

Albright-Knox Art Gallery, Buffalo: p. 71

© Archiv für Kunst und Geschichte, Berlin: p. 13 right, 22, 32, 36, 37, 43, 52, 54, 57, 74, 82, 85, 86, 92

Artothek: p. 16 left, 17, 49, 77, 94

Fondation Beyeler, Riehen/Basel: p. 9 left, 19 right, 79

Bridgeman Giraudon: p. 4, 15 right, 16 right, 18, 33, 42, 44, 61

Solomon R. Guggenheim Museum, New York: p. 81

Kröller-Müller Museum, Otterlo: p. 47

Kunstmuseum Winterthur, Clara and Emil Friedrich-Jezler Bequest, 1973: p. 87 Kunstsammlung Nordrhein-Westfalen, Düsseldorf © Photo Walter Klein: p. 55 Museum of Art, Rhode Island School of Design, Providence: p. 19 left, Photo Erik Gould

Musée Picasso, Paris © Photo RMN: p. 7 left (Photo J. G. Berizzi), 13 left, 26 lower (Photo Michèle Bellot), 38, 45 Estate Brassaï (Photo Hervé Lewandowski)

Centre Georges Pompidou - MNAM-CCI, Paris © Photo CNAC/MNAM Dist. RMN: p. 15 left, 20, 31, 65, 75, 89

The Philadelphia Museum of Art, Philadelphia: p. 59, 69, back cover © Photo SCALA, Florence/The Museum of Modern Art, New York 2004:

p. 7 right, 21 right, 27, 51, 62, 63

Sprengel Museum, Hanover: p. 23 left, 67, 83, 93

Staatsgalerie Stuttgart: p. 10

Page 2 GEORGES BRAQUE

The Portuguese

1911, oil on canvas, 116.5 x 81.5 cm Basel, Öffentliche Kunstsammlung, Kunstmuseum Basel Page 4

Portrait of Pablo Picasso 1912, oil on canvas, 93 x 74 cm Chicago, The Art Institute of Chicago

Reference illustrations:

© Tate Gallery, London 2004: p. 53

© Museo Thyssen-Bornemisza, Madrid: p. 25, 95

© Photo Prof. Dr. Eduard Trier, Cologne: p. 23 right

p. 26: Edmond Fortier, *Types of Women (Types de femmes)*, West Africa, 1906, photogravure (postcard), APPH 14902, Paris, Musée Picasso, Picasso Archive p. 28: The art critic André Salmon in front of the painting *Three Women* in the Bateau-Lavoir studio, summer 1908, gelatine silver print, 11.8 x 8.1 cm, APPH 2831, Paris, Musée Picasso, Picasso Archive

APPH 2831, Paris, Musée Picasso, Picasso Archive p. 32: Paul Cézanne, *The Cabin of Jourdan (Le cabanon de Jourdan)*, 1906, oil on canvas, 65 x 81 cm, Rome, Galleria Nazionale d'Arte Moderna p. 34: Pablo Picasso, study for *Carnival at the Bistro (Carnaval au bistrot)*, 1908/09, watercolour and pencil on paper, 24.2 x 27.5 cm, Private collection p. 36: Georges Braque, *Castle at La Roche-Guyon (Chateau de La Roche-Guyon)*, summer 1909, oil on canvas, 92 x 73 cm, Eindhoven, Stedelijk van Abbe Museum

p. 38: Pablo Picasso, *Self-portrait*, 1909, gelatine silver print, 11.1 x 8.6 cm, APPH 2803, Paris, Musée Picasso, Picasso Archive

p. 40: Pablo Picasso, *Landscape, Horta de Ebro (The Reservoir)/Paysage, Horta de Ebro (Le réservoir),* 1909, gelatine silver print, 23 x 29 cm, APPH 2830, Paris, Musée Picasso, Picasso Archive

p. 42: Braque in his studio at 5 Impasse de Guelma, early 1912 or thereabouts, Private collection

p. 44: Pablo Picasso, *Portrait of Fernande (Portrait de Fernande)*, 1909, oil on canvas, 61.8 x 42.8 cm, Düsseldorf, K20 – Kunstsammlung Nordrhein-Westfalen p. 50: Postcard from Pablo Picasso to Daniel-Henry Kahnweiler, August 13, 1911, Private collection

p. 52: Kees van Dongen, *Interior with Yellow Door (Intérieur à la porte jaune)*, 1910, oil on canvas, 100 x 65 cm, Rotterdam, Museum Boymans-van Beuningen p. 54: Robert Delaunay, *The Poet Philippe Soupault (Le poète Philippe Soupault)*, 1922, oil on canvas, 197 x 130 cm, Paris, Musée national d'art moderne, Centre Pompidou

p. 62: Pablo Picasso, *Gitarre (La guitare)*, 1912/13, sheet metal, string and wire, 77.5 x 35 x 19.3 cm, New York, The Museum of Modern Art, Gift of the artist p. 64: Page of a letter from Georges Braque to Daniel-Henry Kahnweiler, 1912, Private collection

p. 68: Paul Cézanne, *Five bathers (Cinq baigneurs)*, 1892–1894, oil on canvas, 22 x 33 cm, Paris, Musée d'Orsay

p. 72: Juan Gris, *The Smoker (Le fumeur)*, 1912, charcoal and red chalk on paper, 71.5 x 59.5 cm, Private collection

p. 74: Juan Gris, *Violin and Engraving (Violon et gravure accrochée)*, 1913, oil, sand and collage on canvas, 65 x 60 cm, Private collection

p. 76: Photographic composition with *Construction with Guitarist*, Paris, spring/summer 1913, gelatine silver print, 11.8 x 8.7 cm, Private collection

p. 82: Georges Braque, *Mandolin (Mandoline)*, 1914, charcoal, gouache, pasted paper and cardboard, 48.3 x 31.8 cm, Ulm, Ulmer Museum, on permanent loan from the Land Baden-Württemberg

p. 84: Juan Gris, *Still-life with book (Saint Matorel)Nature morte au livre (Saint Matorel)*, 1912/13, oil on canvas, 46 x 30 cm, Paris, Musée national d'art moderne, Centre Pompidou

p. 86: Alexander Archipenko, *Médrano*, 1913/14, painted tin, wood, glass and painted oilcloth, $126.6 \times 51.5 \times 31.7$ cm, New York, Solomon R. Guggenheim Museum

p. 92: Lyubov Popova, *Still-life (Nature morte)*, 1915/16, oil on canvas, 54 x 36 cm, Gorki, State Museum of Art

p. 94: Georges Braque, *Der Hafen (Le port)*, 1909, oil on canvas, 81 x 81 cm, Chicago, The Art Institute of Chicago

Page 1 PABLO PICASSO

Still-life with cane chair weave

1912, oil on waxcloth on canvas framed with cord, 29 x 37 cm

Paris, Musée Picasso

SCHEN	TASCHEN est.1980	TASCHEN	TASCHEN est.1980	TASCHEN	TASCHEN est. 1980	TASCHEN	TASCHEN est.1980	TASCHEN
CHEN st. 1980		TASCHEN est.1980		TASCHEN est.1980		TASCHEN est.1980		TASCHEN est.1980
SCHEN	TASCHEN est.1980		TASCHEN est.1980		TASCHEN est. 1980		TASCHEN est.1980	
CHEN st.1980		TASCHEN est. 1980		TASCHEN est.1980		TASCHEN est.1980		TASCHEN est. 1980
SCHEN	TASCHEN est.1980		TASCHEN est.19%		TASCHEN est.19%0		TASCHEN est.1980	
CHEN ±1980		TASCHEN est.1980		TASCHEN est.1980		TASCHEN est.1980		TASCHEN est.19%
ICHEN	TASCHEN est.1980		TASCHEN est.1980		TASCHEN est.1980		TASCHEN est.1980	TASCHEN
CHEN 1.1980		TASCHEN est.1980		TASCHEN est.1980		TASCHEN est.1980		TASCHEN est.1980
ECHEN	TASCHEN est.1980		TASCHEN est.1980		TASCHEN est. 1980		TASCHEN est. 1980	
CHEN 1.1980		TASCHEN est.1980		TASCHEN est. 1980		TASCHEN est.1980		TASCHEN est.1980
CHEN	TASCHEN est.1980	TASCHEN	TASCHEN est.1980	TASCHEN	TASCHEN est. 1980	TASCHEN	TASCHEN est. 1980	TASCHEN

TASCHEN est. 1980	TASCHEN	TASCHEN est.1980	TASCHEN	TASCHEN est.1980	TASCHEN	TASCHEN est.1980	TASCHEN	TASCH est.198c
	TASCHEN est.1980		TASCHEN est.1980		TASCHEN est.1980		TASCHEN est. 1980	TASCA
TASCHEN est. 1980		TASCHEN est. 1980		TASCHEN est.1980		TASCHEN est.1980		TASCH est. 198e
	TASCHEN est.1980		TASCHEN est.1980		TASCHEN est.1980		TASCHEN est. 1980	TASCH
TASCHEN est.1980		TASCHEN est.19%		TASCHEN est.1980		TASCHEN est.1980		TASCH est.198
	TASCHEN est. 1980		TASCHEN est.1980		TASCHEN est.1980		TASCHEN est.1980	TASCH
TASCHEN est.1980		TASCHEN est.19&0		TASCHEN est.1980		TASCHEN est.1980		TASCF est. 198
	TASCHEN est.1980		TASCHEN est. 1980		TASCHEN est.19%	TASCHEN	TASCHEN est.1980	TO S
TASCHEN est.1980		TASCHEN est. 1980		TASCHEN est.1980	TASCHEN	TASCHEN est. 1980		TASCI- est.198
	TASCHEN est.1980		TASCHEN est.1980		TASCHEN est. 1980		TASCHEN est.1980	TASCH
TASCHEN est.1980	TASCHEN	TASCHEN est.1980	TASCHEN	TASCHEN est. 1980	TASCHEN	TASCHEN est.1980	TASCHEN	TASCI est.19ê

#Gina Ford Baby and Toddler Cook Book

EGINA FORD Baby and Toddler Cook Book

Over 100 easy recipes for all the family to enjoy

Gina Ford

Photography by Clive Bozzard-Hill

Vermilion

WARRINGTON BOROUGH COUNCIL				
34143101016473				
Bertrams	13/04/2012			
AN	£15.99			
WAR				

Gina Ford has asserted her moral right to be identified as the author of this work in accordance with the Copyright, Design and Patents Act 1988.

All rights reserved. No part of this publication may be reproduced, stored in a retrieval system, or transmitted in any form by any means, electronic, mechanical, photocopying, recording or otherwise, without the prior permission of the copyright owner.

First published in the United Kingdom in 2005 by Vermilion, an imprint of Ebury Publishing, Random House UK Ltd. Random House, 20 Vauxhall Bridge Road, London SW1V 2SA

Random House Australia (Pty) Limited, 20 Alfred Street, Milsons Point, Sydney, New South Wales 2061, Australia

Random House New Zealand Limited, 18 Poland Road, Glenfield, Auckland 10, New Zealand

Random House (Pty) Limited, Endulini, 5A Jubilee Road, Parktown 2193, South Africa

Random House UK Limited Reg. No. 954009 www.randomhouse.co.uk

Papers used by Vermilion are natural, recyclable products made from wood grown in sustainable forests.

A CIP catalogue record is available for this book from the British Library.

ISBN 13: 9780091906344

Printed and bound in Germany by Appl Druck Wemding

Managing Editor: Lesley McOwan Editorial Assistant: Imogen Fortes
Editorial Team: Dawn Fozard, Emma Kirby, Kate Parker and Kate Grant
Photography: Clive Bozzard-Hill Design: Two Associates Stylist: Tessa Evelegh
Home Economists: Louise Mackaness, Sarah Louise Tildesley and Pippin Britz
Models: Lucy Bozzard-Hill, Mia Geddes, Charlie Hooper, Barney Howlett,
Tom Michell and Kairo Sackey

The author would like to thank lan Lye, author of A Chef At Your Elbow: Recipes and Wrinkles

The Publishers would also like to thank Jane Bozzard-Hill and Nicole Edwards (née Cooper) BSc SRD Clinical Paediatric Dietitian

Contents

7 Introduction

8 Using This Book

10 How Your Child Develops

20 Soups

34 Lunch

70 Finger Foods

86 Teatime Treats

138 Vegetables on the Side/Accompaniments

158 Puddings

168 Birthday Party Ideas

190 Batch Cooking

206 Index

INTRODUCTION

There are many different views on the various aspects of raising children, but the one area in which all parents are united is the need for their child to eat well. I was inspired to write this book partly in response to the hugely positive feedback to my earlier books *The New Contented Little Baby Book* and *The Contented Little Baby Book of Weaning*, but mainly because I truly believe that establishing good feeding habits in babies and young children contributes enormously to healthy, happy childhoods, and leads to a sensible and healthy approach to food in adulthood.

You don't have to be a wonderful cook or have a great love of cooking to be successful at creating delicious family meals. Family time is often limited and the different demands of babies, toddlers and older children are not always easy to meet. This aims to be a practical, fun recipe book, with the emphasis on cutting corners while not cutting nutritional value. Simplicity, good ingredients and tips for catering for the whole family are the key to my recipes.

My approach to feeding children has evolved over many years. I have been fortunate enough to have helped many families during my career. Making food preparation fun, and an imaginative approach to cooking do not require special training – just a little helpful advice, good ideas and an understanding of food and its nutritional content. I hope you find something to appeal to all the family in this book.

Gina Ford

USING THIS BOOK

Salt

You will notice that I have not included salt in any of my recipes. This is because young babies should not have salt added to any of their meals as it can be harmful to their immature kidneys. Salt is naturally present in many foods and so young children will get all they need from this source. If you wish to add salt to any of the recipes for older children given in this book, first set aside the portion for your baby or toddler before seasoning the dish for the rest of the family. Consult the UK Food Standards Agency guide for the daily recommended maximum salt intake for children.

With this in mind, I have specified unsalted butter throughout the book. In addition, it is important to check the labels on any of the commercially prepared foods that you buy, as these can contain high levels of salt. As a guide, 0.1g sodium or less per 100g is considered a little; 0.5g or more is considered a lot.

Milk and buying organic food

Young children require full-fat milk, and this is what I have specified in the recipes. Try to buy organic milk, if possible – similarly for all foods, if you can. It is particularly important to buy eggs and meat (organic too, ideally) from a reputable source.

Measurements

Most recipes in this book use precise measurements. A few, however, suggest using a cup to measure out the ingredients because there is no need to be so exact. I just use a normal teacup; although the size isn't important as long as you use the same sized cup throughout a recipe.

Serving sizes

The number of servings recipes make will vary depending on whether you are feeding babies, toddlers or older children. The servings given all relate to an average child's portion; if you are making these recipes for adults, I suggest you work on the basis that two child portions are equivalent to one adult serving.

Freezing

Nearly all the recipes in this book are suitable for freezing. You will see I have indicated on each which are, or are not suitable for storing in the freezer. You don't need any special equipment. In the early days just a couple of ice-cube trays, yoghurt-pot-size lidded containers and plastic bags should suffice. As his appetite increases or when you are cooking for more than the baby, some larger pots, or freezer boxes, will come in handy.

- Always freeze food cold, not when it is still warm. So chill and freeze as soon after preparing the recipe as you can.
- Ice-cube trays are great for freezing purées, soup, or sauces but these will dry out if left exposed. Once the food is solid, press out into freezer bags to store.
- It is advisable to defrost foods for children under 2 years in the fridge. For adults and older children you can do so at room temperature (unless it is a hot sunny day).
- Reheat thawed food for babies under 1 year in a heatproof bowl over a pan of bubbling water.
 Microwave ovens can cause hot spots in the food with the risk of scalding.
- Throw away any uneaten food, never refreeze.

For more tips, turn to Batch Cooking (page 190).

HOW YOUR CHILD DEVELOPS

From 6-12 months

All the recipes in this book are intended for babies who have been gently introduced to different foods and new flavours during their first stage of weaning. If you have followed my advice and that of your health visitor for stage one of weaning, then between six and seven months your baby's digestive system will be ready for food that is more textured than the purées of the early weeks of weaning. At this stage foods can be mashed or grated, although babies vary in their readiness for different textures so a patient introduction to new consistencies is the best approach. If, however, you have not yet weaned your six-month-old baby, you will need to follow an appropriate weaning guide before these recipes will be suitable for him.

The most recent information from the Department of Health is based on advice from the World Health Organization (WHO), which recommends exclusive breastfeeding for the first six months; the WHO advice applies to different countries and cultures around the world. In Britain, the Scientific Advisory Committee on Nutrition (SACN), which informs the Department of Health on policy, has confirmed that there is sufficient evidence to suggest that exclusive breastfeeding for six months is nutritionally adequate. All babies are different, however, and mothers' circumstances vary enormously which, when supported by the appropriate medical guidance, might lead to weaning before six months.

If your baby has reached 17 weeks, and you and your health visitor or GP feel your baby is ready to wean, then do consult my weaning advice in *The New*

Contented Little Baby Book and The Contented Little Baby Book of Weaning. I hope both books will help you to introduce the right foods in the right order. Remember that during the first stage of weaning, breast or formula milk still provides babies with all the nutrients they need.

At between six and nine months it is important that your baby continues to receive 530–600ml (18–20fl oz) of breast or formula milk a day, divided between three milk feeds and inclusive of milk used in food. To ensure that your baby gets the right balance of milk and solids aim for a 180–240ml (6–8fl oz) milk feed first thing in the morning and one last thing in the evening.

To supplement the early weaning foods (cooked vegetables, fruit and baby rice) chicken, fish and meat can all be introduced at this stage, along with dairy products and wheat. Full-fat cow's milk can be used in cooking, but should not be given as a drink until one year. Pieces of soft fruit and cooked vegetables may also be given, but again, all of these foods should be introduced gradually and careful notes made of any reactions.

Between six and seven months babies will begin to put food in their mouths, and allowing babies to feed themselves is important. First finger foods include toast fingers and soft, cooked diced vegetables. Small amounts should be offered at every meal. I also recommend trying your baby on mini pasta shapes and thick soups at this stage.

At nine to twelve months, food can be chopped or diced, although meat should still be pulsed or very finely chopped. Further finger foods should be

encouraged, such as raw vegetables, and breast or formula milk consumption will continue to fall gradually. You can also encourage your baby to eat with a spoon. This is an important step in encouraging independence, dexterity and enthusiastic eating. If you feel that your baby's milk consumption falls too quickly and you are concerned about a low milk intake, additional dairy foods such as fromage frais and milk sauces can be introduced into the diet.

From one year it is important that large volumes of milk are discouraged, as this can reduce a baby's appetite for solid food. At this age, your baby needs a minimum milk intake of 350ml (12fl oz) a day, and no more than 600ml (20fl oz), inclusive of milk used in food. Try to abandon the bottle, and offer all drinks in a beaker from now on. Do encourage your child to keep up their fluid intake with water and diluted unsweetened fruit juice although drinking too much before a meal may considerably reduce a baby's appetite, so offer solids first to avoid this happening. I do believe that those babies who enjoy a wide variety of tastes and textures at this stage invariably grow up to be good, unfussy eaters.

From 12 months to 2 years

By this stage, your baby should be enjoying three well-balanced meals a day and eating a wide variety of foods, although it is still important to limit foods that are high in sugar and salt. Your contented baby will start to become a confident child and you may notice a change in his eating habits. The happy baby, who would eat anything, suddenly becomes more selective about food. Favourite meals are inexplicably refused, and some days your toddler will appear to eat virtually nothing. This type

of behaviour is normal and it is all part of a toddler asserting his independence. It is disheartening when your child rejects a nutritious meal, but do keep offering him a variety of foods. Continue to try to make the meals interesting and colourful, and if your child is being fussy, keep the portions small so they are not overwhelmed by the amount of food. Sometimes, toddlers simply want to recognise what they are eating, and one way of doing this is to encourage their involvement with food preparation and cooking. The main thing is to try to stay relaxed so that mealtimes are enjoyable, and do not become an area of conflict.

From 2 years

Eating with children is an excellent opportunity to talk, encourage good table manners and tempt your children to eat foods they may not have tried before. I love the Italian attitude to food, where family meals are the most important part of the day!

During the second year the eating habits of toddlers and young children become much more affected by outside influences, such as television advertisements, attending nursery or eating at the homes of friends and relatives. By establishing good eating habits at home, you will help to prepare children for their inevitable exposure to junk food and hopefully prevent them succumbing to unhealthy eating choices.

At this age, children expend a lot of energy; they will get hungry between meals so snacks will become an important part of their diet. Fruit, raw vegetables, yoghurt, wholemeal bread or cheese should make up their regular choices but biscuits and sweets may be offered occasionally as a special treat.

Another good way of encouraging your children to eat well is to try to involve them in the supermarket trip and the planning of meals. You could also start compiling their own special recipe book by cutting and pasting recipes they like and writing a few notes about the different foods and the countries they come from. Easy, fun recipes for getting children involved in the cooking include mini quiches, vegetable dippers, honeyed sausages, pork and beef meatballs, miniature toads in the hole and, of course, cookies.

It is often during the second or third year that family meals must accommodate the arrival of a second baby. Happily, the recipes I have included in this book can be adapted to suit both baby and toddler, while also providing parents with a nutritious and tasty evening meal. Happy cooking and may the whole family enjoy the results!

Soups

Soups are a great way of using leftovers to create nutritious and easy meals. This section offers a number of different soups that can be prepared in under 10 minutes and cooked in around 20 minutes – ideal at teatime when time is limited and energy levels are low for both mother and child. By adding pasta or croûtons to the soup, and serving with bread and cheese, you will provide your baby or toddler with a well-balanced, healthy meal, packed with vitamins and minerals.

Soups, where the vegetables and other ingredients can be puréed or left in larger pieces, are also a wonderful way of getting your baby to progress from mushy to more lumpy food. What's more, they can be made in large batches and frozen. This will save the busy mother many hours spent in the kitchen, as well as ensuring a quick meal that can be rustled up in minutes.

In addition to the soups, I have included some stock recipes, as stock forms the basis of most soups and is included in many of the other recipes in this book. Homemade stock is of course far tastier and more nutritious than the shop-bought variety which is very high in added salt. Once made, it should be stored in the fridge and used within 24 hours, or frozen in small containers such as ice-cube trays.

Cream of tomato soup

From 7-8 months Makes 1 litre (1³/₄ pints) Suitable for freezing

knob of [15g (1/2 oz)] unsalted butter 2 small potatoes, peeled and diced ½ small leek, diced, or 1 carrot, peeled and diced 300ml (½ pint) Chicken or Vegetable Stock (see page 33) 900ml (1½ pints) Tomato Sauce (see page 194) 2 tbsp double cream or full-fat milk

- Heat the butter in a large, heavy-bottomed saucepan, add the vegetables and sauté for 5 minutes.
- Add the stock and tomato sauce, then bring to the boil and simmer for a further 15 minutes. Purée to a smooth consistency, then bring to the boil once again.
- Cool slightly and then stir in the cream or milk just before serving.

Winter vegetable and lentil soup

From 8 months (mashed)
Makes 2.5 litres (4½ pints)
Suitable for freezing

- 1 tbsp olive oil
- 2 medium onions, peeled and chopped
- 2 sticks of celery, trimmed and chopped
- 6 medium potatoes, peeled
- 6 medium carrots, peeled
- 2.2 litres (4 pints) Vegetable Stock (see page 33)
- 225g (8oz) red lentils, rinsed under cold running water
- 1 tsp dried mixed herbs
- 1 small turnip, peeled
- 2-3 tbsp tomato purée
- 1 medium leek, washed and chopped
- Heat the oil in a large, heavy-bottomed saucepan, add the onions and cook for 2–3 minutes, then add the celery, one diced potato and one sliced carrot, and cook for a further 3–4 minutes.
- Add the stock, lentils and mixed herbs and bring to the boil, then simmer for 20 minutes. Remove from the heat to allow to cool, then purée to a smooth consistency.
- Dice the remaining carrots and potatoes and the turnip into even-sized chunks and add to the lentil mixture.
- Bring to the boil, add the tomato purée and the leek, and simmer for a further 20–30 minutes.

Chicken and vegetable broth

From 6-7 months Makes 600ml (1 pint) Suitable for freezing

1 tbsp olive oil
½ onion, peeled and sliced
75g (3oz) cooked chicken, chopped
300ml (½ pint) Chicken Stock (see page 33)
1 x 200g (7oz) can of sweetcorn, drained pinch of dried mixed herbs
2 tbsp frozen mixed vegetables (such as carrots, peas and cauliflower)

- Heat the oil in a large, heavy-bottomed saucepan and sauté the onion for 1–2 minutes.
- Add the chicken, stock, sweetcorn and herbs, bring to the boil and simmer for 10 minutes.
- Remove from the heat and purée to a smooth consistency. Add the frozen vegetables, bring back to the boil and simmer for a further 10 minutes. Purée the soup again if serving to a six- or seven-month-old baby.

Scotch broth

From 8-9 months Makes 2.2 litres (4 pints) Suitable for freezing

110g (4oz) broth mix

1 tbsp olive oil

2 medium onions, finely diced

3 medium carrots, peeled and cut into matchsticks

4 medium potatoes, peeled and diced

1 small turnip, peeled and diced

1.7 litres (3 pints) Chicken Stock (see page 33)

50g (2oz) red lentils, rinsed under cold running water

1 medium carrot, peeled and grated

2 small leeks, washed and finely sliced

- Soak the broth mix overnight in cold water, drain and rinse well under cold running water.
- Heat the oil in a large, lidded saucepan, add the onions and cook for a few minutes, then add the carrots, potatoes and turnip, and cook for a further few minutes.
- Add the chicken stock, broth mix and lentils, bring to the boil, then cover with the lid and simmer for 40 minutes, stirring occasionally.
- Add the grated carrot and leeks, and bring to the boil again, then simmer gently for a further 40 minutes or until the broth mix is tender.

Cream of chicken and sweetcorn soup

From 6-7 months Makes 1 litre (1³/₄ pints) Suitable for freezing

knob [15g (1/2 oz)] of unsalted butter 2 medium onions, peeled and chopped 2 small potatoes, peeled and diced 25g (1oz) flour 600ml (1 pint) Chicken Stock (see page 33) 225g (8oz) cooked chicken, chopped 1 bay leaf 600ml (1 pint) full-fat milk 1 x 200g (7oz) can of sweetcorn, drained 1 x 142ml (5oz) carton of double cream

- Melt the butter in a large, heavy-bottomed saucepan. Add the onions and potatoes and fry gently for 5 minutes, stirring occasionally.
- Add the flour, then stir in the stock, a little at a time. Add the chicken and bay leaf, then bring to the boil and simmer for 20 minutes.
- Add the milk and sweetcorn and simmer for a further 10–15 minutes. Take off the heat, remove the bay leaf and purée until completely smooth.
- To serve, reheat the soup if necessary, stir in the cream and simmer gently for 5 minutes.

Vegetable stock

Makes 1 litre (1³/₄ pints) Suitable for freezing

- 1 onion, peeled and quartered 2 carrots, peeled and diced 3 sticks of celery, trimmed and sliced ½ leek (green top), washed and sliced 1.5 litres (2½ pints) water
- Place all the ingredients in a large, lidded saucepan, bring to the boil, then lower the heat. Half cover with the lid and simmer for 1 hour.
- Strain the stock into a jug, discarding the vegetables, then cover and leave to cool.

Chicken stock

Makes 1 litre (1³/₄ pints) Suitable for freezing

- 1 chicken carcass
- 1 onion, peeled and quartered
- 1 carrot, peeled and diced
- 1 stick of celery, or ½ leek (green top), trimmed and sliced (optional)
- 1 bay leaf (optional)
- 2 litres (3½ pints) water
- Place all the ingredients in a large, lidded saucepan, bring to the boil, skim off any surface froth then lower the heat. Half cover with the lid and simmer for 2 hours or until the liquid has reduced by half.
- Strain the stock into a jug, discarding the chicken carcass and vegetables, then cover and leave to cool.

Lunch

Lunch

Those of you with babies or toddlers as well as older children at school will probably find you have more time to cook in the mornings than in the afternoons. Additionally, in my experience, it tends to be better for toddlers and pre-school children to have their main meal in the middle of the day, so most of the recipes in this section are quite substantial. They do require more preparation and a longer cooking time than the quick and easy recipes of the teatime chapter, but they can be made in large quantities, then frozen and reheated as required, which means you won't have to spend every morning cooking. Importantly, recipes such as Shepherd's Pie and Cheesy Chicken Gratin (pages 64 and 47) are not only filling but are packed with goodness and energy and, when served with a portion of green vegetables or carrots, will ensure your child is receiving an ideal balance of protein, carbohydrate and fibre plus lots of vital vitamins.

A good healthy lunch will mean that by teatime, when everyone is getting tired, you can take a fairly relaxed view if your child doesn't show much interest in food because he'll already have had a substantial nutritious meal that day.

Plaice fillet with peas and potato

Fish is high in protein, B vitamins and minerals. Omega-3 fatty acids, which are believed to aid brain development are abundant in oily fish. Ideally, you should try giving it to your child at least once or twice a week. Mixing it with other ingredients, as here, can make it much more attractive to young children who might otherwise be reluctant to eat this wonderfully nutritious food.

From 6-7 months Makes 4-6 servings Suitable for freezing

225g (8oz) plaice fillets, skinned and boned 125ml (4fl oz) full-fat milk 3 medium potatoes, peeled and halved 110g (4oz) frozen petit pois or garden peas 25g (1oz) unsalted butter

- Put the plaice and 90ml (3fl oz) of the milk in a saucepan, bring to the boil and simmer for 5 minutes, then strain the fish, saving the milk for later.
- Meanwhile, place the potatoes in another saucepan, cover with water, bring to the boil and simmer for 20 minutes. Add the peas, bring back to the boil for 2 minutes and strain.
- Mash the potato with the remaining cold milk and the butter.
- Either mash the fish and peas together with the back of a fork and a bit of the fishy milk or, for babies who can't yet manage larger pieces of food, purée them with the milk using a hand-held blender. Then mix in the mashed potato.

Cod with cheese sauce and broccoli

Combining fish with a delicious sauce is a great way of ensuring that your child is getting a highly nutritious, power-packed meal. Instead of making the cheese sauce from scratch for this recipe, you could defrost and heat up 6–8 cubes of frozen, pre-prepared Definitive Cheese Sauce (see page 196).

From 6-7 months (puréed) From 9 months (mashed) Makes 4-6 servings Suitable for freezing

225g (8oz) cod fillet, skinned and boned 15g (½oz) unsalted butter freshly squeezed lemon juice 5oz (150g) broccoli, cut into florets

For the cheese sauce 25g (1oz) unsalted butter 1 level tbsp plain flour 300ml (½ pint) full-fat milk 50g (2oz) mild Cheddar cheese, grated pinch of freshly grated nutmeg

- Pre-heat the oven to 200°C/180°Fan/Gas Mark 6. Place the cod fillet on a piece of foil, dot with the butter, squeeze over a few drops of lemon juice and seal the foil like a parcel. Place in the pre-heated oven for 15 minutes.
- Meanwhile, steam the broccoli for 10 minutes.
- For the cheese sauce, melt the butter in a non-stick saucepan. Turn off the heat and slowly add the flour, stirring continuously. Turn the heat back to a medium setting and gradually add the milk, stirring all the time, then turn the heat down and cook for about 10 minutes or until the sauce thickens.
- Add the cheese and nutmeg, and stir on a low heat until the sauce is completely smooth.
- Purée the fish and broccoli for a six-month-old, or mash it using the back of a fork for an older baby who can manage the bigger pieces, then mix in the cheese sauce.

Italian fish stew

This is delicious served with thick crusty bread (for older children) or buttered toasted fingers.

From 9 months (mashed) Makes 2 servings Suitable for freezing

1 tbsp olive oil

½ small red or white onion, peeled and very finely chopped

1/4 garlic clove, peeled and crushed

1 courgette, finely diced

1 tbsp chopped fresh or a pinch of dried basil

300ml (½ pint) Tomato Sauce (see page 194)

1 cup of water or Vegetable Stock (see page 33)

50q (13/4 oz) small pasta shapes

110g (4oz) white fish fillets (such as cod or haddock)

2 tbsp frozen or tinned sweetcorn

- 1 tbsp flour mixed to a smooth paste with a small amount of hot stock
- Heat the oil in a heavy-bottomed saucepan, then add the onion and garlic, and cook over a low heat for 3–4 minutes. Add the courgette and basil, and cook for a further 2 minutes, stirring occasionally.
- Add the tomato sauce and the stock and bring the mixture to the boil, then add the pasta and bring back to the boil. Reduce the heat and simmer for a further 5 minutes, add the fish and sweetcorn and simmer for 5 more minutes.
- Add the flour and stock paste, mixing gently until thickened slightly. Simmer for a further 2–3 minutes.
- Purée or mash the baby's portion.

Smoked fish pie

Smoked haddock has quite a strong flavour and may be more suited to an older child's palate. Serve this with a green vegetable such as broccoli or peas.

From 18 months Makes 4-6 servings Suitable for freezing

225g (8oz) undyed smoked haddock (skin on) 300ml (½ pint) milk 50g (2oz) unsalted butter 50g (2oz) plain flour handful of finely chopped, fresh parsley 2 eggs, hardboiled and chopped (optional)

For the mashed potato 450g (1lb) potatoes, peeled and chopped 1 tbsp milk

25g (1oz) butter

- Pre-heat the oven to 200°C/180°Fan/Gas Mark 6. Poach the smoked haddock in the milk for about 7 minutes until just cooked. Strain the fish, reserving the milk, then skin the fish and flake the flesh, removing any bones.
- Melt the butter in a saucepan, add the flour and cook for a couple of minutes, before gradually adding the milk from the fish. Simmer the sauce gently for 10 minutes until thickened, then add the parsley, flaked fish and eggs (if using).
- Meanwhile, boil the potatoes until tender, drain off all the water, return to the heat and shake vigorously until the potatoes are really dry. Mash well, then add the milk and butter and whip the mixture hard with a fork.
- Spread the fish mixture onto the base of a gratin dish before adding the mashed potato and forking over the top. Bake in the pre-heated oven for 30 minutes or until golden brown on top.

Smoked haddock and mashed potato in parsley sauce

This classic combination is always a family favourite. Serve it with a green vegetable or with my French Pea Purée (see page 142).

From 18 months
Makes 2 servings
Unsuitable for freezing

175g (6oz) undyed smoked haddock fillet, (skin on)
180ml (6fl oz) full-fat milk
15g (½ oz) unsalted butter
1 dessertspoon plain flour
handful of chopped fresh parsley
2 large potatoes, baked in their jackets (see page 94)

- Poach the haddock in the milk at a gentle simmer for 5–7 minutes until cooked. With a slotted spoon, remove the fish from the milk, reserving the liquid for the parsley sauce.
- Skin the haddock and break it up into flakes. Take care to remove all stray bones. Melt the butter in a clean saucepan and add the flour, cooking for 1–2 minutes before gradually adding the reserved milk and parsley. Cook for a further 5–10 minutes, stirring occasionally.
- Spoon the potatoes from their skins into a bowl and break up well with a fork. Add the haddock and parsley sauce and stir gently.

Roast poussin

A poussin is a chicken about the size of your hand. It can have a lot of small bones so you will need to check your children's portions carefully.

From 10 months
1 poussin serves 2 children
Unsuitable for freezing

2 tbsp olive oil 1 poussin ½ tsp dried oregano ½ pear or ½ lemon 1 large potato

- Pre-heat the oven to 200°C/180°Fan/Gas Mark 6. Drizzle 1 tablespoon of the oil onto the chicken, rubbing in well, then sprinkle with the oregano and place the pear or lemon into the cavity.
- Cut up the unpeeled potato into 1cm/½in cubes and spread around the poussin in the roasting tin. Use the rest of the olive oil to drizzle onto the potato cubes and roast in the pre-heated oven for 45–60 minutes, basting everything once or twice during cooking and turning the potato cubes so they brown evenly.

Cheesy chicken gratin

Serve this with some boiled new potatoes or mash for a nutrient-filled lunch.

From 6-7 months Makes 2 servings Unsuitable for freezing

knob of [15g (1/2 oz)] unsalted butter ½ onion, peeled and very finely sliced 1 tbsp plain flour 1 cup of Chicken Stock (see page 33) 75–110g (3–4oz) cooked chicken, finely chopped 1 cup of frozen mixed vegetables, cooked 1 tsp dried mixed herbs 2 tbsp double cream or fromage frais ½ cup of breadcrumbs ½ cup of mild Cheddar cheese, grated

- Pre-heat the grill on a moderate setting. Melt the butter in a saucepan, add the onion and cook until tender. Add the flour and stir well, then pour in the stock a little at a time, stirring continuously, and bring to the boil.
- Add the cooked chicken and vegetables, stir well, then add the herbs and cream or fromage frais and pour the mixture into a small well-buttered ovenproof dish.
- Mix together the breadcrumbs and the grated cheese and sprinkle over the top of the chicken mixture, then place under the pre-heated grill for a few minutes until golden brown.

Chicken and sweet potato casserole

This recipe also works well using butternut squash instead of sweet potato.

From 6 months (puréed)
From 9 months (mashed)
Makes 4-6 servings
Suitable for freezing

2 boneless chicken thighs, skin removed 1 tbsp olive oil ½ small onion, very finely chopped 1 sweet potato, peeled and chopped into 2.5cm (1in) cubes 180ml (6fl oz) Chicken Stock (see page 33) ¼ tsp dried thyme

- Heat the oil in a saucepan and, when sizzling, add the onion and cook for about 5 minutes until softened.
- Chop the chicken into small pieces, then add to the pan. Cook for a couple of minutes, stirring occasionally, then add the sweet potatoes, stock and thyme. Stir well, bring to the boil, then reduce to a simmer and cook for 20 minutes or until the sweet potato is tender. Blend in a liquidiser for a six-month-old or mash with the back of a fork for a nine-month-old.

Chicken and leek lasagne

This recipe is perfect for freezing (divided into smaller batches once cooked) and reheating as required. You may need to place it under the grill to brown before serving.

From 9 months (mashed) Makes 6-8 servings Suitable for freezing

50g (2oz) unsalted butter
2 leeks, washed and finely sliced
1 courgette, chopped
2 large, skinless chicken breasts, diced
50g (2oz) plain flour
600ml (1 pint) full-fat milk
1 tbsp grainy mustard
6 ready-to-cook lasagne sheets
2 tbsp Parmesan cheese, freshly grated

- Pre-heat the oven to 180°C/160°Fan/Gas Mark 4. Melt the butter in a large saucepan or frying pan, add the leeks and cook until they begin to soften.
- Add the courgette and chicken, and stir-fry for a few minutes until the chicken is just cooked through. Add the flour and cook, stirring continuously, for 1 minute.
- Remove the pan from the heat and stir in the milk, a little at a time, until the sauce is smooth. Return the pan to the heat and bring gradually to the boil, stirring continuously, then simmer for 2 minutes. Add the mustard and remove from the heat.
- Lightly oil a square or rectangular ovenproof dish about 7.5cm (3in) deep. Layer the chicken pieces and lasagne sheets, starting with a layer of chicken and finishing with a lasagne sheet, and using a slotted spoon for the chicken so that you leave the sauce behind in the saucepan.
- Spoon the remaining sauce over the lasagne, sprinkle with the Parmesan and bake in the pre-heated oven for 25–30 minutes until golden brown on top.

Quick pilaf

You can prepare and cook this pilaf in just over half an hour so it's an ideal lunch solution when you've had a busy morning.

From 7 months (mashed) Makes 3-4 servings Suitable for freezing

knob of unsalted butter
2 tsp olive oil
½ small onion, peeled and finely chopped
½ red pepper, diced
100g (3½ oz) long-grain rice
300ml (½ pint) Chicken Stock (see page 33)
225g (8oz) shredded cooked chicken
1 tbsp seedless raisins or sultanas
pinch of saffron

- Heat the butter and olive oil in a heavy-bottomed saucepan, add the onion and sauté gently for 2 minutes. Then add the red pepper and rice and cook for 2–3 minutes until the rice is transparent.
- Add the stock, chicken, raisins or sultanas and saffron and bring to the boil, then simmer for 20 minutes, stirring all the time, until the stock has been fully absorbed.

Chicken with cream cheese and Parma ham

Some young children find Parma ham difficult to chew. You could substitute it here for slices of honey roast ham. Serve this with vegetables and new potatoes.

From 18 months
Makes 4-6 servings
Unsuitable for freezing

- 3 tbsp cream cheese
- 2 tbsp chopped fresh parsley and thyme or 2 tsp of the dried herbs
- 3 skinless, boneless chicken breasts
- 6 slices of Parma ham or honey roast ham olive oil
- Pre-heat the oven to 200°C/180°Fan/Gas Mark 6. Mix together the cream cheese and herbs. Slit the chicken breasts down the middle lengthways, then stuff with the cream cheese mixture.
- Wrap the chicken in the Parma or honey roast ham so that it overlaps to cover the open edge. This will prevent the cream cheese from escaping while cooking.
- Place in a greased ovenproof dish and drizzle with the oil. Bake for 20–25 minutes until cooked through. Slice the chicken thinly.

Chicken and mushroom gratin

Children will love this creamy, comforting dish – it's perfect for cold, wintery days when they need something warming that will also replenish their energy levels.

From 18 months
Makes 4 servings
Unsuitable for freezing

- 1 shallot, peeled and finely chopped
- 1 tbsp olive oil
- 2 cooked chicken breasts, or equivalent amount in thigh meat
- 2 cups of broccoli florets, cooked for 3 minutes
- ½ tsp mild curry powder
- 1 tbsp freshly squeezed lemon juice
- 1 x 300g (11oz) can of condensed mushroom soup
- 1 cup of mayonnaise
- 2 cups of mild Cheddar cheese, grated
- 2 cups of breadcrumbs
- Pre-heat the oven to 200°C/180°Fan/Gas Mark 6, then sauté the shallot in the oil for 5–10 minutes until softened.
- Meanwhile, cut the chicken into strips and use to cover the bottom of a gratin dish, then place the broccoli on top.
- Sprinkle the curry powder over the shallot and cook gently for 1 minute. Remove from the heat and add the lemon juice, soup and mayonnaise, mix well, then pour onto the chicken and broccoli.
- Mix the cheese and breadcrumbs together and scatter over the top, then place in the pre-heated oven for about 25 minutes or until golden brown.

Fruity chicken salad

This delicious, nutritious salad is packed full of natural goodness, energy and vitamin C.

From 1 year
Makes 2 servings
Unsuitable for freezing

110g (4oz) cooked chicken, sliced or diced 1 small orange, peeled and chopped 6 seedless grapes, chopped in half 1 small apple, peeled, cored and diced 4 tbsp natural yoghurt 30ml (1fl oz) orange juice 100g (3½ oz) easy-cook long-grain rice 1–2 tbsp sultanas

- Mix together the chicken, fresh fruit and yoghurt, then stir in just enough orange juice for a slightly runny consistency.
- Cook the rice according to the instructions on the packet, adding the sultanas to the rice for the final 5 minutes. Spoon onto a serving plate and top with the chicken and fruit mixture.

Chicken with tagliatelle

Although I wouldn't normally advise giving a baby sugar, I've included a small amount in this recipe to counter-balance the acidity of the tomatoes. You can leave it out if you'd rather not give your baby any at all.

From 9 months (mashed)
Makes 6-8 servings
Tomato sauce is suitable for freezing

50g (2oz) unsalted butter 2 large skinless, boneless chicken breasts, thinly sliced 284ml (10fl oz) carton of double cream 250g (9oz) fresh white or green tagliatelle

For the tomato sauce

- 1 onion
- 2 tbsp olive oil
- 1 garlic clove, peeled and crushed
- 1 x 400g (14oz) can of chopped tomatoes
- 1 tsp dried oregano
- 2 bay leaves
- 2 tbsp tomato purée
- 1 tsp sugar (optional)
- To make the tomato sauce, fry the onion gently in the oil until softened but not browned. Add the garlic and fry for 1 minute.
- Stir in the tomatoes, oregano, bay leaves, tomato purée and sugar (if using), and bring to the boil. Simmer for 15 minutes until the sauce has reduced by half, then discard the bay leaves and keep the sauce warm over a very low heat.
- Melt the butter in a frying pan and fry the chicken gently for 5 minutes. Add the cream and simmer until reduced by a third.
- Meanwhile, cook the tagliatelle according to the instructions on the packet.
- Spoon the tomato sauce over individual portions of pasta and add the chicken on top.
- If serving to a baby under 12 months, mash their portion with a fork.

All-in-one braised lamb and veg

For a child's portion of lamb, cut the meat from the bone (it should come away easily) and chop into small pieces.

From 1 year Makes 6-8 servings Suitable for freezing

- 4 lamb shanks about 450g/1lb each
- 2 tbsp olive oil
- 2 large onions, peeled and finely chopped
- 2 cloves garlic, peeled and crushed
- 1 tsp dried mixed herbs
- 4 large potatoes, peeled and cut into chunks
- 6 large carrots, peeled and cut into large chunks
- 2 large parsnips, peeled and cut into large chunks
- 1 cup of Puy lentils
- about 600ml (1 pint) water or Vegetable or Chicken Stock (see page 33)
- Pre-heat the oven to 170°C/150° Fan/Gas Mark 3. In a large, lidded casserole dish, fry the lamb in the oil until browned on all sides.
- Add the onions and garlic and fry for a further few minutes. Add the herbs, vegetables and lentils and enough water or stock to cover all the ingredients, then bring to the boil.
- Cover with the lid and bake in the pre-heated oven for 3 hours or until the meat is tender and beginning to fall from the bone.

Tender lamb in a pot

Serve this with some plain boiled new potatoes.

From 9 months (mashed)
Makes 4-6 servings
Unsuitable for freezing

- 1 tbsp olive oil
- 1 small shoulder of lamb about 1kg/2lb 4oz
- 1 dessertspoon balsamic vinegar
- 2 tsp redcurrant jelly
- 2 x 400g (14oz) cans of chopped tomatoes
- 1 small garlic clove, peeled and crushed
- 3 courgettes, chopped into sticks
- Pre-heat the oven to 170°C/150°Fan/Gas Mark 3. Heat the oil in a casserole dish and, when hot, add the lamb, skin side down. Fry for a couple of minutes until the skin begins to brown, turn over and fry for another few minutes.
- Add the vinegar, redcurrant jelly, tomatoes and garlic and bring up to simmering point. Cover with the lid and transfer to the preheated oven to cook for 2 hours or until the lamb is really tender.
- Add the courgettes for the last 10 minutes of cooking time.
- Lift out the lamb and transfer to a warm plate. Either carve, or cut away chunks of meat.

Easy lamb and fruit couscous

This is a wonderfully aromatic and flavoursome dish which is good for helping your children's tastes develop. Cinnamon and nutmeg are both very mild spices.

From 9 months
Makes 8-10 servings
Lamb mince is suitable for freezing

1 tbsp olive oil
1 onion, peeled and finely chopped
2 carrots, peeled and finely chopped
500g (1lb 2oz) lean minced lamb
1 tbsp plain flour
1 x 400g (14 oz) can of tomatoes
250ml (9fl oz) Chicken Stock (see page 33)
1/4 tsp ground cinnamon
1/4 tsp grated nutmeg
2 garlic cloves, peeled and crushed

For the couscous

225g (8oz) couscous 110g (4oz) ready-to-eat dried apricots, chopped 25g (1oz) currants freshly squeezed juice of 1 orange

- Heat the oil in a large, lidded saucepan and add the onion and carrots.
 Cook for 2-3 minutes. Add the mince and cook over a low heat until the onion is softened and golden brown, and the mince is browned all over.
- Add the flour and cook for 2 minutes before adding the tomatoes and stock. Bring to the boil, stirring continuously.
- Add the spices and garlic and cover the pan with a lid. Simmer for 30 minutes.
- \bullet Meanwhile, place the couscous, apricots and currants in a bowl, pour over 450ml (% pint) boiling water and leave to stand for 5 minutes. Place the heated couscous mixture in a sieve and steam above a pan of boiling water for 5 minutes. Fluff up the couscous with a fork.
- Stir in the orange juice, spoon a little from the baby pan onto your child's plate and add his portion of mince.

Shepherd's pie

This is ideal for freezing. Fill ten ramekin dishes or one large gratin dish and freeze for later use, then defrost as needed, sprinkle with the grated cheese and cook in a hot oven (see below) for 20–25 minutes.

From 10 months Makes 8-10 servings Suitable for freezing

1 tbsp vegetable or olive oil

1 medium onion, peeled and finely chopped

1 medium carrot, peeled and finely chopped

1 garlic clove, peeled and finely chopped

450g (1lb) minced lamb

1 tbsp finely chopped, fresh parsley

1 tbsp plain flour

1 tbsp tomato purée

300ml (½ pint) Chicken Stock (see page 33)

900g (2 lb) potatoes

25g (1oz) unsalted butter

60ml (2fl oz) full-fat milk

50g (2oz) mild Cheddar cheese, grated

- Pre-heat the oven to 200°C/180° Fan/Gas Mark 6. Heat the oil in a large casserole dish or a lidded saucepan or frying pan. Add the onion and sauté for about 5 minutes until translucent and slightly browned.
- Add the carrot and cook for a further 5 minutes. Stir in the garlic and then the mince, cooking until the meat has browned. Add the parsley and mix in the flour, stirring continuously to soak up the juices. Mix in the tomato purée, then slowly add the stock, stirring all the time.
- Put the lid on the casserole dish and simmer for 20 minutes. Meanwhile, bring the potatoes to the boil in a saucepan of water and simmer for 20 minutes, then drain and mash with the butter and milk.
- Place the meat mixture into a greased gratin dish and spread the mashed potato on top. Sprinkle with the grated cheese and place in the pre-heated oven for 10 minutes until golden brown on top.

Steak and kidney pie

This is ideal for freezing. Rather than make one big pie, you could make 4–5 small individual ones, put them in freezer bags, and freeze for up to 2 months. Reheating them in a hot oven for 20 minutes (see below).

From 1 year Makes 8-10 servings Suitable for freezing

110g (4oz) lambs' kidneys 450g (1lb) stewing steak

1 tbsp flour

1 tbsp vegetable or olive oil

2 medium onions, peeled and finely sliced

2 carrots, peeled and finely sliced

300ml (½ pint) Vegetable Stock (see page 33)

50g (2oz) mushrooms, peeled and finely chopped (optional)

2 tbsp tomato purée

1 x 500g (1lb 2oz) packet of chilled puff pastry

1 egg, beaten, to glaze

- Wash the kidneys under cold running water, pat dry with kitchen paper, remove the skin, chop in half and cut out the cores. Cut the steak and kidneys into equal-sized pieces and coat with the flour.
- Heat the oil in a large, lidded saucepan, then add the onions and cook for until soft. Add the meat and cook until browned all over.
- Add the carrots and enough stock to cover the meat. Bring to the boil, cover with the lid and simmer for approx $1\frac{1}{2}$ hours or until the meat is tender. Check and stir occasionally, adding more stock if necessary.
- Allow to cool, then mix in the mushrooms (if using) and transfer to a large pie plate. Stir the tomato purée into the meat juices and pour over just enough to cover the meat mixture.
- Pre-heat the oven to 220°C/200°Fan/Gas Mark 7. Roll out the pastry into a circle slightly larger than the pie dish, dampen the edge of the dish with water and cover with the pastry. Trim the pastry and press the edges down well using a knife or your thumb.
- Brush with the beaten egg and bake near the top of the oven for about 20 minutes or until golden brown.

Easy roast lamb

Serve the roast lamb with a selection of vegetables and Roasted New Potatoes (see page 146).

From 7-8 months (mashed)
From 1 year (cut into bite-sized pieces)
Makes 6 servings
Unsuitable for freezing

1 tbsp olive oil
1 tbsp redcurrant jelly
½ tsp dried rosemary
2 racks of lamb (about 1kg/2lb 4oz each)
black pepper

For the gravy

dash of Worcestershire sauce 1 tsp balsamic vinegar 2 tsp redcurrant jelly 350ml (12fl oz) Vegetable Stock (see page 33) 1 tbsp plain flour

- Pre-heat the oven to 220°C/200°Fan/Gas Mark 7. Rub the oil, redcurrant jelly and rosemary over the lamb and season with a grinding of black pepper.
- Cook the racks of lamb in a roasting tin in the pre-heated oven for about 20–25 minutes (slightly less if pink meat is desired).
- Meanwhile, start to make the gravy. Add the Worcestershire sauce, vinegar and redcurrant jelly to the stock, stirring well. Keep warm in a saucepan set over a very low heat.
- Once the lamb is ready, keep warm on a carving board by covering in foil. Remove all but 2 tablespoons of juice from the roasting tin and bring up to sizzling point over a medium heat.
- Add the flour and cook for a minute, stirring continuously. Gradually pour in the hot stock, stirring until the gravy thickens. Boil rapidly for 2–3 minutes, then strain into a jug for serving.

Easy roast beef

Serve this with Roasted Root Vegetables (see page 152) and baked potatoes.

From 9 months (mashed)
From 1 year (cut into bite-sized pieces)
Makes 8-10 servings
Unsuitable for freezing

1 x 1.4kg (3lb) topside or rolled rib of beef 1 tbsp olive oil black pepper

For the gravy

350ml (12fl oz) Vegetable Stock (see page 33) dash of gravy browning or Worcestershire sauce 1 tbsp plain flour

- Pre-heat the oven to 220°C/200°Fan/Gas Mark 7. Rub the beef joint with the oil and season generously with black pepper.
- Cook in a roasting tin in the pre-heated oven for 20 minutes. Turn the heat down to 190°C/170°Fan/Gas Mark 5 and roast, basting occasionally, for a further 15 minutes per 450g (1lb).
- Take the beef out of the oven and keep warm by covering with foil. Drain off all but 2 tablespoons of the juice in the roasting tin.
- Mix together the stock and gravy browning or Worcestershire sauce, then place the roasting tin over a medium heat and, when the fat begins to sizzle, stir in the flour and cook for a couple of minutes, stirring continuously. Gradually add the hot stock, stirring until the gravy thickens. Boil for 2–3 minutes and strain into a jug for serving.

Easy roast pork

This dish goes perfectly with Sweet Red Cabbage (see page 150). Remember to remove any wrapping from the pork joint while it is in the fridge to ensure good dry skin for the crispiest crackling which, although not suitable for babies and toddlers, older children will love.

From 18 months
Makes 8-10 servings
Unsuitable for freezing

1 apple, peeled, cored and sliced handful of dried apricots 1 tbsp olive oil 1 shoulder of pork (about 1.4kg/3lb) salt

For the gravy

350ml (12fl oz) Vegetable Stock (see page 33) dash of gravy browning or Worcestershire sauce 1 tbsp plain flour

- Pre-heat the oven to 220°C/200°Fan/Gas Mark 7. Scatter the sliced apple and the apricots over the base of a roasting tin lined with non-stick baking paper and drizzle with the oil.
- Rub a little oil into the pork skin to ensure good crunchy crackling, then sit the joint on top of the fruit in the tin and place in the pre-heated oven for 20 minutes. Turn the oven down to 190°C/170°Fan/Gas Mark 5 and continue to cook for a further 1½ hours or until the juices run clear when the joint is pierced. Baste occasionally.
- Take the pork out of the oven and keep warm by covering with foil. Drain off all but 2 tablespoons of the juice in the roasting tin, reserving the soft apple and apricots for serving with the meat.
- Mix together the stock and gravy browning or Worcestershire sauce, then place the roasting tin over a medium heat and, when the fat begins to sizzle, stir in the flour and cook for a couple of minutes, stirring continuously. Gradually add the hot stock, stirring until the gravy thickens, boil for 2–3 minutes and strain into a jug for serving.

Homemade apple sauce

The classic accompaniment to roast pork never tasted so good. Keep any extra sauce in an airtight container ready to serve with some grilled chops or sausages another day.

From 9 months
Makes about 300ml (½ pint)
Suitable for freezing

knob of unsalted butter
1 shallot, peeled and finely chopped
1 garlic clove, finely chopped
2 Bramley cooking apples, peeled, cored and chopped
150ml (1/4 pint) apple juice
2 tbsp water

- Melt the butter in a medium saucepan and fry the shallot and garlic over a gentle heat for 5 minutes until softened. Take care not to let the garlic burn.
- Add the cooking apples together with the apple juice and the water. Bring to the boil and then simmer uncovered for 10–15 minutes, stirring occasionally, until the apples have fallen to a slush.
- Either mash with a fork or blend to a smooth purée before serving.

Finger Foods

Finger Foods

Eating food with your hands, whether it's cheese on toast or chicken drumsticks, is fun at whatever age, but all the more so when you're a young child and getting messy is part of what makes meals enjoyable. There is an informality about serving finger food that makes mealtimes seem a less serious business, less likely to turn into a battle of wills between parent and child – especially at the end of the day when tempers can easily fray. Because of this, serving your baby or toddler with items he can eat with his fingers can be a good way of tempting him to try foods – such as fish – that he may otherwise refuse.

Welsh rarebit

From 1 year Makes 4 servings Unsuitable for freezing

4 slices of bread unsalted butter for spreading 175g (6oz) mild Cheddar cheese, grated 1 egg, beaten few drops of Worcestershire sauce

- Pre-heat the grill to medium-hot, toast the bread on both sides and butter one side lightly.
- Meanwhile, mix together the cheese, egg and Worcestershire sauce. Spread on the 4 slices of toast.
- Place under the pre-heated grill for a few minutes until golden brown. Leave for 2 minutes to set slightly before serving.

Chicken and Parmesan fingers

Marinating the chicken tenderises it, making it much easier for young teeth to chew.

From 1 year Makes 1-2 servings Suitable for freezing

1 large boneless, skinless chicken breast 90ml (3fl oz) full-fat milk, mixed with 1 dessertspoon runny honey

- 1 tbsp olive oil
- 1 egg, beaten
- 1 tbsp freshly grated Parmesan cheese, mixed with 2 tbsp breadcrumbs
- Cut the chicken into strips and marinade in the milk and honey mixture for about 1 hour.
- Pour the oil into a frying pan and bring to sizzling point. Meanwhile, dip the chicken strips into the beaten egg and then into the cheese and breadcrumb mixture, before adding to the pan.
- Cook for 5 minutes on each side or until the chicken is cooked through and golden and crispy.
- Serve with Vegetable Dippers (see page 174) or any of the suggestions in the vegetable chapter.

Croque monsieur

From 18 months Makes 2 servings Unsuitable for freezing

unsalted butter for spreading 4 slices of white bread, crusts removed 2 slices of Emmental cheese 2 slices of ham 1 tbsp olive oil

- Lightly butter the bread on one side only, then place two slices on a chopping board, butter side down, and cover each piece with a slice of cheese and a slice of ham before sandwiching with a remaining piece of bread, butter side up.
- Pour the oil into a frying pan set over a medium heat, then fry the sandwiches for 2 minutes each side until golden brown and the cheese is melting.
- Allow to cool a little, then cut into strips and serve.

Chicken drumsticks in a marinade

From 18 months
Makes 2 servings
Unsuitable for freezing

90ml (3fl oz) apple juice

- 1 dessertspoon soy sauce
- 1 garlic clove, peeled and chopped
- 2 tsp runny honey or soft brown sugar
- 4 chicken drumsticks
- Mix together the apple juice, soy sauce, garlic and honey. Pour over the drumsticks and leave to marinate for at least 1 hour.
- Pre-heat the oven to 190°C/170° Fan/Gas Mark 5.
- Remove the drumsticks from the marinade and place on a rack over a roasting tin, or alternatively place on non-stick baking paper in the roasting tin, and cook in the pre-heated oven for about 30 minutes or until cooked through.
- Serve with a selection of raw sliced vegetables.

Cheese toasties with cherry tomatoes and ham

From 18 months
Makes 4 servings
Unsuitable for freezing

- 4 English muffins
 unsalted butter for spreading
 4 large slices of ham, cut in half
 8 cherry tomatoes, cut into thin slices
 4 large slices of mild Cheddar cheese, cut in half
- Pre-heat the grill on a medium-high setting.
- Cut the muffins in half and toast, then spread with a little butter. Place a half slice of ham onto each muffin half, followed by some tomato slices and a half slice of cheese.
- Repeat for all the muffins, then put onto a baking sheet and place under the pre-heated grill for about 5 minutes or until the cheese is bubbling.
- Cut the muffins into quarters or slices to serve.

Quick salmon fishcakes

From 10 months Makes 6 fishcakes Suitable for freezing

4 medium potatoes, peeled 50g (2oz) unsalted butter 1 x 200g (7oz) tin of red salmon 1 tsp freshly squeezed lemon juice 1 egg yolk, beaten 1 egg white, beaten 75g (3oz) breadcrumbs 1 tbsp olive oil

- Boil the potatoes until tender, then mash well, adding a third of the butter, and set aside to cool.
- Add the salmon, lemon juice and egg yolk to the potatoes and mix well. Form into 6 patties, then coat with beaten egg white, followed by the breadcrumbs.
- Fry gently in the remaining butter and the oil for 3–4 minutes per side or until crispy.

Crunchy fish sticks

From 1 year Makes 6 fish sticks Suitable for freezing

- 1 cod or haddock fillet, skinned and boned
- 1 egg, well beaten
- 2 tbsp plain flour
- 2 tbsp breadcrumbs
- 1 tbsp olive oil
- Cut the fish, going across the grain, into 6 strips. (Do not cut the strips too small or they may fall apart.)
- Dip the fish strips into the beaten egg, then the flour and finally the breadcrumbs.
- Heat the oil in a frying pan until sizzling and cook the dipped fish, on a medium heat, for 2–3 minutes each side until golden brown.

5

Teatime Treats

Teatime Treats

Most mothers with a baby and other young children agree that 5pm until bedtime is the most hectic and often most stressful part of their day. For children who've had a long day at school, however, teatime should be fun and enjoyable – a chance to relax and spend time with you and their siblings. The teatime suggestions in this chapter are all quick and easy to prepare as well as being popular with the children. Where possible, they have been designed to prevent you having to make several different meals for your family members – most recipes can be transformed into baby, toddler or adult meals as required and several use leftovers from a grown-up supper the day before or easy-to-find, store cupboard ingredients.

Often, older children arrive home from school ravenously hungry. I've found it can be a good idea to have teatime early to accommodate hungry children, since a nutritious meal restores energy levels and good-humour and will help them to concentrate on their homework. If children are hungry later on, you can offer them a healthy snack such as a piece of fruit, a yoghurt or a slice of wholemeal toast before bedtime.

Teatime is also a good time of day to have the children with you in the kitchen. It's a lovely opportunity to prepare tea together while you catch up on the day's events. The children can help put toppings on homemade pizzas, choose their ingredients to go in the baked potatoes or simply enjoy making a sandwich filling, with your encouragement.

I hope you will find lots of ideas for making teatime fun for your children as well as many appetising recipes for your own evening meal. And don't forget, you can turn to the puddings chapter for a delicious treat which does not have to be unhealthy.

Cheesy peasy rice

This makes two generous portions of yummy rice enriched with cheese and peas. It'll be messy but encourage your older baby to feed himself this delicious tea. Use a teacup to measure the ingredients but make sure the same cup is used throughout.

From 6-7 months (puréed)
Makes 2 servings (for 1 baby and 1 toddler)
Suitable for freezing

1 dessertspoon unsalted butter
½ small onion, finely chopped
½ teacup of long-grain rice
1½ teacups of Chicken or Vegetable Stock (see page 33)
½ teacup of frozen peas
about 2–3 tbsp mild Cheddar cheese, grated

- Melt the butter over a gentle heat, add the onion and cook until soft but not browned. Stir in the rice until the grains are completely coated in the melted butter.
- Add the stock, stir once and bring to the boil. Simmer for 5 minutes, then add the peas.
- Cook for a further 5 minutes, or until the stock has been absorbed and the rice is soft. Stir in the cheese and allow to cool a little before serving.

Risotto with pasta sauce

This is a really quick, no-fuss way of making risotto. For your child's tea, you could add cooked peas, sweetcorn and grated cheese. It can also be served as a meal on its own for lunch by adding chopped cooked chicken or flakes of cooked fish, or canned tuna or salmon.

From 9 months Makes 6-8 servings Suitable for freezing

225g (8oz) Arborio or risotto rice 2 portions of Neapolitan Sauce or 300ml (½ pint) Tomato Sauce (see pages 104 and 194) 450ml (¾ pint) Vegetable Stock (see page 33)

- Put the rice into a lidded saucepan and stir in one third of the pasta sauce until the rice is coated.
- Add the stock and bring to the boil. Turn the heat down to its minimum setting, cover the pan and leave for 20 minutes.
- Remove the pan from the heat after exactly 20 minutes and stir in the remaining pasta sauce.

Jacket potatoes

As well as trying the fillings suggested below, you could also serve these (mashed and without the skin for the baby) with baked beans (reduced sugar and salt variety), which can be lightly mashed up for the baby, or diced red pepper, then add a sprinkling of grated cheese.

From 8–9 months Makes 2 servings (for 1 baby and 1 toddler) Unsuitable for freezing

2 potatoes, unpeeled, one small, one medium-sized

Baking in the oven

- Pre-heat the oven to 190°C/170° Fan/Gas Mark 5.
- Pop the potatoes into the pre-heated oven, remembering to prick them all over with a fork to allow the steam to escape, and cook for about 1½ hours or until tender.

Try the fillings on the next couple of pages:

Cheese and ham

2–3 tbsp mild Cheddar cheese, grated 1 slice good-quality ham, finely chopped

- Pre-heat the grill on a high setting. When the potatoes are ready, cut them open, scoop out the insides and mix with the cheese.
- Put half the potato and cheese mixture into a bowl for the baby. (It will need to cool down before you feed him.)
- Add the ham to the remaining mixture, then spoon it back into 2–3 potato skins for your toddler. Pop under the grill for a few minutes to crisp up the top.

Tuna and sweetcorn

1 x 200g (7oz) can of tuna in spring water, drained ½ x 200g (7oz) can of sweetcorn, drained and warmed through 1 tsp unsalted butter splash of full-fat milk

- Place the tuna in a bowl, then add the sweetcorn.
- Scoop the insides of the potatoes into the bowl, add the butter and milk, then mash with the back of a fork. Mix with the tuna and sweetcorn. (Make sure the baby's portion is mashed well to avoid the risk of him choking on the sweetocorn.)
- Divide the mixture into two, setting the baby's portion aside to cool and spooning the rest of the mixture into 2–3 potato skins for the toddler. (A dollop of ketchup on the side with this is popular with many toddlers.)

Creamy spinach and cheese

- 2 cubes or 50g (2oz) frozen chopped spinach
- 2-3 tbsp mild Cheddar cheese, grated
- 1 tsp unsalted butter
- 1 tbsp crème fraîche
- Pre-heat the grill on a high setting. Cook the spinach according to the instructions on the packet, then mix with the cheese in a bowl.
- Scoop the insides of the potatoes into the bowl, add the butter and crème fraîche and mash with the back of a fork.
- Put half aside for the baby and leave to cool, then spoon the rest of the mixture back into 2–3 potato skins (for the toddler) and pop them under the grill for a few minutes to crisp up the top.

Bubble and squeak potato cakes

This is a great way to use up leftover boiled potatoes. They are much easier to grate when they are cool, so if you don't have any cooked potatoes in the fridge, allow enough time to cook some, and for them to cool down, before you prepare this dish. These are delicious served by themselves, or you could add some baked beans if preferred, mashing them for the baby as necessary.

From 7-8 months Makes about 6 cakes Suitable for freezing

- 2 leaves from a large cabbage (Savoy or white), finely chopped 4 small potatoes, peeled, boiled and grated 2–3 tbsp mild Cheddar cheese, grated 1 tbsp olive oil
- Place the cabbage in a saucepan of boiling water for 3–4 minutes, or steam until tender. Drain, squeezing out as much water as you can, then place in a large bowl.
- Mix in the grated potatoes and cheese, then form the mixture into about 6 small, flat patties.
- Pour the oil into a shallow frying pan and place over a medium heat. When the oil is hot, add the potato cakes and cook for several minutes until golden on both sides.

Tomato, egg and cheese bake

Your baby and toddler will both enjoy this nutritious tea. Be extra careful that the egg is set for the baby, and leave enough time to allow it to cool before serving.

From 10 months
Makes 2 servings
Unsuitable for freezing

1 x 400g (14oz) can of chopped tomatoes, drained 2 eggs pinch of dried mixed herbs 3 tbsp mild Cheddar cheese, grated (or enough to cover the dish)

- Pre-heat the oven to 180°C/160° Fan/Gas Mark 4. Place the tomatoes in the base of a small, shallow, ovenproof dish.
- Break the eggs on top of the tomatoes and sprinkle with the herbs, then cover with grated cheese and bake in the pre-heated oven for 20 minutes until the eggs are set.
- Serve with hot buttered toast or diced roast potatoes.

Tasty pasta

Here are two tempting sauces to mix with pasta, which should be as small as possible so that your baby can chew it easily. Almost any combination of vegetables for the purée will work here – carrots, broccoli, sweet potato, courgette, cauliflower or spinach.

From 6-7 months (puréed) Makes 2 servings Suitable for freezing

50g (2oz) tiny pasta shapes (such as farfalline)

• Cook the pasta according to the instructions on the packet, then mix either with the vegetable purée or the cheesy tomato sauce.

Vegetable purée

110g (4oz) mixed vegetables cut into small pieces 240ml (8fl oz) Chicken or Vegetable Stock (see page 33)

• Boil the vegetables in the stock for about 15–20 minutes until tender, then drain, reserving a little of the cooking liquid. Purée in a liquidiser, adding a little of the reserved stock to soften.

Cheesy tomato sauce

2 large tomatoes, skinned (see page 194), deseeded and chopped 2 dessertspoons olive oil 50g (2oz) mild Cheddar cheese, grated 1 tbsp cream cheese

 Sauté the tomatoes in the oil until soft. Tip in the grated cheese and stir until melted, then remove from the heat and stir in the cream cheese.

Neapolitan macaroni

Lots of different brands of tomato-based pasta sauces can be found at supermarkets, but many of these contain a host of additives, sugar and emulsifiers. This homemade sauce is superquick to make and comes without undesirable extras. The baby's portion of pasta can be mashed with the back of a fork just before serving, or quickly blended with a hand-held blender, depending on how lumpy he likes his food.

From 6-7 months

Makes 2 servings (for 1 baby and 1 toddler)

Unsuitable for freezing

50g (2oz) macaroni 3 tbsp mild Cheddar cheese, grated (or enough to cover the dish)

For the sauce

15g (½ oz) unsalted butter ½ onion, peeled and finely chopped 2 tbsp tomato purée 4 tbsp crème fraîche pinch of dried mixed herbs

- Pre-heat the grill on a high setting. Cook the macaroni following the instructions on the packet, drain and place in a small, shallow, ovenproof dish.
- Meanwhile, melt the butter over a low heat and gently cook the onion for about 5 minutes to soften it. Remove the pan from the heat and stir in the tomato purée.
- Return the pan to a gentle heat and stir in the crème fraîche, then add the herbs.
- Stir the sauce into the pasta, sprinkle the cheese on the top and place under the pre-heated grill for a few minutes until golden brown.

Penne in a creamy sauce

This dish freezes well but may need a little more milk when warming it up. If the penne are too big for your toddler to manage, then either mash them after cooking or use smaller pasta shapes.

From 6-7 months (puréed) Makes 2 servings Suitable for freezing

50g (2oz) penne or other, smaller, pasta shapes 15g (½oz) unsalted butter 1 dessertspoon plain flour 175ml (6fl oz) full-fat milk 25g (1oz) mild Cheddar cheese, grated

- Cook the pasta according to the instructions on the packet.
- Meanwhile, melt the butter in a saucepan and add the flour, stirring continuously.
- Cook for 1–2 minutes before gradually adding the milk and then the cheese. Cook for a further 5–10 minutes on low heat, then stir into the cooked pasta.

Simple pasta dish

This is a very simple pasta dish which is really popular with babies and toddlers, and is suitable for them to feed themselves with minimum mess. Older babies in particular like to recognise what they are eating, and some mothers put the additional ingredients in little bowls, to enable the baby to be involved in adding to the meal.

Try to choose a smaller sized pasta shape – many of the major supermarkets do the organic ranges in different shapes.

From 6-7 months (puréed) Makes 1 serving Unsuitable for freezing

25g (1oz) tiny pasta shapes (such as farfalline)

1 tsp olive oil

knob of unsalted butter (optional)

1 tsp frozen peas, cooked

1 tsp frozen sweetcorn, cooked

1 small slice of good-quality ham, chopped

1 tbsp mild Cheddar cheese, grated

2 cherry tomatoes, diced

- Add the pasta to a pan of boiling water together with the olive oil. Cook according to the instructions, and then drain. Add either a dash of olive oil or the knob of butter.
- If you are using a larger shaped penne or fusilli pasta, cut the individual shapes in half to ensure that these are of a size your baby can chew.

Pasta with cream cheese and spinach

For the pasta, you may prefer to use small, easily chewable shapes, which also have the benefit of being very quick to cook.

From 9 months (mashed) Makes 4-6 servings Unsuitable for freezing

110g (4oz) pasta
½ small onion, peeled and finely chopped
1 tbsp olive oil
6 dessertspoons cream cheese
6 cubes or 175g (6oz) frozen spinach, defrosted and chopped into small pieces

- Cook the pasta according to the instructions on the packet. Meanwhile, sauté the onion in the oil until very soft.
- Reduce the heat, then stir in the cream cheese and spinach. Simmer gently for 3–4 minutes.
- Drain the pasta, stir in the sauce and mix well.

Mediterranean fish casserole

This can be divided between smaller airtight containers for freezing. Defrost when needed and heat through on the stove, stirring occasionally.

From 7 months (mashed) Makes 6-8 servings Suitable for freezing

- 1 tbsp olive oil
- 1 medium onion, peeled and finely diced
- 1 garlic clove, peeled and crushed
- 1 red pepper, diced
- 1 yellow pepper, diced
- 2 small courgettes, diced
- 1 x 400g (14oz) can of tomatoes with herbs
- 1 tbsp tomato purée
- 1.25 litres (2 pints) Vegetable Stock (see page 33)
- 110g (4oz) easy-cook rice
- 450g (1lb) white fish fillets (such as cod or haddock), skinned and boned
- Heat the oil in a large, heavy-bottomed saucepan, add the onion and garlic, and cook gently for 2–3 minutes, then add the peppers and cook for a further 4–5 minutes.
- Add in the courgettes, tomatoes, tomato purée, stock and rice, bring to the boil and simmer for 20 minutes.
- Add the fish and simmer gently for another 10 minutes until the fish is cooked. (Be careful not to stir too much or the fish will break up.)

Spaghetti with prawns and peas

Combining a new flavour such as prawns, with an old favourite such as spaghetti is a good way of introducing your children to foods they may not have tried before.

From 18 months Makes 6-8 servings Unsuitable for freezing

400g (14oz) dried spaghetti
1 tbsp olive oil
1 large onion, peeled and finely chopped
284ml (9fl oz) carton of double cream
400g (14oz) frozen prawns, defrosted
200g (7oz) frozen peas, defrosted
Parmesan cheese, freshly grated, to serve (optional)

- Cook the spaghetti according to the instructions on the packet, adding a little oil to the boiling water to prevent sticking. Drain when cooked, reserving 2 tablespoons of the cooking water.
- In a large frying pan, sauté the onion gently until tender.
- Add the cream and bring to a simmer. Add the prawns and peas to warm through. Pour over the spaghetti and sprinkle with Parmesan if desired.

Cajun salmon with cherry tomatoes

Although I've called this dish Cajun salmon, the Cajun seasoning should only be used for the adult servings. The fish alone, however, makes a tasty, highly nutritious dish for children. Serve it with a green vegetable, such as broccoli or runner beans, and new potatoes or couscous.

From 1 year
Makes 6 servings
Unsuitable for freezing

3 salmon fillets olive oil, for greasing and drizzling Cajun Grill & Sizzle Seasoning (such as Schwartz) 10 cherry tomatoes, halved 1 tsp dried mixed herbs

- Pre-heat the oven to 180°C/160° Fan/Gas Mark 4. Grease an ovenproof dish with oil, lay the salmon fillets in the dish and sprinkle the Cajun spice over the adult portions.
- Place the tomato halves, cut side up, around the salmon and sprinkle with the olive oil and herbs. Bake in the pre-heated oven for about 15–20 minutes or until the fish flakes easily when tested with a fork.

Prawn or chicken stir-fry

Stir-fries are so quick and easy, they are ideal for teas when you're short of time. You can liven up these two versions for your own meal by adding sesame oil and fish sauce.

From 18 months
Makes 4 servings
Unsuitable for freezing

2 large skinless chicken breasts, cubed, or 200g (7oz) frozen prawns, defrosted

110g (4oz) medium or thick rice noodles

1 tbsp vegetable oil

1 x 250g (9oz) pack of bean sprouts

2 courgettes, thinly sliced

1 red/green pepper, thinly sliced

1 carrot, peeled and grated

½ red onion, thinly sliced

8 baby sweetcorn, halved if large

For the marinade

1 tbsp sesame oil
1 garlic clove, peeled and crushed
1 cm (½in) piece of fresh root ginger, peeled and finely chopped
1 tsp soya sauce

- Mix together the marinade ingredients. If using chicken, stir it in and marinate in the fridge for several hours or overnight.

 Alternatively, marinate the prawns for 1 hour before serving.
- In a large bowl, soak the noodles in boiling water according to the instructions on the packet, then drain.
- Heat the vegetable oil in a large wok or frying pan, add the chicken (if using) and fry on a high heat for a few minutes. Add the vegetables and stir-fry for a further 5 minutes.
- Add the noodles and prawns (if using), to warm through. First serve the children's portions. Season the adult portions with a little sesame oil and fish sauce. Soya sauce can also be added to taste.

Chicken and butternut squash pie

This recipe is great if you have chicken left over from a Sunday roast. Because children usually prefer the brown meat on the drumsticks, it can be a good idea to pop another chicken in the oven at the same time. The remaining breast meat can then be used for this recipe. To save time, you can bake the squash in the oven while you are roasting your chickens. Add a tablespoon of olive oil and bake for 40 minutes.

From 6–7 months (mashed) Makes 6–8 servings Suitable for freezing

5 large potatoes, peeled and cut into chunks
1 large butternut squash, peeled, deseeded and cubed
75g (3oz) plain flour
50g (2oz) unsalted butter, plus extra for mashing the potatoes
900ml (1½ pints) full-fat milk, plus extra for mashing the potatoes
4–6 tbsp mild Cheddar cheese, grated
breast meat from 2 large cooked chickens, cubed

- Pre-heat the oven to 220°C/200°Fan/Gas Mark 7. Boil the potatoes until tender and, in a separate saucepan, steam the butternut squash until tender.
- Meanwhile, place the flour, butter and milk in a saucepan and whisk until smooth. Bring to the boil while still whisking, making sure you get right into the edges of the pan.
- Turn down the heat to low and leave for 5–6 minutes to cook through. Remove from the heat and stir in the cheese. Mash the potatoes with a knob of butter and a tablespoonful of milk.
- Spoon the chicken and squash into a large ovenproof dish. Cover with the cheese sauce and spread over the mashed potato.
- Cook in the pre-heated oven for 25 minutes until slightly browned on top and the sauce is bubbling at the edges.

Chicken and pea pilaf

For adults, serve with Greek yoghurt seasoned with a little crushed garlic, salt and/or wedges of lemon. For children, set aside some unseasoned Greek yoghurt.

From 6-7 months (puréed) Makes 6-8 servings Suitable for freezing

½ tbsp olive oil
50g (2oz) unsalted butter
a good pinch of freshly grated nutmeg
2 cloves
3cm (1½in) cinnamon stick
340g (12oz) boned chicken, cut into small pieces
200g (7oz) basmati rice
175g (6oz) frozen petit pois
small bunch of fresh, flat-leaf parsley, roughly chopped
450–600ml (¾–1 pint) water or Chicken Stock (see page 33)

- Place the olive oil and butter in a large, lidded saucepan or frying pan, and set over a medium heat. When the butter has melted, add the nutmeg, cloves and cinnamon and fry for 30 seconds.
- Add the chicken and cook, stirring, over a medium heat for 2 minutes. Stir in the rice and peas and half the parsley. Add enough water or chicken stock to bring the level of the liquid to about 1cm (½in) over the top of the pilaf.
- Cover with greaseproof paper and the lid and steam for 8 minutes. Then remove the lid and paper and let the pilaf sit for 5 minutes. Fish out the cloves and cinnamon before sprinkling the rest of the parsley on top.

Fruity lamb tagine

To freeze this dish, divide it into separate portions for all the family, place in airtight containers and freeze for up to a month.

From 7–8 months (mashed) Makes 6–8 servings Suitable for freezing

25g (1oz) unsalted butter

1 medium onion, peeled and finely chopped
450g (1lb) lean lamb, diced

1 tbsp plain flour

2 medium carrots, peeled and sliced

1 x 400 (14oz) can of chopped tomatoes with herbs
200g (7oz) dried apricots, chopped
50g (2oz) sultanas

150ml (5fl oz) Vegetable Stock (see page 33)

- In a large, lidded saucepan, melt the butter, add the onion and cook for 2–3 minutes. Coat the lamb in the flour, add to the onion and cook for a further 3–4 minutes, stirring continuously, until the meat is browned all over.
- Add the carrots, tomatoes, dried fruit and stock, bring to the boil, cover with the lid and simmer very gently for about 1 hour or until the lamb is tender.
- Serve with rice or couscous.

Scrambled egg surprise

This is delicious served on hot buttered toast.

From 10-12 months Makes 2 servings Suitable for freezing

- 1-2 tsp unsalted butter
- ½ small onion, peeled and very finely chopped
- 2 large eggs
- 2 tbsp full-fat milk
- 2 slices of ham, finely chopped (omit for a baby under 18 months)
- 2 large tomatoes, skinned (see page 194), deseeded and finely chopped
- 2 tbsp frozen peas or sweetcorn
- 25g (1oz) mild Cheddar cheese, grated (optional)
- Melt the butter in a non-stick saucepan, add the onion and cook gently for 4–5 minutes. Using a fork, whisk the eggs and milk thoroughly together, then pour into the pan.
- Add the ham, tomatoes and peas or sweetcorn, stir over a low heat for 5 minutes, then stir in the cheese (if using) and cook for a further minute until the mixture is creamy but not too stiff.

Kiddies' mixed grill

From 18 months Makes 2 servings Unsuitable for freezing

2 chipolata pork sausages, or 2 rashers lean, unsmoked bacon 2 eggs

3 tbsp full-fat milk

knob of unsalted butter

- 2 large plum tomatoes, skinned (see page 194), deseeded and chopped
- Pre-heat the grill on a medium setting, then if using the sausages, place them under the grill for 20 minutes, turning over halfway through cooking. Alternatively, place the bacon under the grill for the last 5 minutes, turning over halfway through cooking.
- Beat the eggs with the milk, then heat the butter in a non-stick saucepan, pour in the egg mixture and stir with a wooden spoon until it starts to thicken. Add the tomatoes and stir.
- Remove all the fat from the bacon (if using). Chop the sausages or bacon, and serve with the scrambled egg, tomato and some buttered toast.

Chive omelette with ham, cheese and tomato

From 10 months

Makes 1 serving

Unsuitable for freezing

15g (½oz) unsalted butter

- 1 large egg
- 2 tbsp full-fat milk
- 1 dessertspoon finely chopped fresh chives
- 1 slice of lean ham (unsmoked), chopped (omit the ham for babies under 18 months)
- 25g (1oz) mild Cheddar cheese, grated
- 1 tomato, skinned (see page 194), deseeded and chopped
- Melt the butter in a small frying pan (20cm/8in in diameter is the perfect size). Meanwhile, beat the egg with the milk and add the chives.
- When the butter has melted, add the egg mixture, tipping the pan to spread it out evenly. Then, with a fork or wooden spoon, draw the edges of the egg mixture into the centre so that all the egg runs to the edge of the pan and cooks evenly.
- Once the omelette is set, with the surface still soft, add the ham, cheese and tomato to one half and flip the other half over the filling. Serve immediately.

Homemade crêpes with ham and cheese

You can vary these crêpes by replacing the ham with tomatoes, spinach or tuna.

From 18 months Makes 8 crêpes Unsuitable for freezing

110g (4oz) plain flour
black pepper
2 eggs, beaten
300ml (½ pint) full-fat milk
2 dessertspoons melted butter
110g (4oz) mild Cheddar cheese, grated
4 slices of ham, finely chopped
knob of unsalted butter and a drop of olive oil for cooking each crêpe (butter alone will burn)

- Sift the flour into a mixing bowl, season with a grinding of black pepper, then make a well in the centre and pour in the eggs and milk.
- Stir with a wooden spoon, gradually incorporating the egg and milk with the flour. Alternatively, mix together using an electric hand-held whisk, then stir in the melted butter.
- Place a dot of butter and a drop of olive oil in a frying pan 15cm (6in) in diameter and set over a high heat. When the butter has melted and the fat begins to bubble, pour in enough mixture (about 2 tablespoons) to just cover the pan by swirling the batter around.
- Cook for 1 minute until lightly golden and, using a fish slice, flip the crêpe over. Scatter over some grated cheese and chopped ham and let it cook for a further minute or so. Fold in half and half again using the fish slice, slip onto a warmed serving plate and place in the oven (covered with foil) on a low heat to keep warm while you make the remaining crêpes.
- Repeat for each crêpe, adding a small knob of butter and drop of olive oil for each one.

Spaghetti carbonara

The heat from the pasta will cook the egg yolks extremely quickly but do ensure it is all thoroughly cooked before serving this to your child.

From 18 months
Makes 4 servings
Unsuitable for freezing

110g (4oz) spaghetti 200g (7oz) lardons, or streaky bacon cut into strips 3 egg yolks 6 tbsp double cream or crème fraîche 50g (2oz) freshly grated Parmesan cheese

- Cook the spaghetti according to the instructions on the packet.
 Meanwhile, place the lardons or bacon in a non-stick frying pan and cook for a few minutes on a high heat until they begin to go slightly crispy.
- Mix together the egg yolks, cream and Parmesan in a large serving bowl.
- Drain the pasta and pour into the serving bowl, then add the crispy lardons or bacon together with the melted fat from the pan. Mix everything well to ensure the eggs become cooked through (the heat from the pasta will do this in a few seconds) and serve immediately.

Pasta with broccoli and sausages

This inviting dish of healthy broccoli and tasty sausages is simple but delicious and can be put together in very little time.

From 18 months
Makes 4-6 servings
Unsuitable for freezing

225g (8oz) fusilli

- 1 tbsp olive oil
- 1 shallot, peeled and chopped
- 4 sausages (skins removed), roughly chopped
- 8 small broccoli florets, boiled or steamed for 3 minutes
- 2 tbsp freshly grated Parmesan cheese
- Cook the pasta according to the instructions on the packet. Meanwhile, heat the olive oil in a frying pan and, when sizzling, add the shallot and cook gently for 5–7 minutes until softened.
- Add the sausages, turn up the heat and cook for another 5 minutes or so. Add the broccoli and cheese, and continue to cook for another few minutes over a gentle heat. Add the drained pasta and mix well in a large serving bowl.

Pork and beef meatballs

These can be served with fresh vegetables and pasta or rice.

From 18 months Makes 6-8 servings (or about 16 balls) Suitable for freezing

2 slices white bread

1 small onion, peeled and quartered

1 carrot, peeled and roughly chopped

1 stick of celery, trimmed and roughly chopped

250g (9oz) lean minced pork

250g (9oz) lean minced beef

1 egg, beaten

2 tbsp plain flour

1 tbsp olive oil

For the sauce

1 tbsp olive oil

½ onion, peeled and finely chopped

2 tbsp apple juice

1 x 700g (1½lb) bottle of passata

2 bay leaves or 1 tsp dried oregano

6 tbsp crème fraîche

- Pulse the bread in a food processor until finely chopped, then transfer to a large mixing bowl. Pulse the onion, carrot and celery until finely chopped, then add to the bowl.
- Add the pork and beef, then, using your hands, mix well until combined. Pour in the beaten egg, mixing thoroughly with a fork, and then form into about 16 balls. Dip into the flour to coat lightly.
- Heat the oil in a large, lidded saucepan until sizzling. Add the meatballs, gently turning them until brown all over.
- For the sauce, pour the oil into a saucepan and, when it is hot, add the onion and cook for about 5–10 minutes until softened. Add the apple juice, passata and bay leaves or oregano and cook for 10 minutes, then spoon in the crème fraîche and simmer for 5 minutes.
- Pour the sauce over the meatballs and simmer gently with the lid on for about 20 minutes.

Miniature toads in the hole

Serve these with mashed potato and a green vegetable.

From 18 months Makes 4 servings Suitable for freezing

12 cocktail sausages 110g (4oz) plain flour 2 eggs 225ml (8fl oz) milk

- Pre-heat the oven to 220°C/200°Fan/Gas Mark 7. Place 2 sausages in each space of a six-hole muffin tin and cook in the pre-heated oven for 10 minutes.
- Meanwhile, sieve the flour into a large mixing bowl, make a well in the centre and pour in the eggs and milk. Using a hand-held electric whisk, blend well together. Alternatively, using a wooden spoon, gradually incorporate the egg and milk mixture into the flour until the texture is creamy and there are no lumps.
- Take the sausages out of the oven and turn them over within their individual spaces so that the browned base of each sausage is on top. Pour the batter onto the sausages in the muffin tins and return to the oven. Cook for 15–20 minutes or until well risen and golden.

Quick spaghetti Bolognese

Red pepper and courgette add colour and different flavours to this classic family favourite.

From 9 months (mashed)
Makes 2-3 servings
Sauce suitable for freezing

1 tbsp olive oil
½ small onion, peeled and very finely chopped
110g (4oz) minced beef
½ small red pepper, finely chopped
½ small courgette, finely chopped (optional)
2 tomatoes, skinned (see page 194), deseeded and chopped
1 tbsp tomato purée or ketchup
1 tsp dried mixed herbs
75g (3oz) spaghetti
freshly grated Parmesan cheese, to serve

- For the sauce, heat the oil in a saucepan, add the onion and gently fry for 5 minutes. Add the minced beef and cook until it has browned, breaking the mince up as it is cooking.
- Add the pepper, courgette (if using) and chopped tomatoes, followed by the tomato purée or ketchup and the herbs. Bring to the boil, then simmer for 20–25 minutes, adding a little water if needed.
- Meanwhile, cook the spagnetti according to the instructions on the packet.
- Add the cooked spaghetti to the Bolognese sauce and cook for 2–3 more minutes. Serve sprinkled with grated Parmesan.

Day-after Sunday lunch

If you are cooking a roast meal for Sunday lunch, prepare some extra vegetables, potatoes and gravy. Cover them with cling film and put them aside in the fridge once they are cool. Save some of the leanest and most tender bits of meat from the joint for the next day. (Again, make sure it's cool before you refrigerate it.) The amount of meat you use depends on the appetite of your baby or toddler.

From 6 months

- Take a handful of cold meat pieces, some vegetables, a couple of roast potatoes and place in a liquidiser.
- Add enough gravy to enable to you to purée the mixture for the baby. (Do not mix it to a smooth consistency for the baby some lumps will help his chewing skills develop.)
- Warm the mixture through in a small saucepan and serve.

Leftover roast chicken in a pie

From 9 months

- Pre-heat the oven to 220°C/200° Fan/Gas Mark 7. Place a mixture of the chicken, cut into bite-sized pieces, cubed vegetables and gravy into a single-portion, shallow pie dish.
- Cut about 75g (3oz) ready-rolled puff pastry to size and place it over the pie dish. Seal with water and brush with a little beaten egg.
- Prick the top of the pastry and bake in the pre-heated oven for 30 minutes or until golden brown.

Leftover roast lamb or beef with a mashed potato topping

From 10 months

- Pre-heat the oven to 200°C/180° Fan/Gas Mark 6. Peel 2 small potatoes, or 1 large one, and boil for 20 minutes.
- Cut the lamb or beef into small cubes and place in the bottom of a single-portion, shallow pie dish. Add a few vegetables, cut into cubes, and stir the gravy in.
- Mash the potato with a little unsalted butter and milk. Use to cover the meat, vegetable and gravy mixture. Bake in the preheated oven for 25 minutes or until golden and heated through.

Egg and potato cake

This is a great way to use up leftover mashed potatoes. It works best if the potato is cold, so allow time for it to cool if you are cooking from scratch. The brightly coloured, mixed vegetables are usually the most popular, but you can use just one vegetable, depending on what is in the freezer or store cupboard.

From 10 months Makes 4 potato cakes Suitable for freezing

225g (8oz) cold mashed potato
1 egg, beaten
large handful of frozen mixed vegetables (such as carrots, beans and sweetcorn)
1–2 tbsp olive oil

- Place the mashed potato in a mixing bowl, then stir in the egg.
- Cook the mixed vegetables according to the instructions on the packet, then drain. Mash or chop up the larger vegetables and stir into the potato and egg mixture.
- Mould the mixture into 4 patties. Pour the oil into a frying pan set over a high heat. When sizzling, reduce the heat and cook the potato cakes on both sides for 4-5 minutes or until they are golden brown. Cool for a few minutes before serving.

Vegetables on the Side/ Accompaniments

Vegetables on the Side/Accompaniments

We are all aware of the importance of eating plenty of fresh fruit and vegetables. For most young children, eating fruit is a pleasure, whereas getting them to eat and enjoy vegetables can be more of a problem. During my travels around the world, I have picked up many tips on how to cook vegetables so that they look and taste delicious and appeal to even the fussiest of young eaters.

Over the last few years, it has become very fashionable for writers of children's cookery books to recommend that the only healthy way to eat vegetables is to steam them, so that the nutrients are not lost in the cooking. Unfortunately, for the majority of youngsters steamed vegetables are the most boring food in the world.

In this section, I give lots of recipes that do not involve traditional steaming methods, yet can be cooked quickly without losing their essential vitamins and minerals.

I learned the fast-boiling method (described opposite) from lan Lye, grandfather to Isabella and Oliver Skelley, two of my young charges. Ian has worked for many years as a restaurateur and learned much about cooking from his late French wife, Jacqueline.

Fast-boiling

This involves cooking vegetables quickly in a large amount of rapidly boiling water. Plunging the vegetables into fast-boiling water seals them and the cooking is speeded up, thus retaining more colour and flavour, as well as more of the essential vitamins and minerals.

lan's golden rule for fast-boiling vegetables is:

- everything that grows above the ground lid off, which preserves the colour
- everything that grows below the ground lid on, which speeds up the cooking and does not affect the colour

French pea purée

From 6-7 months Makes 2 side servings Suitable for freezing

¼ onion, peeled and diced
knob of [15g (1/2oz)] unsalted butter
½ cup of frozen peas
a few leaves of the heart of a cos or iceberg lettuce
1 cup of water
1 tbsp double cream

- Sauté the diced onion in the butter for 1 minute, add the peas and lettuce and fry very gently for 1–2 minutes.
- Add the water, bring to a fast boil and cook until the peas are really tender. Remove from heat, purée in a blender to a smooth consistency, then stir in the cream.

Bestest Brussels

From 8-9 months (mashed) Makes 2 side servings Unsuitable for freezing

75g (3oz) fresh or frozen Brussels sprouts 25g (1oz) plain flour knob of unsalted butter 150ml (5fl oz) full-fat milk 25g (1oz) mild Cheddar cheese, grated 1 tsp freshly grated Parmesan cheese 2 tbsp fresh breadcrumbs

- Cook the Brussels sprouts in a pan of fast-boiling water with the lid off for about 5 minutes or until just tender. (Do not overcook.) Drain and place in a small, buttered, ovenproof dish.
- Using the same pan, stir together the flour and butter over a gentle heat until they form a thick paste. Continue cooking for 1–2 minutes, stirring continuously and without allowing to brown.
- Remove from the heat, gradually add the milk and stir until smooth. Return to the heat and continue to cook until the sauce thickens, stirring continuously. Pre-heat the grill on a hot setting.
- Cook the sauce for a further 2–3 minutes, stir in the grated Cheddar, then pour over the sprouts and sprinkle with the Parmesan and breadcrumbs. Place under the pre-heated grill for 5 minutes or until golden brown.

Roasted new potatoes

From 6 months (mashed)
From 9 months (chopped)
Makes 4 side servings
Unsuitable for freezing

16 small new potatoes, unpeeled 1 tbsp olive oil

- Pre-heat the oven to 200°C/180°Fan/Gas Mark 6. Roll the potatoes in the oil before placing in a roasting tin in the pre-heated oven for about 40 minutes, turning once.
- Allow to cool slightly then remove any crisp bits of skin if using for a baby or toddler.

Garlicky square potatoes

From 9 months
Makes 4 side servings
Unsuitable for freezing

- 4 large potatoes (preferably Maris Piper), unpeeled and cut into 1cm (½ in) cubes
 1 tbsp olive oil
 1 small garlic clove, peeled and crushed black pepper
- Pre-heat the oven to 200°C/180°Fan/Gas Mark 6. Rub the potatoes in the oil and garlic, season with pepper and arrange in a single layer in a roasting tin.
- Place in the pre-heated oven for about 45 minutes, turning once.

Green beans in garlic

From 9 months (mashed)
Makes 4 side servings
Unsuitable for freezing

1 x 200g (7oz) packet of fine green beans, topped and tailed 2 tsp olive oil

1 small garlic clove, peeled and crushed

• Fast-boil the green beans until tender – about 5 minutes if very fine. Drain and return to the pan. Add the oil and garlic and mix well.

Provençal string beans

1 tbsp Parmesan cheese, freshly grated

From 9 months (mashed)
Makes 2 side servings
Unsuitable for freezing

6 fresh, green string beans
1 garlic clove, peeled and chopped
knob of unsalted butter
150ml (¼ pint) Tomato Sauce (see page 194)
1 slice of ham, shredded (omit the ham for babies under 18 months)

- Wash the beans under cold running water, top and tail and chop into 2.5cm (1in) pieces. Fast-boil for about 5 minutes or until tender.
- Drain, return to the pan and add the garlic and butter, then cook gently for 2–3 minutes. Add the tomato sauce and cook for a further 2–3 minutes.
- Stir in the ham and sprinkle with the Parmesan cheese.

Mashed potato with pesto and Parmesan

From 6-7 months Makes 4 side servings Suitable for freezing

4 medium baking potatoes, unpeeled 25g (1oz) unsalted butter 1 dessertspoon good-quality pesto (preferably fresh) 50g (2oz) freshly grated Parmesan cheese

• Pre-heat the oven to 200°C/180°Fan/Gas Mark 6. Bake the potatoes in the pre-heated oven for an hour or so, scoop out the flesh and mix with the butter, pesto and Parmesan cheese.

Sweet red cabbage

From 1 year Makes 4 side servings Unsuitable for freezing

1 small red cabbage, inner core removed, cut into sections

1 small onion, peeled and quartered

1 cooking and 1 eating apple, peeled, cored and quartered

1 garlic clove, peeled and crushed pinch of freshly grated nutmeg

1 tbsp soft brown sugar

1 tbsp white wine vinegar

25g (1oz) unsalted butter

1 tbsp redcurrant jelly

- Pre-heat the oven to 170°C/150°Fan/Gas Mark 3. Finely chop the red cabbage, onion and apples in a food processor. Mix together in a casserole dish with the garlic, nutmeg and sugar.
- Pour over the vinegar and dot the butter over the cabbage mixture, then cover with the lid and cook in the pre-heated oven for about 2 hours. Remove from the oven and stir every 30 minutes or so.
- After 2 hours, remove the casserole from the oven, add the redcurrant jelly and stir over a low heat until it has melted and is well mixed in.

Roasted root vegetables

From 9 months (mashed) Makes 4–6 side servings Unsuitable for freezing

- 3 small carrots
- 3 small turnips
- 2 small parsnips
- 2 small sweet potatoes
- 2 tbsp olive oil
- 1 garlic clove, crushed (omit for babies under 9 months)
- Pre-heat the oven to 220°C/200°Fan/Gas Mark 7. Peel and cut all the vegetables into even-sized chunks, place in a roasting tin in a single layer and drizzle over the oil.
- Sprinkle with the garlic and pepper and cook in the pre-heated oven for about 1 hour, turning once or twice.

Carrot and parsnip purée

From 6 months Makes 2-3 side servings Suitable for freezing

2 carrots, sliced 2 parsnips, sliced 15g (½oz) unsalted butter 1 tbsp crème fraîche

- Place the carrots in a pan of boiling water and simmer gently for about 10 minutes, adding the parsnips after the carrots have been simmering for about 5–7 minutes as they take less time to cook.
- When the vegetables are tender, drain, return to the pan then dry for a couple of minutes over a low heat. Mash well with a potato masher before adding the butter and crème fraîche and mixing well.

Cheesy garlic bread

From 1 year
Makes 2-3 side servings
Suitable for freezing (after filling but before baking)

15g (½oz) unsalted butter, softened 1 small garlic clove, peeled and chopped 25g (1oz) mild Cheddar cheese, grated 1 small French stick

- Pre-heat the oven to 200°C/180°Fan/Gas Mark 6. Mix the butter with the garlic and cheese.
- Slice the French stick at 5cm (2in) intervals, but don't cut right through the loaf. Fill each gap with the cheesy mixture and wrap in foil. Place in the pre-heated oven for 20 minutes.
- Unwrap and wait a couple of minutes before slicing.

Honeyed carrots

From 1 year Makes 2-4 side servings Unsuitable for freezing

4 carrots, peeled and cut into batons 1 tsp runny honey

• Place the carrots in a pan of boiling water and simmer gently for about 10 minutes or until they are tender. Drain thoroughly, add the honey and mix well together.

Puddings

Puddings

Whenever possible, it is best to avoid adding sugar to your baby or child's food in order to discourage him from developing a sweet tooth. In addition, giving too much food containing sugar may put him off more nutritious, savoury food, as well as leading to potentially serious problems such as tooth decay and obesity. For this reason, I have not included many puddings in this chapter and those that I have included are all fruit-based and contain relatively little sugar. Cakes and biscuits (such as those presented in the Birthday Party Ideas chapter) should really only be given as a treat.

For the ultimate in quick and healthy desserts, offer your baby or toddler slices of fresh fruit that he can easily chew – such as soft, peeled apple (from nine months; it should be stewed and puréed for younger babies), sliced bananas, plums, peaches, melon, orange segments or seedless grapes. Full-fat yoghurt and the little pots of fromage frais make ideal 'convenience' desserts too, although it is advisable to check that the flavoured varieties don't contain too much sugar.

Gina's mixed fruit crumble

This crumble is ideal for freezing. Rather than making one crumble, fill six ramekin dishes, then place these (uncooked) in separate freezer bags, seal and keep in the freezer for up to four months. Defrost thoroughly before cooking (see below), and serve with fresh cream or vanilla ice cream.

From 1 year Makes 6 servings Suitable for freezing

225g (8oz) cooking apples 225g (8oz) pears 50g (2oz) sultanas 50g (2oz) caster sugar

For the crumble

75g (3oz) unsalted butter 175g (6oz) plain flour 50g (2oz) caster sugar pinch of ground cinnamon

- Pre-heat the oven to 200°C/180°Fan/Gas Mark 6. Grease a 1.25 litre (2 pint) pie dish, then peel, core and thinly slice the apples and pears. Arrange the fruit in layers in the dish with a sprinkling of sugar and sultanas between the layers.
- For the crumble, rub together the butter and flour until it resembles breadcrumbs, mix in the sugar and cinnamon, then sprinkle the mixture on top of the fruit.
- Cook in the pre-heated oven for about 35 minutes until golden brown on top.

Apple snowballs

The only thing that takes any time in this recipe is whipping the egg white for the meringue. You could double the number of eggs and sugar used here and make another four meringues for Junior Eton Mess (see page 166) by putting spoonfuls of the mixture onto a baking sheet lined with parchment paper and cooking for 30 minutes at 140°C/120°Fan/Gas Mark 1. After 30 minutes, turn the oven off and leave the meringues for about 4 hours or overnight. Place the meringues in a tin or freeze them until you need them.

From 18 months
Makes 2 servings
Unsuitable for freezing

- 2 cooking apples, peeled and cored 1 egg white 2 tbsp caster sugar
- Pre-heat the oven to 200°C/180°Fan/Gas Mark 6. Steam the apples or simmer them very gently in a little water for 10–15 minutes or until they are tender, then place in a small, ovenproof baking dish.
- Whip the egg white until it forms stiff peaks. Add the sugar and whip again until to make a stiff and glossy meringue.
- Pile the meringue mixture on top of the apples and bake in the pre-heated oven for 3 minutes.

Junior Eton mess

Vanilla yoghurt makes a healthy substitute for cream in this recipe. You could use sliced peaches or halved mango instead.

From 18 months
Makes 2 servings
Unsuitable for freezing

50g (2oz) strawberries washed, hulled and sliced 3-4 tbsp vanilla yoghurt 1 meringue (shop-bought or homemade, see page 164), crumbled (optional)

- Divide the strawberries between two pudding bowls, then top each bowl with 1–2 tablespoons of yoghurt.
- Stir in the meringue (if using) for a special treat.

Birthday Party Ideas

Birthday Party Ideas

During my years as a maternity nurse, I attended hundreds of children's parties. For the children, they are a time of great fun and excitement and where most of the rules go out of the window. For many parents, though, planning a party, whether it is for a birthday, an Easter picnic, Hallowe'en or Christmas, can be very stressful.

In an ideal world, Mum would spend several weeks planning the occasion, and for the two or three days leading up to the party she would spend hours in the kitchen decorating fairy cakes and creating chocolate logs to represent trains and pizza slices to resemble parts of Noah's Ark.

If this is what you think makes a great party, by all means go down this route. But if the whole thought of planning a party fills you with dread, then simplify things for yourself. Believe me, in years to come your toddler or young child will not remember exactly how much of the food was created by your own fair hand; they will only remember how much fun the party was – and how much fun you were at the party.

So take my advice on this one: keep the amount of time you put into cooking to a minimum. A party is the one time that you can and should take advantage of all of the treats and fancy food available in the supermarket. If you do want to cook anything, think of items that you can easily prepare yourself, ideally with the assistance of your toddler or young child so he gets a buzz out of helping you.

Party boxes

- Buy the small, decorated cardboard boxes that are made for parties and write each child's name on the outside. Or, if you prefer, make and decorate these yourself by collecting empty tissue boxes or suitable-sized cardboard containers before the party.
- Fill the boxes with a small selection of savoury party food and fruit: 2–3 nicely shaped sandwiches, for instance, a couple of Honeyed Sausages or a Mini Quiche (see pages 178 and 172), a satsuma or a small bunch of seedless grapes, some raw carrot sticks or a small box of raisins, and a handful of crisps. The children are much more likely to eat these and there will be far fewer leftovers: I have witnessed parties where the mountains of thoughtfully made sandwiches were neglected in favour of the plates of cakes and biscuits.
- Let the children enjoy what's in their party boxes first before you bring out the delicious party cakes.

Mini quiches

Quiches are wonderful for parties because you can easily vary the fillings to suit different children's tastes. I've given you three options here but you can be inventive and add other things.

From 18 months Makes 12 quiches Suitable for freezing

1 x 375g (12oz) packet of shortcrust pastry
25g (1oz) unsalted butter, plus extra for greasing
1 tbsp olive oil
1 small onion, peeled and very finely diced
2 pork chipolata sausages, sliced or diced
1 x 200g (7oz) can of baked beans
4 broccoli florets, broken into small pieces
2 tomatoes, skinned (see page 194), deseeded and chopped
50g (2oz) ham, finely diced
2 eggs, beaten
150ml (5fl oz) full-fat milk
150ml (5fl oz) single cream
50–75g (2–3 oz) mild Cheddar cheese, grated

- Pre-heat the oven to 200°C/180°Fan/Gas Mark 6. Lightly butter 12 10cm (4in) tart tins. Roll out the pastry and, using a pastry cutter slightly wider than the tins, cut the pasty into rounds and use to line the tins. Set on a baking sheet.
- Heat the butter in a saucepan and gently fry the onion, without browning, then spoon equal amounts into the pastry cases.
- Divide the sausage and beans between 4 tins, the broccoli and tomato between 4 tins and the ham between 4, then top each one with grated cheese.
- Beat together the eggs, milk and cream, then pour the mixture over the different fillings and bake in the centre of the pre-heated oven for 25–30 minutes, or until the filling is set and golden brown on top.

Vegetable dippers

From 1 year

Peel and cut cucumber, carrot and celery into sticks for scooping up the following homemade dips. Broccoli florets are ideal too.

Hummus

Raw garlic can be overpowering, but an oven-roasted clove of garlic – peeled then cooked in the oven for about 1 hour – will give the hummus a sweeter flavour. Once left in the fridge, the hummus can harden slightly so, if necessary, add a little more yoghurt to it before serving.

From 1 year Makes about 225g (8oz) Unsuitable for freezing

- 1 x 400g (14oz) can of chick peas, drained 1 small garlic clove, peeled, roasted
- freshly squeezed juice of 1 lemon
- 4 tbsp olive oil
- 4 tbsp plain Greek yoghurt (or enough to bind the mixture together)
- Whizz together all the ingredients in a blender until smooth.
- Store in an airtight container in the fridge and use within 3 days.

Vegetable purée

Any combination of vegetables will work well for this dip, especially the sweet ones like carrots, butternut squash and parsnips.

Makes about 350g (12oz) Suitable for freezing

450g (1lb) mixed vegetables, peeled and chopped as appropriate 600ml (1 pint) Vegetable Stock (see page 33)

- Boil the vegetables in the stock for 15–20 minutes or until tender.
- Drain the vegetables, retaining the liquid for future use, then purée in a blender until smooth, adding a small amount of the stock to loosen the consistency as necessary.

Quick and tasty hamburgers

Serve these on toasted wholemeal buns or rolls, accompanied by a mixed salad.

From 18 months Makes 8–10 mini hamburgers Suitable for freezing

450g (1lb) lean minced beef
1 medium onion, peeled and very finely chopped
2 tbsp tomato purée or ketchup
dash of Worcestershire sauce
pinch of dried mixed herbs
2 tbsp sultanas (optional)
1 egg
1–2 tbsp olive oil

- Place all the ingredients, except the egg and oil, in a large bowl and mix thoroughly, then add the egg and mix well.
- Divide the mixture into 8–10 equal amounts, forming a small ball with each piece by rolling in the palm of your hands, then flattening into a patty.
- Pour the oil into a frying pan set over a high heat and, when the oil is hot, quickly seal both sides of each hamburger, then reduce the heat and fry for a further 4 minutes per side, or until thoroughly cooked through.

Honeyed sausages

From 18 months
Makes 4 servings
Unsuitable for freezing

16 pork chipolata sausages

- 1 dessertspoon runny honey
- 1 tbsp sesame seeds
- Pre-heat the oven to 200°C/180°Fan/Gas Mark 6 and cook the sausages on a baking sheet for 15 minutes.
- Remove the sausages from the oven, coat in the honey and sesame seeds and return for another 15 minutes until sticky and brown.
- Allow to cool slightly before serving.

Bread and cheese fritters

These cheesy fingers can equally well be served at teatime, accompanied by a green vegetable like peas, broccoli or runner beans, or with cucumber sticks and baby tomatoes. A little tomato ketchup usually goes down well too – serve it on the side or spread thinly on the bread before adding the cheese. The quantities in this recipe are enough for two young children – you would simply need to adjust them depending on the number of children attending the party.

From 1 year Makes 2 servings Unsuitable for freezing

4 slices of bread (preferably wholewheat)
unsalted butter, for spreading
thin slices of mild Cheddar cheese (enough to cover the bread
slices)
2–3 tbsp full-fat milk
1 tbsp olive oil

- Lightly butter the bread, place the slices of cheese on top of each piece of bread and press them firmly together, making 2 sandwiches.
- Cut the sandwiches into fingers and dip in the milk, then drain on kitchen paper to soak up any excess.
- Pour the oil into a frying pan set over a high heat and cook the bread and cheese fingers for 2–3 minutes on each side or until they are golden brown.

Granny Sallie's old-fashioned chocolate cake

The top of the cake can be decorated in a number of different ways, or simply left plain. Ever popular with children are chocolate buttons, Smarties or chunks of chocolate Flake.

From 1 year Makes about 14 servings Suitable for freezing

150g (5oz) caster sugar 175g (6oz) self-raising flour 2 level tbsp cocoa powder 1 tsp baking powder 2 tbsp golden syrup 2 eggs 150ml (5fl oz) sunflower oil 150ml (5fl oz) full-fat milk 2–3 tbsp apricot jam

For the icing

50g (2oz) unsalted butter 25g (1oz) cocoa powder, sifted 2 tbsp full-fat milk 225g (8oz) icing sugar, sifted

- Preheat the oven to 170°C/150°Fan/Gas Mark 3, then grease and line two 20cm (8in) cake tins.
- To make the cake, place the sugar in a large mixing bowl, then sift in the other dry ingredients. Make a well in the centre and pour in the remaining ingredients, beating together thoroughly until light and fluffy in texture.
- Pour the mixture into the cake tins and cook in the pre-heated oven for 30–35 minutes or until risen and firm to the touch. Remove from the tins and cool on a wire rack.
- To make the icing, melt the butter in a pan, then add the cocoa powder and cook for 1 minute on a low heat. Stir in the milk and icing sugar, then remove the pan from the heat and allow to cool, stirring occasionally, until it thickens.
- Spread one cake with a thin layer of apricot jam and the other with a thin layer of the icing mixture and then press the two together. Spread the remaining icing mixture over the top and sides of the cake. Leave to set then decorate as desired.

Chocolate dominoes

From 1 year Makes 12 cakes Suitable for freezing

110g (4oz) butter 110g (4oz) caster sugar 2 eggs, beaten 75g (3oz) self-raising flour 50g (2oz) cocoa powder 225g (8oz) icing sugar, sifted

- Pre-heat the oven to 200°C/180°Fan/Gas Mark 6, then lightly grease a 32 x 20cm (11 x 8in) Swiss roll tin.
- To make the chocolate dominoes, cream the butter and caster sugar until pale and fluffy, then stir in the eggs. Sift over the flour and 25g (1oz) of the cocoa powder and mix thoroughly.
- Pour the mixture into the Swiss roll tin and bake in the preheated oven for 20 minutes, then turn onto a wire rack to cool for half an hour.
- To make the icing, sift the remaining cocoa powder into a saucepan, add 2 tablespoons of water and bring to the boil, stirring continuously. Add 175g (6oz) of the icing sugar and mix well. Add a little boiled water if the mixture is too thick. Spread over the cake and cut into rectangles.
- To decorate the dominoes, mix the remaining icing sugar with a few drops of water and pipe onto the cakes to form the dots.

Chocolate crunchies

This is an ideal recipe for encouraging your children to help you in the kitchen. The crunchies are very quick to prepare, and because they require no baking time (they set in their paper cases) the children won't have to wait long to sample the results of their efforts.

From 18 months

Makes about 14 chocolate crunchies

Suitable for freezing

75g (3oz) unsalted butter 50g (2oz) good-quality dark chocolate, broken into small pieces 2 dessertspoons golden syrup 65g (2½oz) Rice Krispies or corn flakes handful of raisins (optional)

- Melt the butter in a bowl over a small pan of simmering water, then add the chocolate and golden syrup.
- When the chocolate has melted, add the Rice Krispies or corn flakes to the mixture and slightly crush.
- Mix well to coat the Rice Krispies or corn flakes, then add the raisins (if using). Spoon into the paper cases, set on a serving plate and allow to firm up in a cool place.

Buff's crunchy biscuits

Before dividing the mixture into balls, you could add one of the following ingredients: chocolate drops, or pieces of broken-up chocolate, raisins, grated orange or lemon rind. (The biscuits will need cooking for an extra 5 minutes.)

From 18 months Makes about 20 biscuits Unsuitable for freezing

220g (8oz) unsalted butter, or margarine, softened 175g (6oz) caster sugar 225g (8oz) self-raising flour 110g (4oz) porridge oats ½ tsp baking powder few drops of vanilla essence 2 tsp golden syrup 2 tsp boiling water

- Pre-heat the oven to 180°C/160°Fan/Gas Mark 4. In a large mixing bowl, cream together the butter and caster sugar.
- Sift over the flour and fold in, followed by the oats, baking powder, vanilla essence, golden syrup and water. The mixture should be quite firm, leaving the sides of the bowl when kneaded.
- Grease 2 baking sheets. Divide the mixture into about 20 small balls, then flatten them slightly. (If the mixture is too sticky, sprinkle some flour onto the palms of your hands for easier handling, or add a few more oats to the mixture.)
- Arrange the biscuits on trays in batches, fairly well separated as they will spread as they cook, then place in the pre-heated oven. After about 8 minutes, they should look pale gold and slightly crispy round the edges. Transfer onto a wire rack to cool and harden.

Simple fairy cakes

You could add a small quantity of natural food colouring to the icing of these cakes, if you liked. To decorate them, there are a host of ideas to choose from: piping children's initials onto them using contrasting icing, making faces with raisins, or simply adding pretty sweets, are just a few ideas.

From 1 year Makes 12 cakes Suitable for freezing

12 paper cases
125g (4½oz) self-raising flour
125g (4½oz) unsalted butter, softened
125g (4½oz) caster sugar
2 eggs
1 tsp baking powder
3 tbsp milk

For the icing 225g (8oz) icing sugar, sifted 2–3 tbsp warm water

- Pre-heat the oven to 180°C/160°Fan/Gas Mark 4 and place the paper cases in a muffin tray.
- Mix all the cake ingredients, except the milk, in a food processor. Gradually add the milk and continue processing until the mixture has reached 'dropping' consistency (that is, it will easily drop from a spoon held above the mixture).
- Half-fill the paper cases with the mixture and cook in the preheated oven for 15–20 minutes until the cakes have risen and are golden brown. Remove and cool on a wire rack.
- To make the icing, sift the icing sugar into a mixing bowl and gradually add the water, beat with a wooden spoon until slightly thickened (but not too thick or it won't spread easily). Then spread on the individual cakes.

Batch Cooking

Batch Cooking

Cooking in batches is the perfect way to prepare several meals, or the bases for a number of meals, in advance and then freeze them for later use, especially when time is tight. In this chapter, I have included recipes for two extremely useful basic sauces, Tomato Sauce and Definitive Cheese Sauce (see pages 194 and 196), which, when prepared in advance, can speed up the preparation of the many different dishes that incorporate them. Other recipes, like Gina's Fish Pie/Mini Fishcakes (see pages 202–203), use the same basic ingredients, and so it makes sense to prepare similar dishes such as these at the same time.

The majority of the recipes in this book can be cooked in larger batches and frozen (see the freezing instructions on page 9). Particularly suitable for batch cooking are all of the stocks and soups in the Soups chapter, and dishes such as Chicken and Leek Lasagne, Shepherd's Pie or Gina's Mixed Fruit Crumble (see pages 50, 64 and 162).

To prepare batch-cooked items for freezing, it is a good idea to divide the food into individual portions to defrost as required for your baby or toddler. (Smaller portions also take less time to defrost.) Sauces and purées can be poured into ice-cube trays for freezing, other items placed in airtight containers or sealed in freezer-proof bags. The frozen food should be used within 6–8 weeks on average, defrosted fully before use, then stored in the fridge and eaten within 24 hours.

Babies are much more susceptible than adults to food poisoning, so you need to take particular care to defrost and reheat food thoroughly and not to reheat it more than once. Please remember too that food that has been cooked and frozen before should not be refrozen; likewise raw food that has been frozen should be cooked before being refrozen.

Tomato sauce

Tomatoes are rich in antioxidants and a great source of vitamin C, as well as being one of the most versatile food ingredients. When I worked in Italy, we would make a huge batch of tomato sauce every couple of weeks and store it in different-sized containers in the fridge and freezer. It is a wonderful complement to pasta and can be used as a base for many other dishes. Cook it in large batches, transfer to several airtight containers and freeze for up to 3 months.

From 7–8 months Makes about 1.7 litres (3 pints) Suitable for freezing

- 1.8kg (4lb) plum tomatoes
- 2 tbsp olive oil
- 2 medium onions, peeled and chopped
- 2 garlic cloves, peeled and crushed (omit for babies under 9 months)
- 4 tbsp tomato purée
- ½ tsp each of dried basil, oregano and thyme
- 2 bay leaves
- 1.25 litres (2 pints) of water or Vegetable Stock (see page 33)
- To skin the tomatoes, cover with boiling water and leave for
 minute, then peel, cut in half, deseed and roughly chop.
- Heat the oil in a large, heavy-bottomed saucepan, add the onions and garlic and sauté until soft. Add the tomatoes, tomato purée, dried herbs, bay leaves and water or stock.
- Stir well and bring to the boil, then leave to simmer for at least 40 minutes, stirring occasionally.
- Allow to cool, then remove the bay leaves and either pulse or purée the tomato sauce in a food processor, depending on how lumpy you'd like it to be.

Tomato sauce with bacon and mushrooms

From 1 year
Makes about 600ml (1 pint) or about 22 large ice cubes
Suitable for freezing

1 tbsp olive oil 110g (4oz) lean unsmoked bacon, rind removed, diced 50g (2oz) mushrooms, wiped and chopped 1 tbsp plain flour 600ml (1 pint) Tomato Sauce (see page 194)

- Heat the oil in a saucepan, add the bacon and chopped mushrooms, then gently cook for 4–5 minutes. Stir in the flour and cook for a further 2 minutes.
- Add the tomato sauce, mix well, allow to cool then transfer to airtight containers and freeze for up to 2 months.

Definitive cheese sauce

From 6-7 months

Makes 600ml (1 pint) or about 22 large ice cubes

Suitable for freezing

50g (2oz) unsalted butter 1 heaped tbsp plain flour 600ml (1 pint) full-fat milk 4oz (110g) mild Cheddar cheese, grated 1/4 tsp freshly grated nutmeg

- Melt the butter in a non-stick saucepan, add the flour and cook for 2 minutes on a low heat, stirring continuously.
- Gradually add the milk, stirring all the time, and cook the sauce for about 10 minutes, until it has thickened.
- Add the cheese and nutmeg, then stir on a low heat until combined. Allow to cool then transfer to airtight containers or ice-cube trays and freeze. Defrost for use in such dishes as Cod with Cheese Sauce and Broccoli (see page 40).

Bolognese sauce Shepherd's pie Creamy beef and pasta bake

Before starting to cook these dishes, it is a good idea to prepare all the vegetables and lay them out in their different piles on a clean chopping board, then measure and lay out all the other ingredients.

From 9-10 months

Makes 4 servings of each (12 in total)

Suitable for freezing

- 1 tbsp olive oil
- 3 small or 2 medium onions, peeled and very finely chopped
- 3 small garlic cloves, peeled and crushed
- 1.4kg (3lb) lean minced beef
- 2 x 400g (14oz) cans of chopped tomatoes with herbs
- 4 carrots, peeled and diced
- 4 tbsp tomato purée
- 300ml (½ pint) Chicken Stock (see page 33)

For the Bolognese sauce

50g (2oz) streaky bacon (omit for babies under 18 months) 1 stick of celery, trimmed and finely diced 50g (2oz) mushrooms, wiped and sliced

For the shepherd's pie

450g (1lb) potatoes, peeled and diced 1 tbsp milk 25g (1 oz) unsalted butter 2 tsp cranberry jelly

For the creamy beef and pasta bake

250g (9oz) cooked pasta
125g (4½oz) cottage cheese
1 courgette, diced
3 eggs
300ml (½ pint) double cream
75g (3oz) mild Cheddar cheese, grated
1 cup of breadcrumbs
2 tbsp plain flour

 Heat the oil in a large, heavy-bottomed saucepan, add the onions and garlic and cook for 3–4 minutes until softened.
 Add the mince and cook until browned, stirring occasionally and breaking up any lumps as it cooks, then set aside.

Bolognese sauce

- In another pan, sauté the bacon for 3–4 minutes, then add 1 can of tomatoes, the celery, a third of the carrots and the mushrooms. Add a third of the minced beef and onion from the first pan and 150ml (¼ pint) of the stock, bring to the boil, then reduce the heat and simmer for approximately 45 minutes.
- When cool, transfer to individual containers and freeze. Defrost and warm through thoroughly to serve with spaghetti.

Shepherd's pie

- Place the potatoes in a steam pan with lots of water, bring to the boil and then put the remaining carrots in the basket on top and continue to boil rapidly until both are tender. Drain the water from the potatoes and mash well, adding the milk and butter.
- Place half of the remaining mince in another pan and mix in the carrots, 2 tbsp tomato purée, the cranberry jelly and the remaining stock, then simmer for a further 45 minutes. Set aside to cool, then transfer the mixture into four small cooking dishes and top with the mashed potato, ready for freeezing.
- After defrosting fully, heat through in a moderate oven (180°C/160°Fan/Gas Mark 4) for 15–20 minutes.

Creamy beef and pasta bake

- Mix the cooked pasta with the cottage cheese and 1 egg, and spoon into four small, greased ovenproof dishes.
- Stir the remaining can of tomatoes, the remaining tomato purée, the flour and the courgette into the remainder of the minced beef and onion. Simmer for 30 minutes until the sauce has thickened. Divide between the four dishes, then whisk together the remaining eggs, the cream, grated cheese and breadcrumbs, and pour over the top.
- Pack individually and freeze for up to one month, defrosting fully before heating through in a moderate oven (180°C/160°Fan/Gas Mark 4) for 20–25 minutes.

Gina's fish pie Mini fishcakes

The following recipe will provide you with two different fish dishes, both suitable for freezing, which can be served with a variety of freshly cooked vegetables. To freeze, first wrap the fish pie or pies and each fishcake individually in cling film and place in a freezer-proof, airtight container. Defrost thoroughly before heating.

From 9-10 months Makes 10-12 servings in total Suitable for freezing

900g (2lb) fresh white fish fillets (such as cod or haddock) 300ml (½ pint) full-fat milk 900g (2lb) potatoes, peeled and cut into chunks 50g (2oz) unsalted butter

For the fish pie

1 tbsp plain flour
1 small onion, peeled and very finely chopped
1 leek, washed and finely chopped
1 x 200g (7oz) can of sweetcorn, drained
2 tbsp mild Cheddar cheese, grated

For the fishcakes

1 egg yolk, beaten freshly squeezed lemon juice plain flour, for dusting 2 tbsp breadcrumbs

- Steam or poach the fish in the milk for about 5–7 minutes until it flakes. At the same time, put the potatoes into a saucepan of rapidly boiling water and cook until tender. Drain.
- Drain the fish, reserving the milk, and flake it, removing any skin and bones, then divide into two, putting one half into a large mixing bowl (for the fishcakes). Leave the other half in the pan (for the fish pie).
- Mash the potatoes well and divide the mixture into two, mixing one half with the fish in the bowl.

Gina's fish pie

- Melt half the butter in a saucepan, add the flour and cook for a couple of minutes before gradually adding the milk from the poached fish. Simmer the sauce gently, whisking continually, until thickened, then add the onion and leek and cook for 2–3 minutes until softened, then mix with the fish in the pan and stir in the sweetcorn.
- Transfer to a gratin dish (or individual dishes for freezing) and spread half the mashed potato on top, then sprinkle over the cheese.
- To cook the fish pie (from fresh or after defrosting), place in a pre-heated oven at 180°C/160°Fan/Gas Mark 4 for 20–25 minutes.

Mini fishcakes

- Stir the egg yolk and 2–3 drops of lemon juice into the potato and fish mixture in the bowl.
- Form the mixture into 8 small patty cakes, dust with flour and smear lightly with the remaining butter (melted) and coat in the breadcrumbs.
- To cook the fishcakes (from fresh or after defrosting), place under a pre-heated, moderate grill for 10–15 minutes, turning once.

Chicken and sweetcorn casserole Mediterranean chicken Chicken Marengo

It is best to measure, prepare and lay out all the ingredients for these dishes in separate piles before starting to cook. Once cooked, freeze them in individual portions for your baby or toddler. Defrost and heat through thoroughly on top of the stove before use.

From 7 months Makes 10-15 servings Suitable for freezing

- 2 tbsp olive oil
- 4 medium onions, peeled and very finely diced
- 1 garlic clove, crushed
- 10 skinless chicken breasts, diced
- 4 carrots, peeled and thinly sliced
- 2 sticks of celery, trimmed and finely diced
- 3 tbsp plain flour
- 1.25 litres (2 pints) Chicken Stock (see page 33)

For the chicken and sweetcorn casserole

- 6 small potatoes, peeled and diced
- 6 baby sweetcorn, chopped into 1cm (½in) pieces
- 2 tbsp plain flour
- 225g (8oz) double cream

For the Mediterranean chicken

½ red pepper, finely sliced

½ yellow pepper, finely sliced

1 x 400g (14oz) can of tomatoes with herbs

110g (4oz) easy-cook long-grain rice

2 courgettes, thickly sliced

For the chicken Marengo

1 tbsp plain flour

1 x 500g (1lb 2oz) carton of passata

110g (4oz) mushrooms, wiped and thinly sliced

• Pre-heat the oven to 180°C/160°Fan/Gas Mark 4. Heat the oil in a very large saucepan, add the onions and garlic and cook for 3–4 minutes, then add the chicken and cook for a further 10 minutes.

Chicken and sweetcorn casserole

- Remove one third of the chicken and onion from the pan and transfer to a large casserole dish, add half the carrots and celery and all of the potatoes and sweetcorn.
- Mix 2 tablespoons of flour with a little of the hot stock to make a smooth paste, then mix in a further 600ml (1 pint) of the stock and pour over the chicken and vegetables.
- Cover and cook in the middle of the pre-heated oven for 40 minutes. Remove, stir in the cream and return to the oven for a further 10–15 minutes.

Mediterranean chicken

- Transfer half the remaining chicken and onion to a deep saucepan, add the remaining carrots and celery, along with the peppers, tomatoes and rice and 300ml (½ pint) of the stock.
- Bring to the boil, then simmer for 30 minutes, add the courgettes and simmer for a further 10 minutes until the courgettes are just tender.

Chicken Marengo

- Sprinkle 1 tablespoon of flour over the remaining chicken and onion, and cook for 2–3 minutes, then add the remaining stock and the passata. Bring to the boil, then simmer gently for 30–40 minutes, stirring occasionally.
- Add the mushrooms and cook for a further 10 minutes, then serve with long-grain rice.

Index

apples: apple snowballs, 164 homemade apple sauce, 69 sweet red cabbage, 150 apricots: easy lamb and fruit couscous, 62 fruity lamb tagine, 122

bacon: kiddies' mixed grill, 124 spaghetti carbonara, 128 tomato sauce with mushrooms and, 196 batch cooking, 191-205 bean sprouts: prawn or chicken stir-fry, 116 beef: creamy beef and pasta bake, 198-200 easy roast beef, 67 leftover roast beef with a mashed potato topping, 137 pork and beef meatballs, 132 quick spaghetti Bolognese, 134 quick and tasty hamburgers, 176 steak and kidney pie, 65

bestest Brussels, 144 birthday parties, 169–89 biscuits, Buff's crunchy, 186 boiling vegetables, 141 Bolognese sauce, 198–9 bread: bread and cheese fritters, 180 cheesy garlic bread, 155 croque monsieur, 78

broccoli: chicken and mushroom gratin, 54

cod with cheese sauce and, 40 pasta with sausages and, 130 Brussels, bestest, 144

bubble and squeak potato cakes, 98

Buff's crunchy biscuits, 186 burgers, quick and tasty, 176 butternut squash and chicken pie, 118

cabbage: bubble and squeak potato cakes, 98 sweet red cabbage, 150

Caiun salmon with cherry tomatoes, 114 cakes: chocolate dominoes. 182 Granny Sallie's old-fashioned chocolate cake, 181 simple fairy cakes, 188 carrots: carrot and parsnip purée, 154 honeved carrots, 156 cheese: bread and cheese fritters, 180 cheese and ham jacket potatoes, 95 cheese toasties with cherry tomatoes and ham, 80 cheesy chicken gratin, 47 cheesy garlic bread, 155 cheesy peasy rice, 90 cheesy tomato sauce, 102 chicken and butternut squash pie. 118 chicken and Parmesan fingers. 76 chicken with cream cheese and Parma ham, 53 chive omelette with ham, tomato and, 125 cod with cheese sauce and broccoli, 40 creamy beef and pasta bake. 198-200 creamy spinach and cheese iacket potatoes, 96 croque monsieur, 78 definitive cheese sauce, 196 homemade crêpes with ham and cheese, 126 mashed potato with pesto and Parmesan, 148 Neapolitan macaroni, 104 pasta with cream cheese and spinach, 108 tomato, egg and cheese bake, 100 Welsh rarebit, 74 chick peas: hummus, 174 chicken: cheesy chicken gratin, chicken and butternut squash pie, 118 chicken and leek lasagne, 50

chicken and mushroom gratin, 54 chicken and Parmesan fingers. chicken and pea pilaf, 120 chicken and sweet potato casserole, 48 chicken and sweetcorn casserole, 204-5 chicken and vegetable broth, chicken drumsticks in a marinade, 79 chicken Marengo, 204-5 chicken stir-fry, 116 chicken stock, 33 chicken with tagliatelle, 58 chicken with cream cheese and Parma ham, 53 cream of chicken and sweetcorn soup, 32 fruity chicken salad, 56 leftover roast chicken in a pie. 136 Mediterranean chicken, 204-5 quick pilaf, 52 roast poussin, 46 child development, 12-19 chive omelette with ham, cheese and tomato, 125 chocolate: chocolate crunchies. 184 chocolate dominoes, 182 Granny Sallie's old-fashioned chocolate cake, 181 cod: cod with cheese sauce and broccoli, 40 crunchy fish sticks, 84 corn flakes: chocolate crunchies, 184 courgettes: tender lamb in a pot, couscous, easy lamb and fruit, 62 crêpes with ham and cheese. 126 croque monsieur, 78 crumble, Gina's mixed fruit, 162 day-after Sunday lunch, 136-7

dips, 174

eggs: chive omelette with ham, cheese and tomato, 125 egg and potato cake, 137 scrambled egg surprise, 123 spaghetti carbonara, 128 tomato, egg and cheese bake, 100 Eton mess, junior, 166

fairy cakes, 188
fast-boiling vegetables, 141
finger foods, 14, 71–85
fish: Gina's fish pie, 202–3
Italian fish stew, 42
Mediterranean fish casserole, 110
mini fishcakes, 202–3
quick salmon fishcakes, 82
freezing food, 9, 193
French pea purée, 142
fritters, bread and cheese, 180
fruit crumble, Gina's, 162
fruity chicken salad, 56
fruity lamb tagine, 122

garlic: cheesy garlic bread, 155 garlicky square potatoes, 146 green beans in garlic, 147 Gina's fish pie, 202–3 Gina's mixed fruit crumble, 162 Granny Sallie's old-fashioned chocolate cake, 181 green beans: green beans in garlic, 147 Provençal string beans, 147

ham: cheese and ham jacket potatoes, 95 cheese toasties with cherry tomatoes and, 80 chicken with cream cheese and Parma ham, 53 chive omelette with cheese, tomato and, 125 croque monsieur, 78 homemade crêpes with cheese and, 126 Provençal string beans, 147 scrambled egg surprise, 123 simple pasta dish, 107 hamburgers, 176

honeyed carrots, 156 honeyed sausages, 178 hummus, 174

Italian fish stew, 42

jacket potatoes, 94-7 junior Eton mess, 166

kiddies' mixed grill, 124 kidneys: steak and kidney pie, 65

lamb: all-in-one braised lamb and veg, 59
easy lamb and fruit couscous, 62
easy roast lamb, 66
fruity lamb tagine, 122
leftover roast lamb with a mashed potato topping, 137 shepherd's pie, 64, 198–9 tender lamb in a pot, 60
lasagne, chicken and leek, 50
leeks: chicken and leek lasagne, 50
Gina's fish pie, 202–3
lentils: winter vegetable and lentil soup, 26

lettuce: French pea purée, 142

lunch, 35-69

macaroni, Neapolitan, 104
meatballs, pork and beef, 132
Mediterranean chicken, 204–5
Mediterranean fish casserole, 110
meringue: apple snowballs, 164
junior Eton mess, 166
milk, 8, 14, 15
mini fishcakes, 202–3
mini quiches, 172
miniature toads in the hole, 133
muffins: cheesy toasties, 80
mushrooms: chicken Marengo, 204–5
chicken and mushroom gratin, 54
tomato sauce with bacon and,

Neapolitan macaroni, 104 noodles: prawn or chicken

196

stir-fry, 116

oats: Buff's crunchy biscuits, 186 omelette, chive, 125 organic food, 8

Parma ham, chicken with cream cheese and, 53 parsnip and carrot purée, 154 parties, 169-89 pasta: cheesy tomato sauce, 102 chicken and leek lasagne, 50 chicken with tagliatelle, 58 creamy beef and pasta bake, 198-200 Neapolitan macaroni, 104 pasta with broccoli and sausages, 130 pasta with cream cheese and spinach, 108 penne in a creamy sauce, 106 quick spaghetti Bolognese, 134 simple pasta dish, 107 spaghetti carbonara, 128 spaghetti with prawns and peas, 112 vegetable purée, 102 peas: cheesy peasy rice, 90 chicken and pea pilaf, 120 French pea purée, 142 plaice fillet with potato and, 38 spaghetti with prawns and, 112 penne in a creamy sauce, 106 peppers: Mediterranean chicken, 204-5 Mediterranean fish casserole. 110 pesto, mashed potato with Parmesan and, 148 pies: chicken and butternut squash pie, 118 Gina's fish pie, 202-3 leftover roast chicken in a pie, 136 shepherd's pie, 64, 198-9 smoked fish pie, 44 steak and kidney pie, 65 pilaf: chicken and pea pilaf, 120 quick pilaf, 52 plaice fillet with peas and potato,

pork: easy roast pork, 68 pork and beef meatballs, 132 potatoes: bubble and squeak potato cakes, 98 chicken and butternut squash pie, 118 egg and potato cake, 137 garlicky square potatoes, 146 Gina's fish pie, 202-3 jacket potatoes, 94-7 leftover roast lamb or beef with a mashed potato topping, mashed potato with pesto and Parmesan, 148 mini fishcakes, 202-3 plaice fillet with peas and potato, 38 quick salmon fishcakes, 82 roasted new potatoes, 146 shepherd's pie, 64, 198-9 smoked fish pie. 44 smoked haddock and mashed potato in parsley sauce, 45 poussin, roast, 46 prawns: prawn stir-fry, 116 spaghetti with peas and, 112 Provençal string beans, 147 puddings, 159-67

quiches, mini, 172

red cabbage, sweet, 150
rice: cheesy peasy rice, 90
chicken and pea pilaf, 120
fruity chicken salad, 56
Mediterranean chicken, 204–5
Mediterranean fish casserole, 110
quick pilaf, 52
risotto with pasta sauce, 92
Rice Krispies: chocolate
crunchies, 184
risotto with pasta sauce, 92
root vegetables, roasted, 152

salad, fruity chicken, 56 salmon: Cajun salmon with cherry tomatoes, 114 quick salmon fishcakes, 82 salt, 8 sauces: Bolognese sauce, 198–9

cheesy tomato sauce. 102 definitive cheese sauce, 196 homemade apple sauce, 69 tomato sauce, 194 tomato sauce with bacon and mushrooms, 196 vegetable purée, 102 sausages: honeyed sausages. 178 kiddies' mixed arill, 124 mini quiches, 172 miniature toads in the hole, 133 pasta with broccoli and sausages, 130 Scotch broth, 30 scrambled egg surprise, 123 serving sizes, 9 shepherd's pie, 64, 198-9 smoked haddock: smoked fish smoked haddock and mashed potato in parsley sauce, 45 soups, 22-32 chicken and vegetable broth, 28 cream of chicken and sweetcorn soup, 32 cream of tomato soup, 24 Scotch broth, 30 winter vegetable and lentil soup, spaghetti: quick spaghetti Bolognese, 134 spaghetti carbonara, 128 spaghetti with prawns and peas. 112 spinach: creamy spinach and cheese jacket potatoes, 96 pasta with cream cheese and. 108 steak and kidney pie, 65 stocks, 33 strawberries: junior Eton mess, 166 sugar, 161 sweet potato and chicken

casserole, 48

sweet red cabbage, 150

sweetcorn: chicken and

cream of chicken and

sweetcorn soup, 32

sweetcorn casserole, 204-5

Gina's fish pie, 202–3 tuna and sweetcorn jacket potatoes, 95

tagine, fruity lamb, 122 tagliatelle, chicken with, 58 teatime treats, 87-137 toads in the hole, miniature, 133 toast: Welsh rarebit, 74 tomatoes: Cajun salmon with cherry tomatoes, 114 cheese toasties with cherry tomatoes and ham, 80 cheesy tomato sauce, 102 chicken Marengo, 204-5 chicken with tagliatelle, 58 chive omelette with ham. cheese and, 125 cream of tomato soup, 24 tender lamb in a pot, 60 tomato, egg and cheese bake. 100 tomato sauce, 194 tomato sauce with bacon and mushrooms, 196 tuna and sweetcorn jacket potatoes, 95

vegetables, 139–57
all-in-one braised lamb and veg, 59
chicken and vegetable broth, 28
egg and potato cake, 137
fast-boiling, 141
roasted root vegetables, 152
Scotch broth, 30
vegetable dippers, 174
vegetable purée, 102, 174
vegetable stock, 33
winter vegetable and lentil soup, 26

weaning, 12–14 Welsh rarebit, 74 winter vegetable and lentil soup, 26

yoghurt: junior Eton mess, 16